To Sharon,
my wife, muse, fan, and friend.
You're not only the safety net under the risks I take,
you're leaping with me. Thanks, babe.

Acknowledgments

I'm deeply grateful to the following:

To every client I've ever had who has allowed me to do what I love and serve them in the process, thank you. To Lyric especially, my first and favorite client, who took a chance on me because, though my abilities were unproven, we shared the same vision and passion. And then she sent me to a war zone.

To my friend, client, and now my manager, Corwin, for faithfully taking time every week to share a drink or a meal and the ups and downs of life as an entrepreneur.

To my other friends—photographers and otherwise—who have never once asked me when I was going to get a real job, but instead encouraged me and supported me, and a few times helped me pick up the pieces: Troy Cunningham, Eric Pay, Jeff Anderson, Matt Brandon, Gavin Gough, Kevin Clark. Thanks to my friend Alan Smith, impossible to track down most of the time but when we get together his encouragement and business advice is always worth the wait.

To the photographers who gave so generously of their time so I could include them, their work, and their stories in this book. Without exception, they are kind people of great talent and heart who love and give back to the photographic community.

To my editor, Ted Waitt, one of the unseen heroes behind not only this book but many of the best photography books out there. What it takes to corral a stable of photographers trying to express themselves in unfamiliar words, I can only guess, but he's my hero. My book team as well. To Charlene Charles-Will, the designer who makes these books so gorgeous; to Scott Cowlin and Sara Jane Todd, who flog them with the greatest of enthusiasm and integrity; and to my publisher, Nancy Aldrich-Ruenzel, who keeps taking these chances on me. Thanks so much.

To the photographic industry, particularly my sponsors. I know I give the industry a hard time occasionally with all this *Gear Is Good, Vision Is Better* talk. I know you prefer it when I have a lapse and accidentally preach my *Screw Vision, Give Me Something Shiny* sermons instead. Still, we all have a role to

play and your gear makes my job easier, and in many cases, just plain fun. My sponsors—Adobe, Lexar, Think Tank Photo, Gitzo, Drobo, Acratech, BlackRapid, Lensbaby, PocketWizard, Evrium, and ZINK—all support my work with the quality of the products they make.

To the readers of my books and blog who have created a community around my words and lunatic rants. Thank you. What you have given back to me feels generously disproportionate to the words I crank out.

To my mother, Heather, who has been my best friend since as far back as I can remember. She has been my greatest fan, greatest cheerleader, and often my greatest inspiration. To my stepfather, Paul, for raising me as his own, and tormenting me accordingly. His stories of working the steel mills of Hamilton have kept me from honest work for years now, and for that I'm grateful.

To Sharon, for supporting me, loving me, and cheering me on.

Finally, to God, from Whom my calling, and the gifts to chase it, comes. Be Thou my Vision, oh Lord of my heart.

About the Author

David duChemin has taken a winding, unlikely road as he's followed his calling. From aspiring photographer to theologian to professional comedian and eventually back to his first passion, David is now a full-time world and humanitarian photographer, teacher, and author. A passionate contributor to the international photography community, duChemin's first book, the bestselling *Within the Frame: The Journey of Photographic Vision*, received worldwide acclaim for its vision, passion, and depth.

David's work and blog can be found online at PixelatedImage.com.

Photo: Kevin Clark

Contents

CHAPTER THREE

Sounding Your Barbaric Yawp 86

Introduction

IN 2006 I RETURNED TO MY FIRST PASSION, photography, as a vocation, after taking a zigzag path to get there. After theology college and a 12-year stint as a successful comedian, I left the stage and became a full-time working photographer, what some would call a professional. With vision, passion, and 12 years of marketing and entrepreneurial know-how, I made a dramatic change of direction and am now enjoying the calling I've dreamed of since I was 14 years old. I use the word "calling" because that's the word at the core of the word "vocation," and it's the word I feel best suits what I think and feel about this gig.

In fact, if you do not feel like photography is something you are called to—by God, your gifts, your talents, a small nagging voice inside, or just an overwhelming passion for it—then it's probably not the right choice for you. Finding a life through the lens is not hard—if it's what you love, it's easy. But making a living, that's tough.

There's no way around it, so let me get it out there as plainly as I can: making a living as a photographer is just plain hard, and in this book I'm going to be unapologetically discouraging on occasion. If you plan to go into this, it's got to be because you feel so compelled to do it that you'd do anything to make a go of it. That you love it so much you feel like you have no choice in the matter. And you've got to go in with your eyes open. It's hard. Every vocational photographer I know does this for the love of it and is wrestling the beast to the ground, every day, to do it.

> "It's hard, in part, because there are no formulas. There isn't one single path."

It's hard, in part, because there are no formulas. There isn't one single path. It begins with passion and vision, but the way is guarded by self-doubt ("Am I good enough?") and a confusing multiplicity of options ("Who would even buy what I want to shoot?"), not to mention the labyrinth once you get inside ("How do I get the word out?"). If you take a sampling of 12 photographers, even within the same market, you'll more than likely find that all of them do business differently and market themselves differently. They have different goals and different pricing, and they all took very different paths to get there.

You'll see pretty quickly that I approach all this as an idealist trying desperately to be pragmatic. In *Within the Frame* I talked about the uneasy, but necessary, merging of the artist and the geek. This book is about the turbulent coming-together of craft and commerce. Can it be done without sacrificing your vision and your artistic integrity? Yes, it can. Easily, with no anguish? Probably not.

If you're looking, not for a formula, but for wisdom to help you navigate the transition into this vocation, then this book might just be a source of that wisdom. But at best it's merely one source. If you're looking for a template or a set of cookie-cutter do-this-and-do-thats, then move along. There is nothing for you here. It'll only disappoint you because, over and over again, I am going to remind you that this is your unique path. In an industry where the flux is so constant, a book that promises you riches, or even success, without first warning that the journey is fraught with peril, is presumptuous, false, and unkind.

The Visionmonger

These days the word "monger" means something other than what it once did. Originally it meant nothing more than "one who sells or peddles goods"—there were ironmongers and fishmongers. They traded on their skill, their craft, or their product, and aside from it being an impossible distance from the dignity of the aristocracy, there was no shame it. Now we have warmongers and gossip-mongers, and the words come to mean something different. But as is the organic nature of language, there's no reason in the world why we shouldn't take the word back and appropriate it for more honest use. And it's in that spirit that I coined the term "visionmonger." It's a handle for myself to remind me that this business is an honest combination of craft and commerce—the hybridization of expressing my vision and bringing it to market. It's a reminder that my true value, the thing I bring to the market for which they will pay higher prices, is not in the printed image itself but in the unique creativity and vision from which that image sprang. You are free to call it whatever you like, and the word you put on your business card may be simply "photographer," as it is on mine. But in the back of my head I'm a visionmonger, and I'll sell it to anyone who will honor my work and put it to noble use.

It's hard because the lines between amateur and professional are blurring, the old rules have changed, the market is full to bustin' with people who bought $2,000 worth of gear and a business card and now work furiously to undercut the rest of us—not to mention the fact that traditional markets are drying up, stock agencies are rising (and falling), and the industry, in general, is in a state of unparalleled flux.

And you, you intrepid soul, want to make a living in this maelstrom. If you're like me it's not because you don't have other options. It's because something inside you will burst out—or die—if you don't follow the voices of the sirens calling you to this. If I weren't so much like you, I'd think you were crazy. Maybe you are; maybe we all are. But as the classic Apple advertisements used to trumpet: Here's to the crazy ones.

There are many photographers out there doing their thing, that thing they love. Some of them are full-time, some part-time. Some shoot weddings, some make portraits of dogs or babies. Some are photojournalists, some shoot for humanitarian organizations or Fortune 500 companies or rock stars. You can choose to look at this crowded industry with dismay ("How in the world can I make a living in this oversaturated industry?") or you can look at it as a challenge and see the other side of the coin. Yes, the fields are full of photographers. But they're making a go of it. They go to work daily and struggle the same way—they make phone calls, they work on marketing materials, they spend hours sweating over how to better serve their clients, and they do it all while also working on their craft. All so they can what? Be famous? Be rich? Hardly. They do it all so they can keep shooting for another day, keep feeding the family while they pursue the next image. And if there's room for so many now, there's room for a few more.

The Images in This Book

The photographs in this book represent images I've shot in pursuit of this career. If I had my choice, I'd fill the pages with my best commercial work, but the work I do for nongovernmental organizations (NGOs) is usually very tightly controlled by child protection policies and agreements that limit my use of the images to portfolio use only, which this book is not. I chose them for a couple reasons. First, this is a book about photography, so it's fitting that there are photographs in it; with few exceptions these images represent work I've done either as play or for clients who lie outside my usual work. Either way, they represent images I've sold and, as such, they illustrate, along with the images the profiled photographers have contributed, images that we've found markets for, and they go to show that what the markets want is as diverse as the subjects the photographers want to photograph. Second, without images this book would require way more words, and I'm already pushing my luck. Hopefully the diversity of these images will make the book a lighter read and add a level of inspiration that words alone can't provide.

This book will not make you a successful photographer. Only you can do that. This book isn't a textbook, an encyclopedic checklist, or—God forbid—a system. It's more like a sketchbook of ideas, wisdom, and inspiration for photographers braving the waters of vocational photography in particularly turbulent times. What this book does, I hope, is give you a handful of wisdom—some of it hard-earned, as you'll see from the photographer profiles—that gives you tools and courage to bushwhack your own path, hear the call of the sirens, set the mainsail, and turn toward their call. Now if you know your mythology, that's a dangerous metaphor, and I'm hoping you won't run your ship into the rocks, but it's going to feel that way at times; it's going to feel like the call of the sirens and your own desperate need not to shipwreck yourself are the two opposing extremes that keep you in tension. And that's a good thing. That's the exciting place in which we look to balance craft and commerce, and live another day to both sail our ship toward the call and still avoid the rocks. If the metaphor doesn't work for you, that's okay. If I could say everything with words, I wouldn't have picked up a camera.

CHAPTER **ONE**

Foundations

BEGINNINGS ARE HARD. Transitions even more so, I think. For many of us, the notion that we might one day make our living through this craft we love so much is a hard one to shake. It's an idea, a calling that we can't let go. But that doesn't make it an easy process. Hearing my story—and the stories of others—is a good place to start. Listening to the wisdom and mistakes of others always makes a good beginning. But you must first understand that the most foundational stuff is not anything you learned in photography school. The foundations are much rarer—vision, passion, and a broad perspective.

My Story

Like so many people who now make photography their vocation, as a teenager I saw an image that convinced me of the potential power of a photograph. It was 1984, and the image was the now iconic portrait of Sharbat Gula, the Afghan girl that Steve McCurry photographed in a refugee camp in Pakistan. Her piercing green eyes stared down at me from my wall as I learned my craft, and I was sure that my future involved cameras, *National Geographic*, and certain infamy. And then I began to look at the realities of day-to-day life as a photographer. I shadowed a local photographer for a couple days while still in high school, and those two days involved a whole lot of nothing photographic. I got this sinking feeling that going into photography as a profession would quickly kill my passion for it.

So I did what all rational people faced with this reality might do—I ran off to the Amazon, spent a summer building a school for street kids, then began a five-year exile at not one but two theology colleges in the cold Canadian prairies. I continued to shoot, spent endless hours in the college darkrooms, went on to both shoot for and edit the school yearbook, and occasionally wondered if I hadn't made a mistake or missed my calling. And then I graduated and, again, followed the traditional path of all frustrated photographers with a theology degree: I went into comedy and spent 12 years performing.

Life has a way of taking you in unlikely directions on the way to getting where your heart lies. After 12 years of performing on stages across North America, I grew dissatisfied. I was still shooting, though inconsistently. And one day I sold it all and bought a little digital Canon PowerShot. That PowerShot sat on top of an unwieldy tripod as my wife and I traveled through the Canadian maritime provinces, and the ability to immediately see, polish, and output my images brought my first love for photography rushing back. We got home, and the next day I walked to Leo's Cameras in Vancouver to buy the first of many DSLRs, a Canon Digital Rebel. And I decided I'd pursue travel photography as a sideline business, if for no other reason than to write off my gear purchases. I shot like I hadn't shot since I was 14, seeing through the frame again for the first time.

Within a year the dissatisfaction on the stage was still growing, and I had a chance to go down to Haiti wearing two hats—one as a comedian observing the work of a small development organization, and the other as a photographer. The organization had stumbled on my photography and asked if I would do some

shooting for them. I went down wearing two hats, but from the moment I shot my first frames I knew I'd go home wearing only one. That year I went to Ethiopia with friends—one a photographer, the other a chef—to work on a cookbook concept we were developing. The cookbook has yet to find a suitable publisher, but that trip sealed it for me. I came home and began making the transition to what people suspiciously call a *professional photographer*. I also went legally bankrupt. Years of financial mismanagement had forced me into a corner I could have avoided if I had used some sense. But I hadn't. And that year I stepped off the stage for the last time. Here I was, bankrupt and nervous, and with only a handful of intangible assets—none of which was a solid business plan.

But I had certain important things: a solid sense of calling—that my work as a photographer made the most sense of my talents and my passion; a passion for creating images and telling the stories of foreign cultures; my wife's support; and a clean slate financially. I had everything, and at the same time, I had nothin'. My business plan was 100 percent vision and passion—and it would be called vision only if it panned out. If not, it would be seen as delusion. The plan wasn't even a plan. It was a what-if. It was a "Hey, you know what would be awesome?" After 20 years of hiatus, I had discovered what I loved: photography. It had taken me that long to find my vision, and now all I had was a crazy notion that I could somehow make a living at it while creating photographs for organizations like World Vision, who works with orphans and vulnerable children.

In hindsight it was a terrible business move. But I wasn't doing it for business. I was doing it for the sake of the call. For the opportunity to do that one thing I loved doing more than anything else. There's a great freedom when you pursue something from this passion—it's tough to be dissuaded. You don't do it because you can, but because you can't not.

So that's where I began. Bankrupt, with a former career in comedy and formal training in theology. From the traditional angle, I can't imagine a greater set of liabilities. There aren't many photography schools that'll officially endorse this particular path. But on the brighter side, I had a clean financial slate, 12 years of verbal and nonverbal communications training, a couple degrees' worth of entrepreneurial courses, and a sense of calling. And by this point, I had 20 years working on my craft, learning how to shoot compelling images. Within a year of taking the trip to Ethiopia, I had business cards, a great contract with a high-profile client, and one last gig as a comic.

"There's a great freedom when you pursue something from this passion— it's tough to be dissuaded. You don't do it because you can, but because you can't not."

I knew that getting published would help, so I gathered the magazines I wanted to be published in and looked for submissions information; then I sent in my work according to their specs. My work was accepted in a couple places, and momentum continued to grow. I need to take a breather here and say that this stuff, when you step back from it, isn't magic. I get asked all the time, "How do I get published?" You ready for this? You submit your work. "Right, but to whom?" Well, that depends. Grab the publication and look. Allocate $100 from your budget, go to Barnes & Noble or your local bookmonger, and buy the top 15 magazines you realistically want to be published in first. Find the submissions information. Follow the instructions, and don't be daunted when you get rejection letters (or no answer at all). Keep trying.

This is where it gets a little tougher because the last few years have been a bit of a whirlwind for me, and I'm conscious that anything I say here could be pretty easily taken as grandstanding. So let me preface it and say this: any one person's success depends heavily on so many factors that it would be ludicrous for any of us to claim all the credit for our victories. There are so many other circumstances, so much outside influence, so much chance, fate, luck, or divine intervention. It often feels as if we can make all the best decisions in the world only to get passed by, and at the same time we can make some really big mistakes and still land on our feet. But I think there's value in my story because, after a number of failures, I strung together enough of the tougher lessons learned and got to some pretty great places. So read this with a grain of salt.

When I hung out my sign and told the world I was a Professional Photographer, I'd already launched a successful career as a comedian. It was my ability to simultaneously act like a financial moron that eventually sunk me, not my inability to market and run a good business. That was the only model I knew—the world of show business—so that was the model I adapted. Comedians know their audience, and it is for that audience that they craft their persona and their material, and it is to that audience that they play and sell themselves. They don't all do it this way, but the most successful ones seem to.

My photography career began with my vision. It took 20 years to get there, but when I found it I knew what I wanted, and I drafted a rough statement of vision for my career: I wanted to shoot advocacy and fundraising images for the international nongovernmental organization (NGO) community. I wanted to teach and

write. I wanted to do whatever it took to accomplish my goal, but I had to begin with a knowledge of who my audience was.

> "Photography begins with vision. So does a career."

Photography begins with vision. So does a career. Asking "How do I get there?" before stating your destination is a fool's errand. Perhaps you don't yet know where "there" is. That's fine. I hope this book helps open your eyes to some of the possible destinations and some of the paths others have taken to get there. My path began with a clear destination and a roadmap that I made up along the way according to the terrain. Part of creating that roadmap meant:

- Working my ass off to bring my craft to a professional standard and to learn the digital technology my film days didn't prepare me for

- Learning everything I could about who my market was and what they wanted

- Discovering who I was, what I had to offer, and what I most wanted to photograph

- Creating branding that made sense to me and clearly communicated what I was about

- Creating the best portfolio I could, followed by creating the best website I could

- Submitting my work to every magazine I felt I had a shot at, and many that I didn't

- Reaching out to every photographer I even suspected might be able to help me, connect me, or inspire me

- Touching base with potential clients and beginning to build relationships based on what I could offer them, not what they could give me

- Taking every opportunity to shoot, and every chance to have a conversation, that came my way

- Reaching out to potential sponsors with whom I could associate myself and extend both my reach and my credibility

- Making decisions about my finances that were proactive, and not reactive, and making a commitment to staying debt-free

- Never assuming my product or service was good enough, and always looking for ways to understand and serve my market better

- Repeating, tweaking, and improving all of the above—and others—on an ongoing basis

I am still not there yet—wherever *there* is. This is a long, winding road, and I love the journey. I enjoy the marketing. I love the assignment work and the phone calls. I love the thrill of booking a new assignment, being in the field on a mountaintop in Nepal or in a Maasai home in Kenya. I'm writing this at 3:30 a.m. in a hotel in Addis Ababa, Ethiopia, and I'm awake partly because of jet lag and partly because I'm still too excited to sleep. I have lessons yet to learn, plans yet to overhaul, and bad decisions about my career yet to make. But loving what I do, and having an unshakeable passion to get where I am going, makes the journey such great fun. I don't hope or plan to get rich with this. I hope simply to do what I love, do it debt-free, and feed my family for as long as I can. If I had different goals, I'd do things differently. So this book's not a roadmap; assuming everyone's got a different destination and a different starting place, one roadmap doesn't make much sense. But a book about the paths many of us have followed, the way we've made our own maps and dug out from our dead ends—that just might be helpful.

Driven by Vision

I have no idea why you bought this book.

Perhaps it was the catchy name or the great-looking cover. I doubt it. There's something in you that wants to do more than practice your craft on weekends and evenings. Something about photography that you love so much that you feel more complete when you're creating images, and you know that you could channel that passion into making a life and a living—whether part-time or full-time—and you're looking for information, inspiration, or the ammunition to convince your spouse to let you leave your soul-sucking job for another that will allow your soul to flourish but will, instead, rob you of every other resource. Whatever it is, there's a greater chance than not that you're reading this because your love for making images through photography has become so much a part of you that there's a promise of not only making a life, but a living,

from the craft. If you're like me, it might even be so strong that when people ask why you're doing it you've got nothing left to say but to tell them you simply *can't not* do it. It's a compulsion. A calling. A nagging feeling that you won't be happy until you follow that calling, or at the very least begin to earn back some of the insane money you've been spending on gear.

However you look at this, it begins—it must begin—with vision. It starts with what you see and the unique way in which you see it. It is the meeting place of all that you are, all that you bring to your craft, and the medium of photography itself. The hard work in making your vocation is not finding someone, anyone, who will pay you a few bucks to press the shutter; it's in finding a market for your vision. Your photography. It's in making the connection, and the biggest earners and those to whom the rest of us laud our professional praises, are the ones who have retained their vision while serving their chosen market. They've married their craft with their commerce and done it while upholding their creative integrity and loyalty to their vision.

> "In an age where high levels of competence at your craft are assumed, the thing that differentiates us is vision: the way in which you wield your craft to tell the stories you see with your eye and your heart."

Vision is your biggest asset. It's that one intangible for which clients will hire you. In an age where high levels of competence at your craft are assumed, the thing that differentiates us is vision: the way in which you wield your craft to tell the stories you see with your eye and your heart. Even commercial photographers, working from a creative brief and with artistic directors, are hired for their vision and the ability to *interpret* the brief they've been given. Arguably, there are levels of competence at this craft. And there are certainly true masters and total hacks, but those are the extremes. In the middle are those who've paid their dues and work on a level playing field. We've learned technical proficiency and wield our tools well. It is how we wield them and the visual poetry we create for which the market will pay us, whether we are stock photographers, wedding photographers, or commercial photographers. It's a huge ball of wool that involves marketing, client care, and myriad other factors, but the center of that ball of wool is who you are, which stories you tell, and how you tell them. That's vision.

By saying this whole journey begins with vision, I don't mean your photographic vision exclusively. It is also the vision for your life, the receptivity to see the future as you'd like it to be, to hear the whispers of a voice that is calling you to something beyond what you are now. Calling you to a life beyond convention

and comfort. To sustained creative efforts that feed both your soul and your family. It is that vision that will help you find your way when it's confusing and good opportunities threaten to jeopardize even greater ones. It's that vision that will put you back on the track when the pull of the commercial world is so strong it draws you too far from your craft and you need to make your way back. Vision, if I haven't beaten this poor old metaphoric horse to death, is everything. It's what marks great photography and great lives. It's all the virtues at once— the hope to see a different future, the faith to reach for it, and the love to keep going when it just seems like working at the local convenience store would be the path of least resistance, if not also the path of least reward.

Sustained by Passion

This is not going to come off sounding like business advice. It's artsy-fartsy and touchy-feely and it's not quantifiable. But the evidence bears it out. The more I look at the photographers I respect and look up to, the more I see the constants as more than coincidence. Chief among those constants are vision and pas- sion. Vision drives the endeavor, and passion fuels it. There is no substitute for passion—no way it can be made up for with an abundance of slick tactics.

Photojournalist Karl Grobl was in the middle of the Sudan in the front seat of a Land Cruiser covered in dust. In the back seat, two bigwigs were talking about what they would do if they won the lottery. None of their plans involved being right where they were and doing what they were doing. Karl sat in the front seat and realized he'd already won the lottery because he was where he wanted to be, doing what he wanted to be doing. Following his passion.

Passion sustains you through the hard work and the need to learn skills you never planned on learning—like marketing or bookkeeping.

Passion pushes you to be better, to improve your craft and give a more salable, unique offering to the marketplace.

Passion makes the difficult moments and clients worthwhile.

Passion attracts people to you like nothing else because there are so few people doing it this way.

Passion defines what gigs you take and why you take them. It defines how you do what you do.

Passion is the thing that made people like van Gogh or Picasso such celebrated craftsmen and artists. It's the thing that got mistaken for insanity and obsession.

Do it for money and your mojo will come and go. Do it for passion, and while the same thing might happen, you'll have a reason to keep going.

There is no substitute for passion. When I made the decision not to do this vocationally after high school, it was for this very reason. I feared that doing it as a career would kill the passion. At that stage it probably would have. But as I've grown the passion has only deepened, and if the day comes when I find my passion leading to something else, I'll follow the passion there, too.

Like vision, passion is an asset you need to protect and fiercely nurture. Shoot the stuff you love, and when you're asked to shoot something you don't love, don't shoot it. Or shoot it in a way that you do love. But being chained to your camera and shooting things that suck the life out of you isn't why you began this journey. There's a trap in not doing what you love for a living. You take the gigs because you have to, even the ones you don't enjoy, and one of those leads to another. Not hard to imagine that one day you wake up to find yourself chained to the camera in the same way others feel chained to their cubicle or 9-to-5 job.

Find a way to keep the passion or consider going back to doing this for the love of it alone. Life is too short. But find your passion, follow it, nurture it, and you'll be nearly unstoppable.

The Lines Are Blurring

As Bob Dylan once wisely noted, the times they are a changin'. Indeed. If the words *amateur* and *professional* once meant the same thing to everyone—and I doubt they ever did—it's surely no longer the case. Not only do the words no longer mean what they once did, but the lines between them are becoming so blurred that the whole thing is begging for a new lens through which to see it all.

Here's where the clever author would put forth that new paradigm and cash in on being a pundit. I have no such insight to offer, except this: if the old words

carry ambiguous meaning, and if the lines between the old categories have become so permeable that they are now meaningless, perhaps it's time to shake them all off. I suggest that having the notion of vocation is much more helpful. It hints at something bigger than just a job, something that won't be pigeonholed by words like *amateur* or *professional*.

For one thing, *amateur* has come to mean someone who doesn't engage in their craft to make a living, or worse, it implies a lower standard of excellence. But it comes from the same root as words like *amorous*, and from which the French get *amor*—love. An amateur, in the true sense of the word, is one who does what she does for the sheer love of the craft. A professional, on the other hand, is assumed to do it for money, and to hold to a higher standard. I don't buy that, and neither do you. If you did you'd have bought a book about sales and marketing—no doubt with a slick cover and the promises of riches.

There are plenty of so-called amateurs out there whose dedication to the craft of photography results in art at a level of excellence and depth I will never achieve. There are numerous professionals who do what they do first for the

love of it, and only second for the paycheck. And to further disabuse us of the notion that being a professional means being good at what we do, we all know that there are plenty of so-called pros whose mediocrity is a shame to us all. The terms have become meaningless at best and harmful at worst, and I think it's time we looked through a different lens—one that accommodates people who want to make forays into joining commerce to the craft they love.

To be a professional means nothing more than that you make money at what you do, but to assume that you can't be both a professional and an amateur all at once harms this craft. In fact, many amateurs love their craft so much that they do it for a living. To do anything else would impoverish them on a deep level. For them, photography is more than a hobby; it's a calling—an impassioned distraction that feeds the imagination and keeps them daydreaming when everyone around them says they should be doing something else.

Vocation, which we mistakenly use interchangeably with the word *career*, is much more than that. It comes from the Latin word *Vocatus*, which means calling or invitation. That word, in turn, comes from the word *Vox*, or voice. We once spoke of things not as a mere job but as a life's work, a calling. A vocation. It's as though there's a voice beckoning us to distraction, a preoccupying whisper that, at some point, we give in to and follow.

So it's that lens I am looking through. It's a more meaningful, more helpful way of looking at all this, including this book, which at one point was simply going to be about making the transition from so-called amateur to so-called professional. Because not all of you will abandon your day jobs. Some will moonlight with this craft, saving your best energies and creative passions for the hours left after you've punched out of your "real jobs." Some will do this on weekends, shooting senior portraits. Some would like to start shooting weddings, pet portraits, wildlife, or some other part-time commercial project.

This book is about that call and the paths we walk to respond to it. For many readers, the book will be a foundation on which they start to build their photographic business; for others, it's a book that will generate ideas on how to do better the work they've been doing for years. For all of us, I trust it's a celebration of the process by which we combine our love of the craft with our desire to do something we love for a living, to not only make a living but to make a life while doing so.

> "To assume that you can't be both a professional and an amateur all at once harms this craft."

The Rules Are Changing

The path someone took to establish a career in photography used to be more predictable than it is now. Each discipline had a time-honored approach and a market that was more easily definable. Even then that might have been merely an illusion, but it was a comforting one all the same. Now almost everyone is in agreement: the rules have changed. In fact, I'd suggest it's worse—and better—than that: the rules have disappeared altogether.

> "What the abolition of the old rules has done for us is clear the fog of illusion."

What once was a path that might have seemed well beaten, or even paved, and that led to a career in a particular market is now overgrown, leads in multiple directions, and holds no particular promise of success. I'm writing this book in a time of economic turmoil and uncertainty. Things are not easy. It is, by all appearances, an inauspicious time to begin entertaining the idea of leaving that steady job and joining the masses of visionmongers already wrestling with the fusion of craft and commerce. On the other hand, you might be revisiting this idea because you no longer have a job, and it's time to throw to the wind what little caution you have left. I think it's helpful to remember that at the best of times security is just an illusion, that there's risk involved no matter who our employer is—ourselves or a major corporation. We risk failing on our own or we place our careers in the hands of others who might fail. We ride the waves of economic trends on our own or we allow others to do it for us, but the ups and downs, and the accompanied risks, are still there.

What the abolition of the old rules has done for us is clear the fog of illusion. It has disabused us of the notion that there's a clear way of doing things that will lead to success, however we define that. I don't mean to romanticize the loss of these rules—it's brought its share of challenges. But with those challenges come new opportunities. Most creatives have a streak of anarchy in them, and the loss of these rules gives us permission to forge our own paths. Rather like the old cry, "The King is dead! Long live the King!" One way has passed, giving way to another. For those of us to whom the old king was a tyrant, the new king brings hope, freedom, and the chance to start all over again. Same thing with the abolition of old rules and the realization that now is our time to recognize, not rules, but principles that will allow us to forge a life and living through the craft we love.

> "Creating your career—your calling—can be an act of creativity as much as creating your photographs."

What am I saying? Simply this: making a living, even in easier times, has always relied on each of us doing it in our own way. The great ones, the crazy ones, the ones to whom we look up have always beaten their own paths and followed none. The deconstruction of the old models and rules puts us in a place, both individually and as an industry, to dip into our creative wells and water our careers with the same creativity, passion, and inspired action as we water our photography. Creating your career—your calling—can be an act of creativity as much as creating your photographs.

You can worry about whether the glass is half full or half empty. These days there are a good many half-empty people out there. However you look at it, though, there's the same amount of wine in the glass. The more interesting, and more relevant, question is, "Where do I get more wine?" Even better, "How do I make my own wine?" Silly metaphor, but it works for me. No one's handing out careers in photography; they never did. These are unprecedented times, and the challenges they present—the collapse of traditional media and markets, the explosion of the digital photography and citizen journalist movement, the rise and fall of different stock photography models, and a tough economic climate—all combine to make for very unsettling times. But in there lies an opportunity to redefine ourselves, excavate our creativity for new ideas and models, and, since it's hard work anyway, a chance to follow our passion and shoot the stuff we love.

At the end of Shakespeare's *King Lear*, Edgar utters these lines: "The weight of this sad time we must obey, / Speak what we feel, not what we ought to say." It's permission to recognize the hard times and to act from the heart, not from obligation or in obedience to voices that say we should do this or that. Consider this your permission to indulge that inner anarchist. Stop following the path you ought to take; follow instead the one you long to take.

The King is dead! Long live the King!

Chris+Lynn

ChrisPlusLynn.com

CHRIS AND LYNN JAKSA are a Vancouver-based husband-and-wife team specializing in wedding photography. A multiple award-winning team— among them an Emmy, six Western Magazine Awards, six Northern Light Awards, and four International Regional Magazine Awards—together they form Chris+Lynn Photographers, a successful business built on their passion, vision, and love of story.

Chris and Lynn met and fell in love within the first week of meeting each other at Bishop's University in Quebec, and eventually abandoned their grown-up plans in favor of traveling the world. A photographer since he was 12, Chris got his start when his father built him a darkroom; Lynn began shooting to accompany her writing after university. After backpacking around Central and South America— spending their time photographing, interviewing, exploring, and writing—they earned their first dollar from photography with a travel feature about Antigua's Semana Santa celebrations published in Florida's *St. Petersburg Times*, but not before accumulating an intimidating stack of rejection letters. Two years later, they became regular contributors to *British Columbia* magazine, a gig that took them from the ice glaciers of northern Stewart to the lighthouses of the west coast to the potlatches of the Tsimshian peoples.

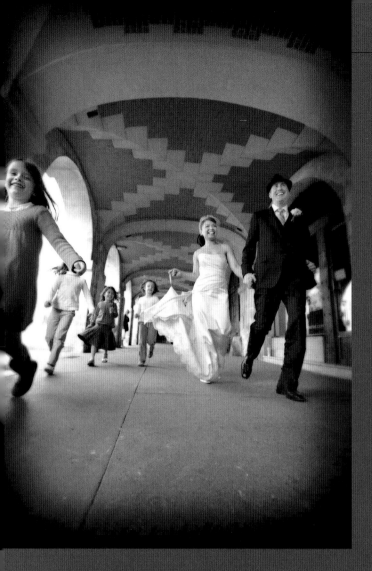

In 1996, Chris and Lynn sent an extensive book proposal to Harbor Publishing and were given a book deal based on a personal project of visiting and documenting all the remaining staffed lighthouses in British Columbia. The book became a Canadian bestseller and was nominated for a BC Book Prize. It also gave them new credibility and opened the door for more regular and profitable magazine assignments, paving the way for an eventual Emmy award—winning documentary about

the lightkeepers of Nootka Island. That storytelling background became the backbone of their wedding photography business and a core aspect of their branding.

Five years later they were married on a beach in the U.S. Virgin Islands. They were so disappointed by their wedding photographs that Lynn put on her dress the next day and Chris photographed her in the streets of San Juan. They still laugh as they joke that the first wedding he ever shot was his own. That initial disappointment opened their eyes to how important and beautiful wedding photography can be, and it was the initial spark for the direction their business eventually took.

The love of storytelling, and for love itself, has proven a solid core for their brand. Their work, their website, and every incarnation of that branding is strongly unique and reflects their bold artistic style and love for storytelling. But more than that, their love for their clients is unmistakable. Chris and Lynn know that you can't compete on price, and their pricing reflects this. Weekend weddings begin at $8,000 (Canadian) and go up to $19,000. "We don't compete on price," said Lynn. "We design Wedding Collections that create the most value for our clients and create the conditions that allow us to do our best work." Their pricing packages include custom art books and other extras; they feel strongly that the story is part of what they do, and stories are not told through a bunch of files burned to a DVD but through a carefully created album. Nothing they create is generic because no wedding is generic, and while there is a market for photographers serving budget clients, that space doesn't allow Chris and Lynn to do what they love in the way that they

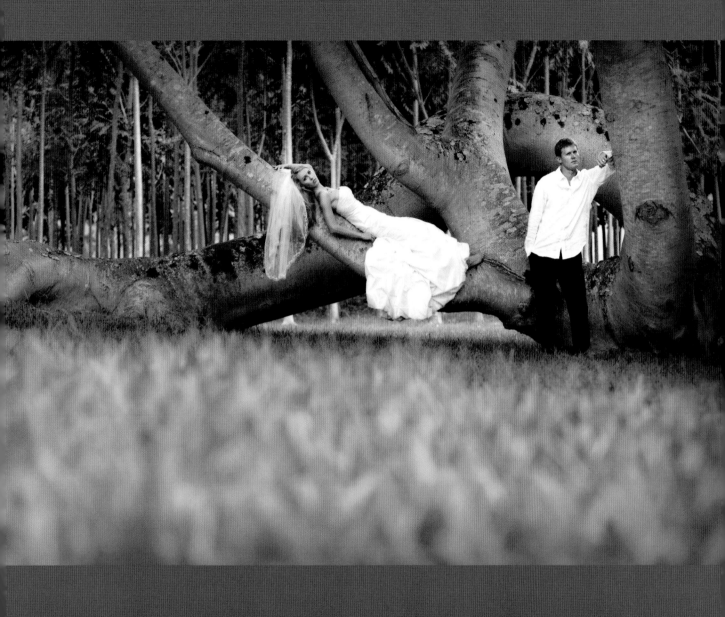

love doing it. They price themselves consistent with their brand, not as a commodity.

Because they have so carefully chosen their market, their efforts to connect with that market are as intentionally chosen and consistently presented. "Our company name, logo, and colors are consistent throughout our marketing materials—ads, blog entries, business cards, and promo books. We also play off our trademarked Chris+Lynn Photographers name, using the '+' and '=' signs throughout our branding. Our relationship as a couple resounds with our clients and the plus and equals symbols add a little nostalgia and innocence from your first crush as a school kid when you doodled the name of your boyfriend in your notebook."

The notion of relationships kept coming up when I talked to Lynn. Their business is about relationships, their work is created as a relationship, and their marketing too is highly relational. When I asked if they participate in large wedding industry trade shows, Lynn just laughed and said, "No. Thankfully." Instead, they focus on connecting with their clientele on a personal basis. They still engage in traditional marketing, but it's the relational aspect of their blog and social networking tools that allows them to really connect. "Our most important and

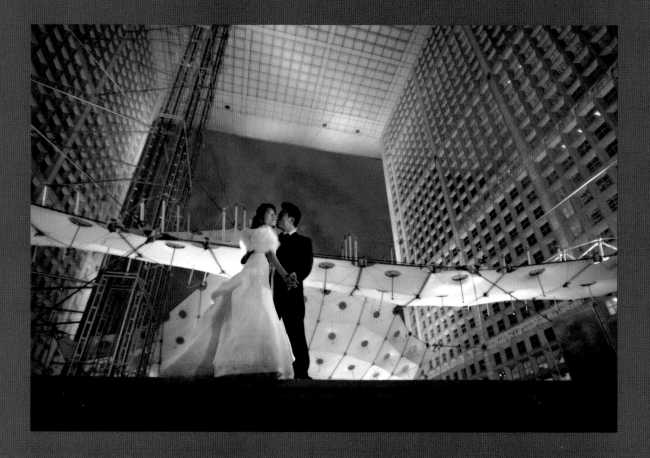

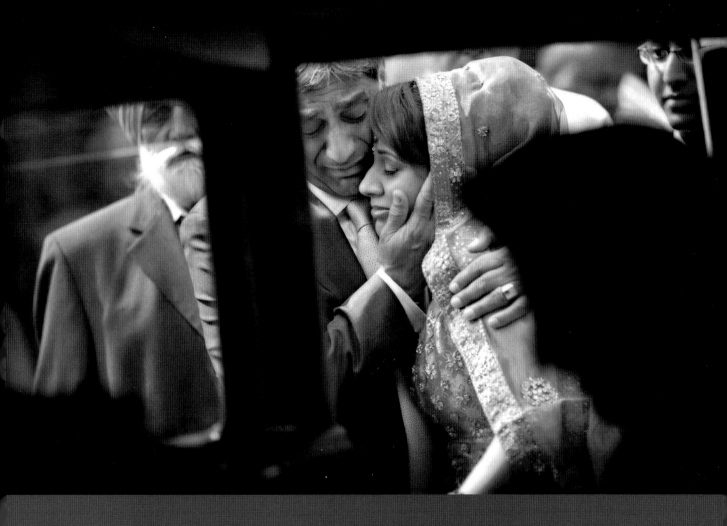

valuable marketing strategy is creating loyal and loving clients who spread the love about us! We should network more with the vendors and planners, but our primary connection has always been with our brides. That means creating a meaningful, personal relationship from the first e-mail and meeting to the final delivery of wedding signature art books. Close relationships with our fellow photographers are also a key aspect of our business—we share booking calendars and referrals and talk each other up with our brides. We also work hard to get as much print publicity as possible by regularly submitting and getting published in wedding magazines. Having a consistent brand and message throughout all these areas—client experience, print publicity, and final product—gives us mind share with brides."

Chris and Lynn are managing a business that grosses well over a quarter million dollars a year, and they're building a dream home in Baja, Mexico. They haven't done it by being slick or looking for gimmicks. They've chosen a niche and made it their own by being the best they can be, paying attention to detail, playing to their considerable strengths, and making good decisions. Frankly, talking to Lynn was disarming; she's so darn nice and down to earth I found it hard to believe the two of them have such strong business minds. Even their advice comes off sounding like it comes from a hippie with an MBA; Lynn talks about love so much you worry she'll float away on a cloud, then she talks unapologetically about the need to make good decisions and aggressively save your receipts and get a strong bookkeeper and accountant...but then it comes back to love again. Their four-point sermon for photographers wanting to do this vocationally? "Do what you love; trite but true. There's little worse than a wannabe fashion photographer shooting weddings. Love what you do; nourish your passion for your craft—whether that's by creating personal assignments, reading books of the masters, taking seminars from those you respect—keep on learning, experimenting, and growing as an artist. Love your clients; it will push you to do your best for them and they will love you back for it. Understand your market: who are they and what do they want? Figure out their needs and make them need, want, and love you!" ▨

All images on pages 19–25 © CHRIS+LYNN PHOTOGRAPHERS

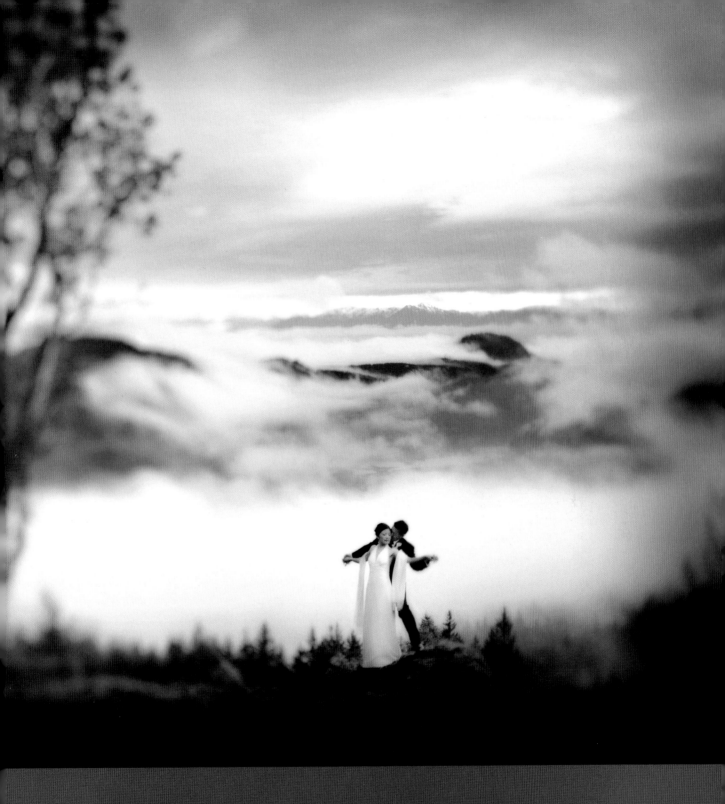

Work, Work, Work

I ALWAYS THOUGHT the seven dwarves were crazy. All that cheery whistling while they worked. Something about it just seemed sociopathic. But I get it now. They just loved their work. Make no mistake about it: running a business is hard work. A labor of love is no less labor, despite songs like "He Ain't Heavy, He's My Brother." I'd carry my brother if I had to, because I love him. But he's a grown man; he's still heavy. Even creating is work, and most artists, after a time, come to subscribe to the notion that inspiration comes from working. In short, this is no walk in the park. By all means, whistle and enjoy it. It's your calling, after all. You should love it. But you still have to put in the hours and log the time. These dreams aren't going to chase themselves.

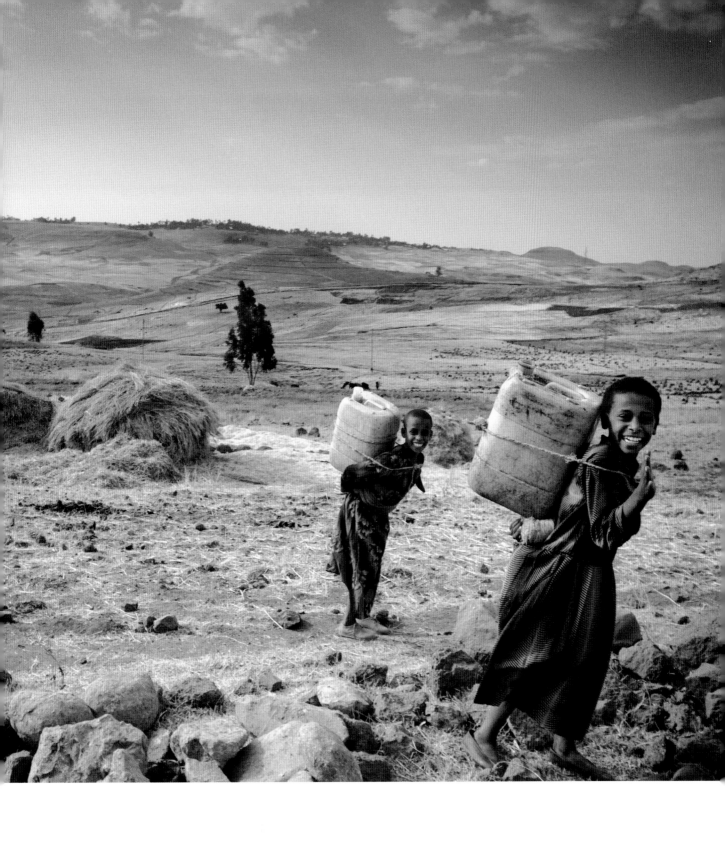

It's Hard

We keep getting told by the camera-makers that you just need a newer, bigger, better camera and the rest is easy. Shoot like a pro, they say; all you need is this new camera. It used to be hard, but not now. Now the camera has face detection and autofocus and light meters that Stephen Hawking made with pixie dust and the help of voodoo. Shoot like a pro! Looks like the secret's out—being a professional is about having the gear. So long out of reach unless you had lots of money and knew the secret handshake, it's now available to anyone with a thousand dollars and a trigger finger.

Rubbish. It's *not* easy. It's hard to master a craft—it takes a lifetime. It's a journey of many small steps. Companies flogging their gear under the spell of this nonsense ought to be ashamed of themselves. Why? Because we keep believing them and buying their latest gear and latest program, and of course we need it to be better. But it doesn't make us better, and countless amateurs who passionately loved photography when they first picked up a camera are now giving up in frustration. Or worse, they're resigning themselves to being mediocre.

Just once I want to hear a manufacturer say, "You know what? This new camera will make a really tough craft just a little easier, and it'll give you a fighting chance. But in the end, it's just that: a craft." It takes a lifetime to master, and while that fact will discourage impatient photographers, it ought to give the rest of us hope—this stuff isn't cloaked in secrecy, and it doesn't take a secret handshake. It just takes time, and the kind of work you'd put in if you wanted to play the violin. No violin plays itself—no camera makes photographs by itself. All it takes is time, and in the meantime there's the thrill of discovery and self-expression for the sake of it.

So if you're discouraged and wondering why it's so hard sometimes, know this: it's tough—in varying degrees—for all of us, for anyone who wants to be good at something. We're in this together. So settle in; you've got a long way to go, but a long time to do it in. We all do. Now, let's all take a breath, stop buying new gear, and get to work learning our craft.

It's not just the new photographers, either. Photographers who are new to the craft look to photographers who've been doing it for over 20 years, and they only see the results of those 20 years. They don't see the years' worth of crappy

> "It just takes time, and the kind of work you'd put in if you wanted to play the violin."

images, the number of mistakes made, the books we've read, the lectures we've been to, the stupidity we have engaged in when buying gear and hoping it turns out to be the magic wand. They don't see the contact sheets of current shoots, either. What they see is the best foot forward, and they assume that it's effortless, a result of being hit on the head by the mythical Talent Fairy when we were young and being raised by artsy parents who put a Leica into our crib as an infant instead of a teddy bear.

You don't see the thousands and thousands of frames of garbage we've shot—and still shoot—the visual experiments that we've tried and failed at, the stages we've gone through to find our vision and master our craft. But this can be your path, too—and because time both speeds by too fast and seems to take forever to get here, I can confidently say, "Be patient, you'll get there." If you study your craft. If you shoot and shoot and shoot some more. If you give up trusting your gear to create great images and start trusting your vision instead. And most importantly, if you love putting the world into a frame for the sheer sake of it, for your love of expression.

But there's something else you need to know. You'll probably never get where you think you're going. I know, I said you would and now I'm backtracking. You might well get to where your photographic heroes are—it just won't be where you think it is. If you believe that great photographers wake up in the morning, wash their face with genius soap, and then confidently make great images one after the other, I can tell you I've yet to meet one. I'm not claiming to be anything more than what I am—a photographer struggling to express his vision—but any photographer who is looked up to by any other, well, we're always looking forward, wishing we could more perfectly express ourselves. Those photographers who look up to us see that we've arrived, while we ourselves are looking up to others, conscious that we've not arrived, that there are better stories to tell in stronger ways. It is all only a journey. Each day you embark, you move forward, and each night you go to bed knowing not that you've arrived, but that tomorrow is a new day to move ahead, to creep forward. It's the moving, the creeping, that matters. Like a pilgrimage—it's the journey itself that changes you, not the destination.

And that's just if you pursue the craft of photography as a hobbyist. If you want to do this as a vocation, it's exponentially harder because the challenges I just

> "It's the moving, the creeping, that matters."

listed are still ours in spades—but with the addition of financial concerns and the need to care for current clients, develop new markets and new materials to reach those markets, tend to the taxman, and replace older gear on which we depend to make our living. There are insurance costs and membership fees for professional associations and, at the end of all that, the total absence of any promise that all the hard work will pay off.

Let me go on record. It's hard. At times, it's really hard. There are no rules, and the ones we once had are changing so fast it makes my head spin. The markets are changing, and there is no template, scheme, or other program that will guarantee you the ability to shoot the things you love and make a living at it. This should come as both a warning and an encouragement. If you're on the outside, about to graduate from a bachelor of fine arts program in photography and thinking all you need to do now is rent a studio and buy a Yellow Pages ad, you've got a long road before you. On the other hand, if you're a working photographer and you find this hard, that's okay. Everyone I know finds this hard. It's the price we pay for not taking a job with corporate and pulling down $60K a year working in a cubicle. But remember, this is a hill you climb one step at a time, not a huge wall you have to leap over in one jump. One step at a time, you begin where you're at and start moving. The greatest barrier to this whole thing is not taking those first steps.

The First Question

The first question most often asked before making a transition into vocational photography is usually the wrong one entirely.

"What does the market want?" is not the question that will lead you to opportunities shooting what you are good at or passionate about. Had I asked that question first, I'd have ended up shooting weddings. And while I've shot the occasional nuptials, it's not what I love, and it's not why I wanted to be a photographer. For most of us, the point of becoming a vocational photographer is not the chance to play with cameras; it's the opportunity to make a living while creating and expressing ourselves. The money isn't the point—it's purely the means by which we sustain the ability to create and share our art.

Sure, eventually you need to consider what the market wants, because they won't buy what they don't want. But before that question ever bounces around within you, it's important to pursue the most important question.

What do you want?

What do you want to shoot? Why do you want to photograph it? What stories are you burning to tell? At the beginning you might not have a clue; you might be a generalist for a while. Even after you've found a market for what you love, I hope you'll continue to explore your creative gamut, never allowing your marketing niche to become your creative rut. And while what I'm suggesting seems counterintuitive to some degree, you've got to remember that you won't one day awake to find yourself shooting fashion models in Paris if the path you choose now is to be a stringer with a local paper until you "make it." As they say, you can't get there from here.

> "Never allow your marketing niche to become your creative rut."

Putting first things first is profoundly pragmatic, because the alternative is to become a vocational photographer simply to trade on your ability to press a button and push a histogram around, and few of us really want that.

If the point of all this was just to make a living, you might just have as easily—no, *more* easily—remained in your career as a mechanic, doctor, janitor, oil tycoon, whatever. If the reason you want to pursue this craft, this art, as a vocation is because you love it, then you must at all costs avoid making decisions that will suck the life from it and force you down a road that, when initially setting out on this journey, you wanted specifically to avoid.

Let's go back to the notion that asking the right question at the beginning is pragmatic. When I finally made the jump, I chose a market that was wildly impractical. I chose for my clients the agencies and organizations with some of the smallest, if not totally nonexistent, budgets for photography. It's a market swarming with people willing to volunteer their dubious talents and use that experience as a stepping-stone to something else, and for the most part it's a deal these groups take happily. Mediocre images that cost nothing are better than great images they can't afford. Of course, mediocre images by photographers unfamiliar with international development and the necessity of creating compelling images that communicate key values and benefits to a specific demographic aren't much help in fundraising, but budgets are restrictive and it

takes a very forward-thinking organization to assign budget to the gathering of specific photographic resources. So it was into this market I leaped.

Had my first questions been about how realistic this might be, and how deep the pockets of my clients were (never mind how willing they may or may not be to pay for strong images), I'd have never made that leap. I'd be shooting weddings or events, and I'd be a miserable photographer shooting second-rate images and serving a clientele I increasingly resented. Nowhere in that scenario is there a good business idea. I use weddings only as an example because they're the opposite of what I love, in the same way that what I love calls to very few people. Not everyone wants to wake up under a mosquito net and worry about dying in a car wreck in India or getting shot by a child-soldier with something to prove. Good wedding photographers, like Chris+Lynn, are good because they love it, understand it, and create gorgeous images because of that.

Your passion for what you shoot—and who you shoot for—will place you head and shoulders above the mediocrity that's so prevalent in our industry. Bono once said that it was easy to rise to the top in the 1980s by virtue of merely being a good rock band in an era of mediocre ones. In a difficult marketplace, your passion and expertise are not a liability or a luxury; they are what set you apart and guarantee a solid, loyal, and well-paying client base. It's not the passionate photographer who specializes in something she loves and does it well who is being unrealistic. It's the one who shoots it all, spreads himself thin, trades on his ability to press a button, and thinks he can build a strong client base that finds value in this. That's not to say there aren't passionate photographers out there who are generalists that serve multiple markets well. I just haven't met one.

If you want to live the dream, as I'm often happily accused of doing, then you need to begin with the dream and never lose sight of it. Let it determine the destination. Then dig in to the practical stuff—the business and marketing savvy that you need to pull it off. Tenaciously learn what you need to, and be wildly practical about your finances and related decisions, but don't lose sight of the dream. Forge your own path, but don't forget where you're heading.

The Benefits of Hobby

Pursuing your vision and loving your craft have precisely nothing to do with how you make your living. The real photographer is the one who shoots what she loves and is committed to learning her craft well. Money often just makes it unnecessarily complicated. So if you're reading this in order to be a "professional photographer" simply so you'll be someone else's idea of a "real" photographer, then give this some thought: not only does being a so-called professional have exactly nothing whatsoever to do with being a "real" photographer, abstaining from career photography can have advantages.

Abstaining from career photography can mean having a day job to fund the gear you want. Pros are often forced to spend their money on necessities like newer marketing materials instead of the 14/2.8 lens they want. The hobbyist gets the cool lens, the pro gets postcards.

It can mean the flexibility to shoot what you want to shoot without the demands of clients hemming in your artistic impulses.

It can mean being free of the pressure to create on demand, and instead being able to create as you are inspired and on your own timetable. It can mean the freedom to pursue the art of your vision without commercial concerns or distractions. Ideally, a working photographer finds (or makes) the time for personal projects she is passionate about; it just doesn't always work out that way.

It can mean the freedom to love your images without feeling like they're only truly good photographs if someone buys them. Allowing your vision to be validated only by dollars is a terrible trap.

In the best-case scenario, doing this for a living is as good as doing it as a hobby. Sometimes more so. Doing this for a living can mean doing it more, pressing deeper into the art simply from necessity, and being able to write off some cool gear. I love doing this and making a living at it. Right now I wouldn't change that for anything. But the notion that you aren't a real photographer until people are paying you is rubbish. Vincent van Gogh didn't sell any of his work during his lifetime. Sure, he went crazy and lopped an ear off, but he was incontrovertibly an artist. So if following the call to be a vocational photographer allows you to both make a living and pursue your vision, go for it. If remaining a

> "Allowing your vision to be validated only by dollars is a terrible trap."

hobbyist allows you to pursue your vision without the pitfalls of making it your trade, go for it. But be sure you understand there is a trade-off. The moment you make your craft into your career and begin to associate it with financial concerns, it changes. Those changes may be changes you love—or they may not—but it changes all the same.

Making a living through your lens is not merely the same as doing it as a hobby but getting paid for it; it's a completely different beast. Engaging in photography on a commercial level changes why you do it, and it changes how you do it, when you do it, and for whom you do it. Managed well and done with careful intention, those changes are not all undesirable. The creative collaboration that can result in partnerships with great clients and producers can be exciting, just as the frustrations and pitfalls of some collaborative efforts can be hellish. The money that can be made on a well-planned commercial shoot can be as good as the money that can be lost on a poorly conceived job that runs over budget. The time you spend doing what you love can be as creatively exhilarating as the time you spend on delinquent clients can be soul-sucking.

I'm not trying to scare you off. Clearly my colleagues and I love what we do so much that we're still at it and still loving it most days, and it's not because we're unable to find work elsewhere. I could still be juggling, after all. I'm just hoping to disabuse you of the notion that "real" photographers must do this for a living. We're not necessarily better photographers; we just want it so bad we're willing to do the hard work it takes to get to this place.

Know Thyself

"We shoot best that which we love best."

As a photographer, you are the product. You might see the final images, prints, wedding albums, or other deliverables as the product, but that's only partly so. The true product is you. Brand You. We'll talk more about the whole concept of branding later, but first wrap your brain around this concept: if you've chosen to be more than a commodity, more than a mediocre camera operator in a sea of mediocre camera operators, but a photographer with a unique vision and voice, then starting to think about who you are and what you have on offer is the beginning of your ability to communicate those offerings to the marketplace.

Imagine for a moment that you are a conventional brick-and-mortar store. Not running a store. You *are* the store. It's a bit Zen, but give it a try. Within you— your skills, passion, vision—are every item on offer, and before you offer it up for sale you have to know a few things.

What's On Offer?

Before you even open the store, you need to do an inventory and become acutely aware of what's in stock and on offer. Without knowing this, you can't possibly begin to answer questions like: What makes you unique? What differentiates you from other photographers? What unique spot in the marketplace do you occupy? Or more bluntly: Why in the world should anyone hire you? These questions can be answered by asking yourself other clarifying questions, all of them aimed at identifying your inventory.

What Do You Love?

Generally, we shoot best that which we love best. And spending your days shooting things you love is a great way to make a living. It can energize you, prolong your sanity, and improve the quality of your creative work. Better work, marketed right, can mean better prices. Take some time and look at the work you've done that you take the most satisfaction from. See any patterns? Finding that 80% of your work is with children? That's a good sign you've got a natural love for kids and probably an easy rapport with them. Make a note.

What Past Experiences Have You Had?

If you've earned a PhD in marine biology, you're uniquely poised to be a marine or conservation photographer. Expertise is not only profoundly salable, but it likely points toward a deeper passion. When stacked against another photographer who shoots food, you have a distinct advantage if you spent years as a chef in Paris, and that advantage makes you more salable than the photographer who just shoots food for the money.

What Are You Good At?

I love writing. Writing is not photography. But writing about photography allows me to give back to the industry, establish an area of expertise, and develop another area where I can express myself, work in and for the industry, and contribute to my income. For you, it might not be writing. It might be retouching or composite work. It might be video work. Live lecturing. Cleaning sensors. Multiple income streams can free you to be choosier about your work, and they give you a fighting chance when the bottom drops out of one thing. It also provides an outlet for creatives with short attention spans, allowing them to do their best work without getting drained.

Which Shelves Are Empty?

Alternately, why not look at things in reverse? As long as you're looking at the shelves and counting your inventory, where are the empty spaces? What are the areas you don't like, the areas where you've experienced the least amount of success or creative satisfaction? Those empty shelves likely mean one of two

things: an absence of passion or an absence of talent or skill. You've got two choices in this regard. You can use that knowledge to define the gigs you don't want so that you can focus on your strengths, or you can put your energies into shoring up the weak spots and stocking those particular shelves.

The truth is, there are hundreds of thousands of photographers out there, skilled and otherwise. It is generally not your singular ability to wield a camera and pick an f-stop that clients want. It is your unique passion, your individual vision and style, and your unique skill set that will determine which clients find a match with which photographer. Knowing the ongoing state of your inventory, selling that particular stock, and doing something about the empty shelves— these make it all significantly easier to put your craft on offer in the marketplace. Hitting a dry spot? Just starting out? Close shop for an afternoon and do some inventory. It's easier to sell what you know you have.

This inventory is not merely your skill set. It's everything—who you are, what you are passionate about, what you are good at. It's all connected, forming the foundation for every foray into the marketplace. Before you name the store and hire a clown for the grand opening, you have to know what you're selling and to whom.

> "It is generally not your singular ability to wield a camera and pick an f-stop that clients want."

Who Cares?

This isn't just another flippant question. For each item you find during your inventory, there are potential benefits to your hypothetical customer. Look at things from your customer's perspective. What do they care about?

One of my strengths in the market I am most excited about serving is my experience working in that market. But working for other nongovernmental organizations (NGOs) in the developing world is just one feature on offer in my store. The big question is, "So what?" My experience working in the field with other NGOs means I understand their staff and the limitations within which they work. It means I've developed a way to work within those limitations, and I understand the value of diplomacy and the need to maintain tenuous relationships. It means I am not a liability. More than that, it means I understand how the development works, how funds are raised, and how to communicate with fundraisers—a crucial benefit when I'm being hired to create compelling fundraising images for an orphanage.

Let's look at it in another way. What does your market need? What solutions are they looking for? If that's what you provide, you need to know it and know how to communicate that clearly. It begins with taking stock.

Yeah, But Am I Good Enough?

When I first started writing this book, I asked a lot of people if they had questions about becoming a vocational photographer. The overwhelmingly common question was one for which I have no answer. In fact, I still wonder about it myself.

"Am I good enough?"

I don't know. I suppose it's a tough question because it's incomplete. Good enough to what? If you could, in a glance, survey the work of all the photographers out there in the marketplace right now, I guarantee that you would find a sea of mediocrity. And among those whose work is solid and increasingly good, you'd find enough self-doubt to sink a ship. I tell you this so you'll understand that it's a question that, in one way or another, you'll always wonder about. Don't wait until you can answer yes. In fact, it's the ones who never question if they have the goods who stop improving, who stop finding new ways to ramp up their craft and serve their clients. But for those of you dogged by the constant doubts about whether you are good enough, let me remind you of something—we're all always getting better. Day by day, if you work on your craft you are getting better, closer to being "good enough," which is a standard most artists always feel they fall just short of. Why? Because as our vision slightly outpaces our ability to express it, we're always following the carrot, always feeling that our best shot is our next one, not our last one.

Are you good enough?

Talent is important; it makes all this easier anyway. But talent alone doesn't make you a success in the marketplace. More pertinent questions that often aren't asked include these: Am I willing to work hard at tasks that seem completely unrelated to photography? Am I willing to research and learn and make mistakes? Am I willing to take risks? Am I willing to put my work and my business practices under the scrutiny of a mentor or peers so I can improve? Sure, natural

talent is an undeniable asset. But there are plenty of less-talented but harder-working photographers out there making a living. Better, more direct questions might be these: Do you want it badly enough? Do you love it enough?

I thought so.

You may never be able to answer the question "Am I good enough?" to your own satisfaction, but one client at a time you'll begin to hear the answer. Keep at it. Don't let fear hold you back.

Whatever the next step for you is, take it boldly. These are not times for the timid; there's no reward in tiptoeing through life only to make it safely to death.

Your Next Step

You might be one of those rare people who maps things out and makes lists in your brain. Most of us are not. For most of us, the act of writing something down is a part of the thinking process. When I suggest taking inventory I'm not being purely metaphorical. I suggest you actually sit down with a pen and paper, or your laptop and a cup of coffee, and make an actual inventory. The questions I've asked aren't just devices to get you thinking; they're actual questions needing actual answers, and the more conscious you are of those answers, the better equipped you'll be to move forward. If I read a book and it tells me to make a list, the last thing in the world I'm likely to do is make a list. But seriously, make a list. Take stock. It might take a weekend, or a whole month of weeks as new ideas come to you and you add to the list, but the more fully you know what's on offer, the more able you will be to take it to market. Not to spoil the ending or anything, but this whole thing is pretty simple. Know your product really well. Know your market really well. Then get them talking to each other.

> "The more you understand the culture and language of that market, the more easily you can communicate with that culture."

Know Your Market

Without an understanding of your market, you'd have no idea what they need and want, how they want it, and how to communicate to them that you have the goods. You wouldn't know how much to charge and still be seen as a professional. Knowing your market is the communicator's version of knowing your audience. You wouldn't stand in front of 100 autoworkers in Mexico and give

a speech about Søren Kierkegaard and religious existentialism in English. I'm guessing the same speech in Spanish would still meet with blank stares. Wrong message, wrong means of communicating it.

I couldn't begin to guess what your chosen market is. It might be a small town in Montana where you've chosen to work with equestrian clients. It could be bar mitzvahs in Manhattan. It could be Fortune 500 clients looking for the best annual reports they've ever seen. You must do more than identify your market. You need to understand them as deeply as possible—to find out what they need and want, and how they want it. The more you understand the culture and language of that market, the more easily you can communicate with that culture.

It's generally accepted that we trust people who are like us. It's a natural instinct, and it bears remembering when you approach a market. But knowing them is only a start. Sharing their values, interests, and even their style are additional steps closer to trust. For example, if you've chosen to do pet photography in the upscale artsy areas of Vancouver, you've got a better chance if you're seen not only as an expert at your craft, but as an insider. If you yourself have a dog, that's a step. If your clients wear high-end designer clothes and you got yours at the local Stuff-Mart, there's a good chance you'll be seen as an outsider. Snobs, you say. Maybe. And that might influence your decision about working within that market, in which case perhaps you should start by asking what markets you could serve where you are *already* an insider. If you're a world-class snowboarder, you're already an insider and you're probably already a passionate expert. Unless you're sick to death of snowboarding, you'd probably do well to consider this market rather than one that will be a long uphill battle.

Your Next Step

Ask yourself these questions: What magazines does your market read? Are you looking to shoot for a market defined by a lifestyle or a common interest? It's an innocuous question but a helpful one. Magazines are communities in print. They reflect the values, desires, and needs of the groups that read them, and staying current with them keeps you up-to-date on what is relevant to your market. I doubt you'll want to advertise in these magazines, but they should suggest to you possible partners for cross-promotion and possible clients.

I also suggest you consider subscribing to *PDN* (*Photo District News*). *PDN* is a top-notch magazine specifically for the working photographer—the magazine and its companion website, which is increasingly deeper and more current than the print version, are excellent sources for insight into markets, trends, and the promotional efforts of photographers serving those markets. For the money, I've found more content here that is of better quality and relevance to me as a vocational photographer than in any other magazine. Look for it at PDNonline.com.

Know Your Craft

The assumption that needs to be made before continuing with the rest of this book is a simple one that I'm going to touch on but never dive into. It lies outside the scope of this book, and it's the subject of many great books. It is presupposed in every discussion about marketing, and without it, you might just as well put this book down and get back to the basics. The assumption is this: you know your craft and your product is truly excellent. And ever-improving. There are no hidden tips and tricks for selling mediocrity in this book. You can con almost anyone into hiring you once, but if you do not deliver on your promises you can bet you won't be hired twice. Not only that, you'll lose the goodwill and word of mouth that might otherwise have been generated by delivering excellence.

Your product and service—whether that's you as an assignment shooter, prints through online sales, or stock photography to an online agency—have to rock. They have to be better, much better than just okay. Too many decent photographers are out there who will deliver if you do not. If you consistently deliver mediocre work, then you're competing in the largest field possible— clients looking for low-end, mediocre photographers have the greatest selection imaginable at the best prices: free. The trickle-down of technology, once only available to working photographers who could afford it, has made every teenager and bored uncle a photographer, and you can bet they'd be thrilled to shoot a wedding for nothing as long as they can play with their toys and wear their photo vest. The ability to work a camera on even a basic level now affords more people the illusion that they are "professional photographers," and it gives more potential clients the illusion that those new photographers can deliver professional results. Longevity and success comes with excellence, knowing your craft, and always sharpening your skills.

If you are not there yet, then consider holding off. Spend a year really studying your craft and finding people who will give you honest feedback. Remain a hobbyist for a while longer, shoot for a few smaller clients, do some pro bono work, do a workshop. Find whatever opportunities you can to sharpen your edge.

Whenever you get to a spot in this book where it sounds like I'm a little excited about marketing, remember the last three paragraphs. Remember that the assumption underlying every word in this book is that your product, your service, and your craft are already great and are always getting better.

10% Show, 90% Biz

There's this mantra in showbiz, a nod to how tough it is to make it and an acknowledgment that talent is not the be-all and end-all. In fact, plenty of really talented people are out there who have yet to make it. The mantra is this: showbiz is 10 percent show and 90 percent biz. I know, as mantras go it isn't pretty. Or profound. But it's true. It's not meant to be a comment about priorities or how we spend our time, but simply a way of acknowledging that putting your nose to the grindstone and working—not merely waiting for the phone to ring—is what gets a performer where he's going.

It's not wildly different in the photography world, where the myth of talent too often gets a foothold in our thinking. The myth of talent says, simply, that if I'm more talented than another photographer against whom I compare myself, and they've built a solid career, then I will, too, and better. The flaws in this thinking should be immediately obvious. Talent is not something so easily evaluated; it's not a quantitative commodity we can look at and compare like a child's math problem. If Billy had three apples and we take away one, how many apples would Billy have? Talent is qualitative, and even if it weren't I'm pretty sure measuring our talent against that of another would only result in either a bloated ego or crippling discouragement. The second problem, of course, is that we often have no idea how hard another craftsman has worked, and while we might look down at him as a hack, that hack has worked harder than we've ever considered working to get where he is. From our competitive vantage point, the other person is always less talented, has gotten lucky, or has had things handed to him on a silver platter.

> "The assumption underlying every word in this book is that your product, your service, and your craft are already great and are always getting better."

But that's really not the point at all. The point is that while the mantra I learned in the showbiz world is meaningful, it falls apart when you look at it too long. In photographic terms, the math of the showbiz equation needs to be translated into 10 percent craft and 90 percent business. But that's not the point, either. To begin with, the math is purely speculative. Who knows what the math looks like for you or me? It changes from person to person, and things might look different from one week to another. But I think there's a bigger problem, because the math simply doesn't add up. It's not a 90/10 split at all—it's 100/100.

Where the craft of photography meets the world of commerce, two different worlds are at play. They intersect best where the craft is given 100 percent attention and the business is given 100 percent attention, neither giving room for the neglect of the other. Doing it any other way means one side of the equation is imbalanced and neglected. You are a photographer when you're conceiving and creating photographic work. But the moment you answer the phone, speak with a client, or plan a marketing initiative, you are a business person.

Why is it that so many photographers do such lousy marketing? Because they're thinking and working like photographers, not marketing professionals. When you study your craft, study it well. Be diligent. But when you engage in other business activities, stop being a photographer. If you know nothing about marketing, then learn; finish this book and pick up a marketing book. Not a book about marketing for photographers (though you'll be hard-pressed to find one), but a book about actual real-world marketing. As a photographer, you know that merely picking up a digital camera, pointing, and clicking doesn't make you a skilled photographer; printing and mailing out your business card won't make you skilled at marketing either. Both photography and marketing are communications specialties, and being good at one doesn't necessarily qualify you to do the other. What qualifies you is study.

Recognizing this, and then either putting in some serious study time or finding a marketing professional to work with, are the first steps in applying the 100 percent principle. If what you want most in the world is to be a photographer, then the fastest path to that goal is to remain a hobbyist. Doing it, even part-time, as a vocation means learning to run a business, tend to finances, and market yourself. It's 100 percent craft and 100 percent commerce, and while the sexy, romantic, fun stuff is playing with lights and cameras, neglecting your skills as an entrepreneur will crash you faster than mediocre photography ever could.

> "It is impossible to create a one-size-fits-all template for success."

Get Rich Quick! (But Do It Elsewhere)

If the last few pages didn't make you hurl this book into the lake and give up entirely, let me try again from a different angle. Then, if you're still hanging on, it's a good sign you're made for this. But let me take one more crack at convincing you not to follow the voices in your head calling you to make a living in photography. Fact is, it's not the people who think they might want to give photography a whirl as a career that have the best chance of making it. It's the ones who simply can't be pulled away from it or convinced otherwise, the ones who know photography might just cost more than it ever gives back and are not only prepared to make the sacrifice but are already reaching for their pens to sign up.

So as this is my last-ditch effort to convince you otherwise, let me speak plainly. You might never get rich doing this. And if you do, it will more than likely take a

long, long time to get there. Any train that offers to get you there—and get you there fast—is a train you don't want to be on, and you'll have to sell your creative soul to ride it. Making a living in the arts is not for the faint of heart. There are too many variables in the creative arts, too many people with too many different goals and talents. It is impossible to create a one-size-fits-all template for success.

> "Your energies are better spent on creating great work and serving great clients, and that's a long road."

You will have to create your own path, beat the bushes in front of you with your own hands, and find your own particular buyers for your own particular vision and talent. Throughout this book are case studies of nine very different photographers, all of whom share several characteristics despite how incredibly diverse their stories are. They are, without exception, as creative in their business lives as they are in their photography. They are hard, hard working. They are patient. They give as much care and attention to taking their craft to market as they do to developing their craft. They have an exceptional product, and they serve their clients with exceptional care. And they have taken the long, intentional road to getting where they are, with an eye on a long road ahead. None of them have gotten rich quick because that's not their goal. Their goal, in the broadest terms, is to be the best photographer they can be, to shoot the stuff they love, and to find the best market for it. A great living, when it happens, is not the goal; it's the by-product. Leave chasing money to the con artists. Your energies are better spent on creating great work and serving great clients, and that's a long road.

Lastly, I think it's worth noting that the marriage of craft and commerce is an uneasy one at best. Most days, we straddle the line between creating art and selling ourselves—to put it crassly—into photographic prostitution. And even when we don't, there's a good chance that's how we're feeling at any rate. There are days you'll spend more time asking what the market wants and less time asking what you want, and you'll close up for the night and feel like you've taken two steps backward. It's an uneasy combination of priorities, and it can be a soul-stretch to bring the competing priorities into alignment. The only comfort I can bring you is to tell you we've all been there; we all wrestle with it. It's not a barrier to doing this work. It's part of the territory in which we do the work itself.

Kevin Clark

KevinClarkPhotography.com

KEVIN CLARK is a Vancouver photographer occupying two very different niche markets: actors' headshots and food. While the two are different from each other, he shoots both because he loves it and both appeal to a different aspect of his creativity and vision. Kevin was my publicity photographer in my previous life as a comedian, and he was one of my mentors as I made the exciting but scary transition to photography. Rather than turn Kevin's words into my own, I've left our interview intact.

In the broad sense of being a vocational photographer, why do you do this?

I picked up my first camera in art school. I was taking graphic design because I was good at art as a kid, and I couldn't figure out what else to do. I was blown away by the camera, the darkroom, all of it. I couldn't think of anything else I wanted to do after that.

How did you get started? How long were you a hobbyist and how long a vocationalist? What's your story?

During and after art school, I worked as a bartender/waiter. I shared studio space with several people and starved. I had two pairs of jeans and two shirts. I often lived illegally in the studio space I was sharing, rode around on a bike, and borrowed

my gear from friends. At one point I was sharing a studio with a friend and couldn't pay the rent. The landlord came in with the bailiff and my girlfriend—now my wife—had some savings and got me out of hock. The friend I was sharing with had had enough and went out on his own, leaving me with no gear,

no studio, and no clients. So I went and got a job in a small town up north. My goal was to save the money for gear and return to the big city. I spent six months working as a machinist's helper in a coal mine. I returned to Vancouver with a medium format system and some lights. That was the last time I worked at a regular job. For the last 19 years, my wife and I have lived on the income from photography.

How would you describe the niche you occupy, and why this particular niche?

I have shot actors' headshots for the last 20 years. When I was getting started, the film industry was growing big time in Vancouver. I had a studio in Gastown and met some agents who used me for their clients; then I met my wife—who became my makeup artist—and that set the pace for the next 20 years. So I occupy the niche I do by accident and design. I found I had a knack for lighting

people and a personality that could put people at ease (as did my wife), so we pursued actors' headshots. The thing that has kept me in it is that everyone I shoot is unique—so I always find it interesting and challenging. My newest love is food photography, which I started about five years ago. I find it challenging in a different way, and I like working with chefs, stylists, ad agencies, and food clients. The collaborative nature of the job brings fun, creative surprises and challenges.

What were your early victories and early defeats?

The first break we had was working for a modeling agency shooting headshots for models and actors. I would shoot 30 people a day but would only get my costs for the film and developing covered. My wife sold prints to the clients and that's how we made our living. Doesn't sound like much of a break, but I shot a lot of people, and it developed my ability to get people comfortable quickly and get the shot.

Do you look back at one particular turning point around which your career pivoted?

I think I've had a few. The first one was shooting for the modeling agency; the next was when we quit shooting for agencies and went on our own. It was a scary risk, because we had no steady flow of income. We started working with individual entertainers and didn't know from one week to the next if we would have enough to pay our bills—or eat, for that matter. Somehow, though, our name got around. We tried all kinds of things to get known, but word of mouth seemed to work the best, and we ended up doing better on our own than when we were shooting for the agencies. The main upside was we were shooting far fewer people, so we got a lot more time to experiment and be creative. The next turning point came years later when

I was contacted by a small restaurant chain to do a test for a possible food job. They had found me online and seen some of the food work I'd done for a magazine. I didn't get the job but it got me excited about shooting food. A month or two later, I met a talented chef with an interest in food styling. We spent the summer shooting tests and sent out a promo that got us a gig with a large restaurant chain. That experience showed me there was a future for me in food.

What makes you the unique photographer you are to the clients who use you?

My use of light. I'm a freak about lighting. I love everything about it—natural or manmade—and I have fun with it. The other thing is my ability to get people relaxed and enthusiastic about the shoot. Our whole team does that, from Rob

and Andrea (our staff and first point of contact) to my wife (she does the makeup and gets the clients ready to shoot)—she has a gift as an artist and puts people at ease with her positive, nurturing personality.

My food and advertising clients hire me for the same reasons—there's a particular visual style to my work. The lighting and composition are crucial to making food look tasty and three-dimensional.

What are the particular challenges in your corner of the photography industry, and how are you dealing with them?

The actors I shoot have been having a hard time lately—the economy, the writer's strike, and the forever-simmering SAG (Screen Actors Guild) drama haven't been easy on them. We've countered that by bringing repro printing in house. It's a value-added service that gives our clients a superior product while increasing our revenue from each client. That helps in a shrinking market. We are also looking for other areas to sell our headshot services, such as the corporate market. We've been actively pursuing food clients in an organized way as well, with monthly promos to local prospects and e-mail blasts on a national level.

Marketing has changed so much in the last few years with the incredible rise of the internet. How has the internet changed your marketing?

Our website is definitely our biggest proactive marketing tool. We use e-mail a lot to communicate with our clients, and we have a portfolio on Workbook (www.workbook.com/photography) as well as Viisual (www.viisual.com). We also use ADBASE (www.adbase.com) to do e-mail promos and research potential advertising clients. Most people book us through our website—so we try hard to drive traffic to our site. We also have a blog and a Facebook page.

You obviously have an online presence. Do you also have a book to show clients? Do you have a print book? Is it applicable to your industry?

In my experience, and in our market, art directors like to see and feel a book. It also gives you something to bring with you when you have a meeting. It's a good visual aid when making a "sales call." That being said, most of our jobs have been booked from our website.

What are your key marketing initiatives?

We are sending out a monthly promo piece to our local food clients. We photograph a tasty food item and deliver the food item to the potential client with a printed promo of the same food item. We also do a bi-monthly e-mail blast through ADBASE across North America, directing people to our website. We have three separate websites—one for headshots, one for food, and a general site for advertising clients—and a blog. We promote each one separately and, as mentioned earlier, we have a Workbook and Viisual portfolio online, as well as a presence on the CAPIC (Canadian Association of Photographers and Illustrators in Communications) website, all of which shows our work and points people back to our websites.

Do you have a logo? A particular approach to your branding?

We have logos for each niche we occupy, and all are consistent with our overall branding, but we promote each facet of our business separately.

Everyone says word of mouth is the best marketing, but they still pour thousands of dollars into traditional marketing and cross their fingers when it comes to word of mouth. What percentage of your work comes from word of mouth?

Easily 90 percent of our work comes from word of mouth. We do all the usual marketing, but we know at the end of the day it's existing clients who will bring others to us.

How have you made a go of it? Have you made any particular choices—like renting or leasing gear—that have contributed to your success?

We buy only what we need. We keep our overhead as low as we can and rent stuff when we need it.

If you were to sit down with someone making the transition from a hobbyist to a vocational photographer, what key wisdom would you give them?

A couple of things. First off, shoot as much as you possibly can—it takes time to find your groove. The beauty of digital is you can try stuff with little risk, so shoot lots and try different things. Experiment. Try your lighting a thousand different ways, and when you find stuff that works for you, learn how to repeat and perfect it. That's the professional part; your client is going to hire you for the cool stuff you do—but you better be able to repeat it for them.

Secondly, stay on top of bills and, especially, taxes. Getting behind will seriously bite you in the butt. In 2003, we found ourselves five years behind on taxes, owing the government and other creditors over $90,000, forcing us into bankruptcy. We're over that now, but it doesn't take gigantic mistakes for this to happen; it takes small mistakes over time that snowball out of control. You have to be diligent about this stuff and stay ahead of it. Having to dig out from debt—taxes or otherwise—creates a massive overhead that can cripple you.

All images on pages 49–55 © Kevin Clark Studios

Make a Plan, Stan

I'm a big fan of intentional living. Perhaps I trusted my mother too much when I was a child, and all that talk about doing whatever I set my mind to just sunk in. It's made me a hopeless idealist in some ways. Also got me into trouble more than once or twice; I know I tried flying on more than one occasion. The thing is, I think in broad terms my mother was right, but I just didn't hear her properly. I heard, "You can do *anything* you set your mind to." What she was really saying was closer to "You can do anything you set your *mind* to." The emphasis was on the mind, the determination. The mind is an astonishing thing, and while I'm certain it's not unlimited—Einstein said the only thing approaching the infiniteness of space was the infiniteness of human stupidity—I am sure that it's got more potential than we allow it.

Perhaps we've seen too many Hollywood movies and been lulled into thinking that if we're just good-looking enough and try hard enough it'll all go well and the business will thrive and the underdog will rise and Tom Hanks will run off with Meg Ryan, giggling deliriously. But it doesn't work like that. Our course, inasmuch as it depends on ourselves, can be plotted intentionally or left to chance. Chance is fine if you have no particular inclination as to where you want to go, but if you've got a specific goal in mind then you're better off making a plan.

I can't tell you how many people I've talked to who say they wished they were doing what I do. But not one of them, having identified this as a desirable destination, has gone looking for the best roadmap. Some have even set off in the direction of their destination, relying on their enthusiasm and their faith in the Hollywood ending.

If you already know your destination, your first step shouldn't be buying a car. It shouldn't be putting gas in the tank. It shouldn't be packing your bags and making sure the oven is off. It should be finding the best roadmap you can find.

Starting out, take your time to determine where you're going and how to best get there from where you are. But first, take a long look at the destination. Before you study the map, read the brochures and make sure this is a destination you really want to end up in. Look at other vocational photographers

> "Chance is fine if you have no particular inclination as to where you want to go, but if you've got a specific goal in mind then you're better off making a plan."

working in the field you want to work in, see how they live their lives and what it's taken them to do what they do. What sacrifices have they made to get there, and are those sacrifices you'd make to pursue your craft? How long did it take them to get there? After speaking to a photographer who's shot for *National Geographic*, you might find that being waste deep in muck and mosquitoes in Borneo or stuck in cross-fire in Afghanistan isn't your idea of fun, and what you really want is to be shooting photographs of luxury resorts in Montenegro. You might discover that serving a certain market means being on the road an average of 10 months out of the year and decide that your spouse and children need you home more than you need to be out shooting. Do your homework and you'll be better equipped to pick up the map and gas up the car, or to change your destination before you're halfway there and running out of gas, money, and love for this particular journey.

Once you're certain this is the destination for you, it's time to proactively find, or create, the best roadmap possible. What makes a good map or plan? Knowing exactly where your start and end points are, and having as much detail as possible about the waypoints along the way. You need a goal, and you need clearly defined steps that can be measured and evaluated. Before launching into this as a career, even if it's just evenings or weekends, you'll need at least three sets of plans: a strategic or organizational plan for your business; a marketing plan; and a financial or business plan.

At least once a year I get together with one of my best friends for a weekend to double-check our roadmaps and make adjustments where necessary. We take off somewhere, get a double hotel room, and launch into 24–36 hours of plans, PowerPoint presentations, and marketing materials, and we pick at each other, ask probing questions, and look for the blind spots. We eat some good food, have a couple drinks, and have a great time because we love this kind of thing, but every minute not spent eating or sleeping is spent taking turns at hammering out our respective roadmaps. Every time we do this I emerge with a clearer picture, or having seen opportunities or pitfalls I'd have missed otherwise. Occasionally I'll be so stuck on tweaking my marketing that I completely miss the need to proactively plan the development of my craft, or I'll have been so focused on one area of my financials that I forget to plan for the taxman or the eventual failure of one of my cameras. These weekends ground me.

Plan it out, break it down, track it, and then do it. If you need to read a book on time management or goal-setting, do it. If you need a notebook or a day to get yourself organized, make it happen. Financial management will make or break a business, and so will time management. It begins with a plan, but that plan is worthless unless it can be broken down into steps, evaluated, and followed through.

Your Next Step

As a start, I suggest that you create an imaginary five-year plan. It's just hypo-thetical, an exercise. Determine where you want to be in five years. Who do you want to be shooting for? How much do you want to be earning? Do you want to be in a studio or based out of Kathmandu? Now ask yourself, realistically and with no punches pulled, what it would take to get there. Step by step, map it out. If part of that means you'd need a killer portfolio on both your website and in a print book, what steps do you need to take to get there? When do you need to have the work to your web designer or book printer? Work backward. If you need it printed in December, when does it need to be at the printers, and when at the designers? If the designer needs it in October, when do you need to have your images shot and ready? If shooting needs to happen between June and August, when do you need to find models or book flights? What about other materials? You weren't going to produce a whole new portfolio and release it silently to the world, were you? Didn't think so. So how will you get it to art direc-tors and agencies? And how much is this going to cost, anyway? Your plans all connect like a map of a big city; the financial path crisscrosses the marketing path, which intersects here and there with your larger business plan.

Once you've created a hypothetical plan with no consequences or emotional baggage, you're ready to begin your own planning. Start with what you know. Where are you now? Where do you want to be? What do you need to do to get there? It should be about now that you begin to see the wisdom in having a mentor—I'll talk about this in a moment—and staying connected to colleagues who are open and generous with their experience and wisdom.

The more detailed your plan, and the more you research what this is going to cost in terms of time and money, the more able you will be to follow through on

the plan. At the risk of belaboring the road-trip metaphor, you need to make sure you've got enough gas in the car. If you do your homework—and by this I mean actual research, not daydreaming or mentally shopping for gear at B&H Photo—you'll have a better sense of the resources required to make this happen. Don't go in without a carefully considered plan.

When I talk about the power of being intentional, I don't mean the power of wishing, but of making a plan and doing it. This applies in macro terms—the broad strokes that you need to make in order to craft the career you want—as well as the micro, the small steps you need to take in order to get your craft and your career where you want it. There is so much that lies outside of our control that grabbing the reins on the things we can do is vital. It also keeps us from being overwhelmed. I have a growing stack of notebooks I write in, treasured pocket-sized Moleskine books into which I put endless checklists and to-do items. The moment I think "Hey, I should…," I write it down, and put an empty checkbox next to it. Every week I look through the book and make sure I've taken care of those items, or that I'm in the process of doing so. There are so many things in life, so many great ideas that could change our careers and we "just never got around to it." Procrastinate all you like, but it's your career. These checklists—and they are legion, let me tell you—may look obsessive-compulsive to some, but they're what keep me on track, keep me from procrastination, and allow me to get as much done as I can.

Don't Quit Your Day Job

While still a comedian I was often told, after the show and by an overly enthusiastic fan, that I was good. I mean *really* good. So good in fact, that I should quit my day job. I always chuckled because performing *was* my day job. Some compliment.

People still do it. "What's your real job?" they ask. Either I'm not passing the way I thought I was or people just find it hard to believe anyone can make a living at such odd jobs. Truth be known, there are days I do, too. So when it comes to making the transition from your so-called real job to the one you've been dreaming and scheming about, likely the best advice anyone can give you is to go in very carefully, very intentionally, and through the back door.

There are two approaches here, both of them valid but carrying significantly different degrees of risk. The Front Door approach is the *Jerry Maguire* approach. Burn your bridges, launch your ship, and hope to God it goes well. If you're really lucky you'll have someone cute like Renée Zellweger to keep you company along the way. The Front Door approach is the take-no-prisoners approach. It's also the approach that leads to more business failures within the first two years than anything else, because the Front Door approach has more bravado than wisdom.

The Back Door approach is slower, more cautious, and prone to fewer risks. You take the moonlighting gigs, sell your prints on weekends, and do the hands-on market research to determine what the response is to your work. You ease in. You have a full-time job supporting you, some savings to lean on when you finally cut the ties to your real job. You take the time to find a mentor to see you through the transition and warn you of the dangers. You create a plan, test it, tweak it. You give your family time to adjust to all this. You pay for needed gear, websites, business cards, etc. with actual cash instead of going into debt to launch your ship.

The Back Door gives you room to make mistakes, finance the venture intelligently, and test the waters. It gives you the time to find your niche, plan a smooth transition, or work your market to the point that you're so busy you have no choice but to leave one job or scale back your photography work. When it comes to that point, you've got what the Front Door guy doesn't have—the luxury of carefully considered decisions and the resources with which to make them.

> "The Back Door gives you room to make mistakes, finance the venture intelligently, and test the waters."

The Back Door gives you room to hear a reply to that nagging question, "Am I good enough?" It gives you a chance to find a few clients, get some feedback, and have some initial victories. When you've got a growing handful of paying clients, or a couple of published articles and the praise of an editor, then you have your answer. You've got the goods for that market. You'll get better, you'll work harder, and your market will deepen and expand. But for now, just enjoy hearing the answer. Few things in life are as gratifying as hearing that answer resonate on the inside and knowing, Hey, I can *do* this!

Find a Mentor

Is there any way Luke Skywalker would have made it without Obi-Wan Kenobi or, later, Yoda? He'd still be shooting womp rats on Tatooine and whining about never getting off that moon. Without his mentors, Luke would never have saved the galaxy, and we'd be living under the rule of the Empire. It's more than likely he'd have kissed his sister, too.

Despite the claims of photographer bios everywhere, none of us is self-taught. All of us have influences, giants we look up to and on whose shoulders we stand. Those influences for me were people like Steve McCurry and Yousuf Karsh; their work inspired me and lit my path until I had walked that path long enough to go it alone.

A mentor is different from that. A mentor is intentionally chosen and plays an active role in your journey, warning of dangers ahead, giving wisdom, and telling the truth when no one else will. It's someone who has walked the path ahead of you and will tell you what you need to hear, not what you want to hear. A mentor will look at where you are, where you want to go, and help you navigate the journey. Like a caddy who's played a golf course a thousand times, he's there to warn you of the hazards and suggest the best tools for the terrain. I've just hit the limits of my golf knowledge, but the metaphor is a sound one. Except that a mentor won't carry your bags.

When I decided to make the transition and make photography a full-time vocation, I chose a number of working photographers and picked their brains. Kevin Clark, who is among the visionmongers profiled in this book, began as my publicity photographer while I was still a comedian. He became a friend, he shot my

wedding, and when I began to make the transition, he became a mentor. Not in any official capacity, but he and I have lunch at least once or twice a month and talk. I listen carefully to his stories, his thoughts, his ways of doing things, his opinion about my work. He has been doing this much longer than I have, and he's had some hard knocks and learned some important lessons because of it.

Photographers tempted to forge out as entrepreneurs often have the kind of personality that makes them lone rangers. Control freaks to the end, we seem to have the propensity to want to do everything ourselves. We do our own bookkeeping, marketing, design, administration. We do it all. If we stink at design, we do it anyway, which accounts for more than our fair share of aesthet- ically bankrupt marketing materials in an industry that is entirely about visual language. Not to mention photographers who are broke with tax debts and wildly disorganized calendars and inboxes. It's that personality, coupled with the anarchist found in most creatives, that also seems to form a resistance to asking for help or seeking a mentor. I'll talk about the lone-ranger dysfunction later, but for now consider this—whatever your definition of success, finding a good mentor will make you more successful in less time, with less failure.

Mentors come in all kinds of forms, some of them in more formal relationships than others. What matters is that you choose a mentor you respect, someone who's been where you are now and is where you want to be. Whether they are photographers in the same discipline is probably less important than that they are people who define success in similar ways and have gotten there in a way that you can get on board with. Look for someone who will be totally honest with you and who will share their wisdom as well as their failures with you, not just a program. A program is the last thing you should be looking for. Programs are generally designed for the widest common denominator; they are not at all suited to a unique photographer moving in a unique direction with a unique starting place. True mentoring is a relationship, not a program.

When you begin your search for a mentor, decide ahead of time what your needs are, how long you can commit to the process, and how receptive you are to change. If what you're looking for is someone to tell you you're doing it all just fine, then save your time and money and ask your mom to tell you that. Also, decide how much you can afford to pay. Not all mentored relationships are paid arrangements, but the busier a working photographer gets the more valuable her time, and if she's going to give you the attention you need, she may well

"Finding a good mentor will make you more successful in less time, with less failure."

have to be compensated in some form. If you don't like that, find someone who will happily do it for free, but you may find their time even more limited than a mentor you pay for.

Whomever you choose, and however you find them, I encourage you to consider mentoring as a powerful tool. This is more than standing on the shoulders of giants. It's standing there while the giant surveys the landscape with you, shows you the potholes and hazards, and helps you see further and move in that direction. Not every successful photographer is capable of, or even wants to be involved in, mentoring younger photographers, so hold out until you find someone passionate about their craft and about your success.

Oddly, many photographers seek mentors once they've headed down the road a ways, only to find themselves wandering aimlessly. *Then* they approach a mentor. How much more useful would a mentor be if you began a relationship with them at the beginning of the journey? In fact, as I talk to photographers plagued by self-doubt and the "Am I good enough?" question, I'm continually reminded of the mentoring process and how much more easily this question could be asked and responded to if they had someone acting as a mentor. Having an honest voice in your life to affirm your abilities and your vision, or to tell you the brutal truth at times, will keep you from completely derailing from a loss of confidence or an abundance of ill-placed confidence.

Love Your Fans, but Listen to Your Critics

There's no shortage of ego among creatives, photographers included. We often find, to our detriment, much of our identity and worth in the work we create. This unspoken need to be approved by our peers leads us to seek praise much more rabidly than we seek, or heed, criticism. There are more photographers who want to hear that their work is great than there are photographers who want to hear that their work is good but can improve. Caring more for our ego than our craft is the sign of an immature photographer, one who won't listen to criticism even when it comes from qualified sources.

This dependence on praise, and avoidance of true criticism, leads us to the illusion that we're better than we are. It also stalls our development in the craft. It betrays the fact that, for us, the point is not how well we express ourselves with our craft but what other people think of us. Not to put too sharp a point on

it, because I've been there as well—and will be again—but that's narcissism, not photography. Finding that we've shot 100 frames of weak, uncompelling photographs is no reflection on our character or even necessarily on the strength of our craft. But how we react to it certainly is.

Listening to our fans is seldom a good idea. It assumes that our fans even know what they're talking about. It's gratifying to hear your sister tell you it's The Best Photograph Ever, but if I may be so blunt, what does she know about it? Her praise is a refection of her love for you, not a reflection of where you are as a craftsman. Let her praise affect your emotions, not your perspective on your craft.

For that we need other voices. Voices that are 1) qualified, and 2) care more about our craft and our business than our feelings. Seek critics. Let them be ruthless. The good ones aren't attacking you; they're evaluating the strengths and weaknesses of your images so you can create stronger, more compelling photographs. Fans will encourage you but seldom make your work and business stronger. In addition to finding a mentor, find someone you respect who can evaluate your images with more than comments about their artistic preferences. "I really like this image," someone will say. Great! Be pleased, be thrilled that your image has resonated with them. I've got no interest in art snobbery, so when friends and family say they love my work it means that for some reason it resonates and that's why I do this. But they are not the voices to listen to if you want to know *why* they resonate and *how* you could have made the image, and therefore the resonance, even more compelling. For that, you need qualified critical voices to whom you can listen, voices who will lead you to stronger work.

We're a long way from talking about business and marketing, so now's as good a time as any to remind you that separating our product from our efforts to sell it in the marketplace is a false separation. The quality of your craft directly impacts how easily you can sell it, to whom, and for how much. Don't ever neglect your craft.

Your Next Step

If finding a mentor or someone who can give you a helpful, qualified critique of your work sounds like a next step for you, then the best thing you can do is start looking. Find someone you respect and reach out to them. In my experience,

> "Separating our product from our efforts to sell it in the marketplace is a false separation."

the photography community is full of people who've been given a leg up at some point and are eager to pay it forward. If what you want is a more dedicated mentoring relationship, then I still suggest reaching out to someone of your own choosing rather than limiting yourself to photographers advertising a mentoring service. That's not to say a photographer offering to mentor others isn't a great idea; it's just more than likely a backward approach. What's important is that you connect with them, respect them, and that they create work you admire or work in a niche you want to work in. You might get a couple polite declinations before you find someone willing to work with you, but it begins with reaching out.

Join a Gang

There's a proverb that says people sharpen each other in the same way that iron sharpens iron. Peer relationships can have this sharpening effect on our craft and our business.

The man who is currently acting as my manager is one of my closest friends. For the last four years we've connected on a weekly basis to have a drink or a meal together and give a report on our victories, defeats, goals, and plans. We talk about things completely honestly and, more often than not, just talking about something clears up an unresolved question or an issue over which one of us has lost perspective. And when the issue is more complicated, the synergy of two people thinking creatively about the thing brings up more options and angles than one person might have done alone.

The more people who contribute to the well from which you take your creativity and your business ideas, the fewer blind spots you'll have. I have weekly conversations with photographer friends, some shooting for similar markets as I do, and some shooting for markets I will never pursue. We connect from different corners of the globe via Skype and other messaging technologies to pick each others' brains, often beginning the conversation with, "Hey, can I ask you a question?" As I write this, Twitter is the social networking application flavor of the month. Last year, it was Facebook, and who knows what it'll be next year. Through Twitter I've connected with hundreds of photographers, all of whom have different areas of expertise and experience. Some of them are people to whom I look for advice and honesty, while others look to me. To return to the proverb, that's a whole lot of sharpening going on.

In cities around the world, there are meet-ups that have originated online, a perfect example of which is David Hobby's Strobist community (strobist.blogspot.com). Thousands of photographers wanting to sharpen their off-camera lighting skills with small flashes are doing so every week, and it's not costing them anything. There are camera clubs and professional associations that act in the same way, and where they don't offer the same formal opportunities they certainly offer a pool of like-minded people with whom to gather informally.

Don't, however, limit yourself to other photographers. The power of multiple inputs and influences is not limited to those within the industry. Corwin, my friend and manager, isn't a photographer. He wouldn't know an f-stop from a bus stop, but he knows management, has a sharp entrepreneurial mind, and

knows his way around social media and marketing in ways that make my head spin. Find and nurture relationships with people from other areas of expertise and let someone else keep an eye on your blind spots. However you do it, proactively suppress the natural desire to do it alone. Connect to others and draw on their strengths in exchange for sharing yours with them; it will make things easier and much more enjoyable. Sometimes it's not even sharpening we need; sometimes it's enough just to know we're not alone as we wrestle through uncharted territory.

Fake It Till You Make It

I've got this recurring thought that one day my peers are going to wake up and discover that they've all collectively mistaken me for someone else. Someone with talent. Someone who knows what he's doing. Someone, unlike me, who isn't faking it. The thing is, many of them seem to feel the same way, too. In my braver moments, when I've given voice to this heretical line of thinking I'm usually met with disbelief: "You feel that way, too?!"

> "Where there is no path leading us to our desired destination, it's up to us to create that path on our own."

So I'm going to go out on a limb and write it right into my manifesto: anyone who's ever been an innovator or forged their own path has been faking it to some degree. Or they've felt that way. I don't mean to suggest they've been deceitful—not that kind of faking it. The honest kind of faking it that leads us to make it up as we go, knowing full well that where there is no path leading us to our desired destination, it's up to us to create that path on our own.

One of my buddies tells me that at the end of every gig he goes home and tells his wife he didn't get the knock. You know, the knock. The one where they finally discover you have no talent, that all along they've mistaken you for someone else with a similar name, and they've come to tell you to pack your bags. Almost everyone I know in the creative arts has a similar fear. It's not a bad thing. I think it comes from the way we do things in the west. There's a sense that there's a right way to do things, a well-beaten path that we should be following, and when we don't—because we're artists, dammit!—we feel like we're thrashing about, trying to discover our own path, and so sure that other creatives are all on a nicely paved path of gold. How did we miss that path? Are we less talented? Less motivated? Nope. We just haven't discovered the secret: there is no such golden path. You make your own, and it's only as others look at your path once it's been blazed and bushwhacked that it looks easy.

Get to Work

When one of my closest friends made the entrepreneurial jump, we began jokingly referring to the whole thing as the world of self-unemployment. Generally the truer something is, the more potential it has to be funny. While working for ourselves is held up to be the ideal work situation for most creatives, a unique challenge lies therein: our boss is often lazy and clueless, and when times are hard he doesn't pay us. Too often the transition is made in the hopes that the moment our business cards are printed, the phone will begin to ring, we'll make the commute to our office in our bathrobe and bunny slippers, and we'll spend so much time working for great clients that we'll be rolling in cash and giggling like schoolgirls in no time.

What never occurred to many of us was that without the accountability of an actual boss we'd begin sleeping in, become paralyzed by the lack of phone calls, and we alone would be responsible for turning that around. I've found the best way to do this is to treat it like the "real job" all my friends keep talking about. I get up at, or before, 7 a.m.; check my e-mails; and make a list of meetings and errands to complete by the time I clock out. In short, I make a schedule and I bust my butt to get it all done. Where there are empty spaces I fill them—I find a client or colleague to have a meeting with, I check a list of recurring things that need to be tended to monthly or weekly. I get busy.

It's a well-known principle that work begets work, and my own experience has proven this time and time again. A schedule that pushes me to intentionally and proactively build my business and work on my craft is essential to me. Every time that I've let that slip, I've noticed a slide in the amount of paying work that comes in. It's been a while now, but on those days when I couldn't think of anything to do, I would schedule an hour or two to go to a coffee shop, sit down, and make a list. Building a business, serving clients, and making a living in photography is proactively, not reactively, achieved.

Nowhere, however, is it written that you need to work a traditional eight-hour day from 9 to 5. My creative mind takes a holiday around 2 p.m. I'm useless during that time and will often take a nap, go for a walk, or head out for coffee for an hour or more. I'm not being lazy; I'm just going with my strengths. I learned years ago that powering through that mid-afternoon time only makes me tired and frustrated. But I also begin work pretty early and often put a couple hours

"Building a business, serving clients, and making a living in photography is proactively, not reactively, achieved."

> "It's often said we should work smarter and not harder. I think we should work harder and smarter."

in later in the evening when my creative mind is working overtime. I also know where I work best, which is not always at my home office. I write at a coffee shop to which I need to take a small water taxi on Vancouver's Granville Island. The walk and boat ride there relaxes me and gives me time to calibrate and think. The coffee shop removes me from distractions. That's how I work best. It's often said we should work smarter and not harder. I think we should work harder and smarter. If that means doing it over a cup of tea, or at a certain time of day, or in a certain place, then do what it takes to put yourself in a frame of mind to get your work done. I get up at 7 a.m., but the first hour of my day is spent in bed with my laptop, checking e-mail and checking in with websites and blogs of friends within the industry. I just work better that way, and it starts my day well.

However you need to do it—and I encourage you to do it creatively by recognizing the ways, times, and places in which you work best—make sure you put your time in. I encourage you to make actual schedules if that helps. Every entrepreneur I know works harder than their "real job" counterparts. They love the work and wouldn't trade it, and much of the time it feels like play—but they work more, not less, because they know that not working leads to more of the same.

Your Next Step

Begin each week with a staff meeting. Chances are it'll be just you and the cat. Sit down and look at the week ahead and put in the big pieces of the puzzle. What needs to be done this week? Now look at the whole month. What do I need to get done this week in order to accomplish those goals? Still have time? Look at your goals for the year. What do you need to do this week to keep those goals on track? Is your website up to date? When's the last time you called a client just to check in and offer to serve them? Still have time? Go work proactively on your craft; if you're not careful, you can get so busy with business that you let your photographic chops get sloppy.

Too Busy Chopping Wood

The best thing that can happen as a result of your efforts to make a living, even part-time, as a photographer, is that it all comes together and makes you wildly successful. It's also one of the worst if it's not anticipated and handled well. Getting so busy chopping wood, as the saying goes, that you don't take time to sharpen the axe is a professional hazard for anyone making a living in the creative arts. You get so busy with the affairs of running a business and shooting projects for clients that a year or more can go by without you ever taking time to sharpen your creative edge and tend to the creative core from which your vision and skill come.

While it's true that inspiration comes from working, and that more work can often lead in more directions taken by your inspiration, it's equally true that a certain kind of work leads to certain kinds of inspiration, many of them good for the marketplace but not of long-term benefit to your creative life.

Creativity and inspiration are the sources of your vision and, as such, are some of the most valuable assets, if not the most valuable assets, your business has. Allowing them to stagnate or devolve means you aren't offering your market the freshest product. What the market wants doesn't generally remain the same; it moves with an ebb and flow in the same way your vision and voice do.

Making time to work on personal projects keeps artists and craftsmen of any discipline sharp. When I first made the transition to vocational photography, I

promised myself I would tend to my most delicate resource—my creativity—by doing at least one personal project a year. For me, this means getting away to some other place, giving myself a few light assignments—to play with a new tool, to work on a new technique or find an angle on an old one. This time away, with no demands from clients and no brief to confine my eye, has been important on so many levels. I can't recommend it highly enough.

> "If you are not moving forward in your ability to serve clients, you are moving backwards relative to them."

Your creativity is not the only thing to suffer if you do not intentionally push your craft forward. Taking time to brush up on a skill like CMYK conversion or printmaking, taking a marketing seminar, or working on sharpening some of the other dull knives in your professional drawer is not only a good idea, it's necessary. If you are not moving forward in your ability to serve clients, you are moving backward relative to them. Clients' needs become more sophisticated every year, and if you're not keeping pace with them you're falling behind.

The same can be said for any craft in which technology plays a crucial role. In photography, where the technology behind the tools of our trade is developing at a mind-blowing and wallet-busting pace, it's as important to keep abreast not only of the technological training but of the technology itself. Your clients may not need images from a 21-megapixel camera, but that's not the point. If they believe they do, they will look to a photographer who can meet that perceived need. If you are shooting digitally, it is inevitable that your technology will obsolesce. You will need new cameras with better sensors because digital noise, for example, that a client once tolerated, they will tolerate no more. Bigger sensors mean bigger files, and that means you will need faster computers to do the same work in the same time, along with larger hard drives to store your expanding archives. Not carefully budgeting time or resources to best accommodate these needs gradually can mean a sudden, and crippling, outlay of finances.

Take the time to anticipate your axe-sharpening needs. When will you replace aging gear, when will you get down to Photoshop World or some other professional training conference, and when will you get out to shoot your own work? Planning and budgeting for this will ensure you don't find yourself in the middle of a busy season and tapped dry creatively or several steps behind the industry in expertise.

You Need Help

You can't do it alone and still grow to what you are capable of. At a certain point, you will reach the limits of your resources and it will be time to bring someone else into the fold. This doesn't necessarily mean hiring employees, but it will mean drawing on the services of other freelancers who are experts in their own areas.

There are two obvious areas in which we feel our limitations and need to be aware of them. When we hit these limits, we are faced with choosing between growing with the opportunities ahead of us or staying where we are. One means getting help, the other means remaining happy with the status quo and not growing.

The Limits of Expertise

This is the first limit you're likely to hit. We can't do it all, and if you're wise you won't try. Many of us are good at several things, but allowing our focus to stray to 20 things means it's not solidly locked on one main thing. If you're a photographer, be the best photographer you can be. Time spent becoming an expert at accounting, tax law, marketing, design, and the related software, not to mention all the other areas our work rubs up against in the course of a year, is not only unrealistic, it's unwise. A good accountant will pay for herself by keeping you from running afoul of tax laws or just plain financial stupidity. A good designer will bring to a logo or a marketing piece an expertise and knowledge of design trends that you don't have. The time spent not learning and practicing these disciplines is time you can spend serving clients and being the best photographer you can.

By all means, ease into this, but don't make the classic mistake of believing you can't afford this. You can't afford not to. Spend less money on new lenses and instead get a fantastic logo and website. The former can be rented while the latter can establish you deeper and faster in your chosen market.

The Limits of Time

At a certain point you're going to get busy. Too busy. As I write this I'm on a plane heading back to Vancouver. Staring down the pipe at the coming two months, I'm getting overwhelmed by how much I have to do. I can't do it alone. I've got a manager taking on more and more of my logistics, and that gives me serious breathing room. Not having him means I'd have to decline contracts worth many, many times more than I am paying him to lighten my load. Easy choice. If you can hire someone for $20 per hour to do the tasks that distract you from work that can earn you $500 per hour, then the math is a no-brainer. You might have to ease into this, and your initial expenses might seem higher, but your ability to take new clients will quickly expand to the new space in your calendar. Or you'll have time to work on your craft—which, as we've just discussed, is not an option; it's an investment with a proven return. So when things get tight, find someone to help lighten the load for a day or two a week or on a task-by-task basis.

"If you can hire someone for $20 per hour to do the tasks that distract you from work that can earn you $500 per hour, then the math is a no-brainer."

Your First Assignment

This won't apply in the same way to all photographers. We all have our niche, so a paying gig means different things to different shooters. But there's a way of approaching it that many of us can share and implement in order to make that first assignment, wedding, or portrait session as successful as possible. I offer it here because the sooner we approach the whole thing as an intentional process from beginning to end, the sooner it all becomes a habit, and fewer things slip through the cracks. From the moment that a client contacts you to the moment you conclude the contract and begin following up in anticipation of future work and generating word of mouth, you have much more to do than taking photographs.

The first steps occur before you even sign a contract. Like a dance, this is where you begin to know your client, listening to their needs and asking about needs they themselves may not have anticipated. They're the client, and while it would be nice if clients knew everything they needed or wanted, it's the job of the photographer to guide them through that process. The more you do this, the more aware you will be of the areas in which your first-time clients need guidance. Many of them will be unaware of the specific deliverables they will need, not to mention realistic timelines, budgets, or even their own need for model

releases. If it's a wedding, there's a good chance they've got no idea what they want or what it will realistically take to get it. If it's a commercial client, they will fall anywhere on the spectrum from completely unaware to more savvy than you are. At any rate, it is your job to guide them carefully through this. It could be argued that this is the client's job, but that kind of argument is made by divas, not photographers bent on serving their clients and building long-term relationships.

Once you've established their needs, it is up to you to provide a quote, and I urge you to do this in writing, after some consideration. There are some markets in which a set fee is applicable, but I can't think of many that wouldn't be better served by a photographer who answers the question, "So what's it going to cost me?" with a considered, and customized, response based on the client's needs. Taking the time to find out what they want shot and how, where the shooting will happen, how much post-production is needed, and what your technical and support needs are will not only pay off but will better serve your client. I never, ever quote a fee without a conversation to determine the needs of the clients. I then put it in writing and I'm specific about what that price includes, and does not include, and how long that offer is valid.

> "Great images are important. Great images shot by someone people like and enjoy working with are even better."

Once the offer is accepted, I make sure I put it into a written and signed agreement. If it's my contract, I include a date until which the offer is valid. The last thing I want is a bunch of unactivated contracts out there that are holding hostage dates on my calendar for longer than I like. It is at this point that I ask for a deposit. While it's not always possible, I ask for a 50 percent deposit to secure my time, and I am very clear about the penalties for canceling. I know this will be harder for some of you than others, but remember you are selling your time—that's the biggest piece of inventory they are buying from you, and if they cancel two weeks out it's more than likely you won't be able to fill that spot.

When contracts are signed and a deposit is received, I begin asking for a phone call or a face-to-face meeting to discuss the brief in greater detail. It doesn't matter if this is a wedding or a commercial shoot—if you've been hired to shoot something, you should have a clear and specific idea of the client's expectations. You can't meet and exceed expectations you don't know. Don't hound them or overcommunicate, but be sure you fully understand the brief and the context in which you'll be shooting. Discuss the timeline for post-production and delivery of files, prints, albums, or other deliverables.

When the assignment finally comes, be sure you've got your gear and backup gear ready. Extra batteries, extra everything. Making a pre-shoot packing checklist is a great idea. Don't assume you have the gear. Pull it out of the bag. Turn it on and off, check it off the list. Print the creative brief or shot list. Print model releases if needed. Double-check that your second shooter or rental gear is confirmed and ready to go. Then go and shoot the best work you can. But don't flip the diva switch. Remember that future work hinges not only on your images but the entire experience. If you are difficult to work with, offend international field staff, wedding guests, or others with your artiste mentality, you're not likely to get the gig again. I got my first big assignment because the previous photographer made himself so difficult to work with that no one wanted him back. So they called me. Great images are important. Great images

shot by someone people like and enjoy working with are even better. Be flexible, listen carefully, be willing to collaborate, and put your ego into the bag when you take the camera out.

When the work is done and the post-production is finished and the files are delivered, don't close the file and move on. This is the time to work on your follow-up skills and show your clients that you care about them beyond just this one gig. Send them a thank-you gift commensurate with the size of the contract they sent your way. Ask them for feedback and evaluation, and listen carefully to them. Ask them if you could contact them in six months just to check in, and ask them directly if they have friends or colleagues that you could serve. If you've worked well with this client and connected with them, getting a referral should be easy. If you're looking to serve your clients, this is an easy ask, and it will be perceived for what it is.

Your specific niche will determine the exact path you take from beginning to end, but being consistently concerned for your client's needs and paying attention to details from the beginning through the point where final products are delivered will build your client base faster than slick sales efforts and one-client-is-like-another service templates. In the long term, it is client care, excellent product, and overdelivery that will build your business. Being proactive about that, and not allowing it to simply happen by accident, is the best way to get there.

> "It is client care, excellent product, and overdelivery that will build your business."

Your Next Step

You know your market better than anyone else. Or you should. Even if you're just beginning, you've done some market research. You've had a couple clients. Based on their feedback, you know what they love and what they need. Consider sitting down and making a flow chart of the steps you need to make within your niche to serve your clients. Sit down and create a standard contract that you can edit for specific assignments. Make an evaluation form. Have some branded thank-you cards printed. Consider the whole process from beginning to end, and then make a checklist. The more easily you can track the process, the more certain it is that you'll guide your clients through it, and no one will slip through the cracks.

Darwin Wiggett

DarwinWiggett.com

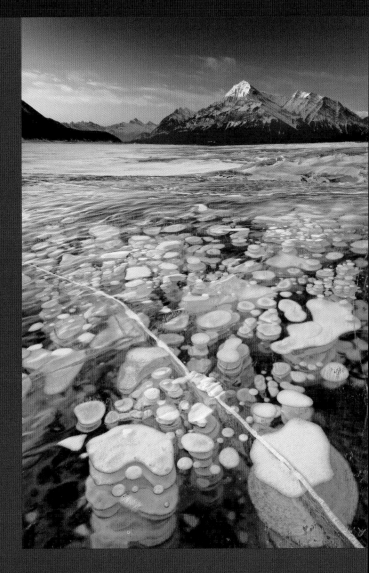

DARWIN WIGGETT, like so many others who find themselves full-time vocational photographers, didn't set out to do so. He got serious about photography when he was 25 and doing postgraduate research in animal behavior in the Department of Zoology at the University of Alberta, purchasing a camera to document his research in Columbian ground squirrels. His frustration that so much research took place in the office and not the field was mounting, and he found himself spending more and more time with his camera, reading Freeman Patterson's *Photography of Natural Things* (Key Porter Books, 1994), and joining Images Alberta Camera Club. Under the guidance of camera club members, and inspired by Patterson's writing, Darwin was soon creating images he was proud of. In 1989, he was accepted into a stock agency, where he worked part-time for 6 years until 1996, when he began working full-time.

As specialties go, Darwin didn't choose what most would consider a lucrative niche. He specializes in landscape and nature photography, but choosing to shoot what he knows and loves has made him a significant full-time income for over a decade. Not surprisingly, his path has been his own, but there are waypoints on his journey that are similar to so

many of us, and like many of us his journey hasn't been easy or his success instant. Early on, Darwin's drive to succeed, and his failure to balance his personal and business life, cost him his first marriage. Balancing our lives as people making a living from our art is not always easy, but as our personal lives are the well from which we draw our inspiration and creativity, it's important to keep them in balanced tension.

Darwin's career began with winning a couple of national photography contests, and those victories gave him more confidence in his work, as well as needed publicity. He's still winning contests, including the prestigious Travel Photographer of the Year award in 1998. Using contests as a promotional tool is no guarantee unless you win them—and then leverage those wins—and Darwin's been carefully leveraging his wins and turning them into work since the beginning.

In 1996, after winning a handful of competitions and having his work published in magazines like *Photo Life*, *Outdoor Photographer*, *Shutterbug*, *National Geographic Traveler*, and *Time*, Darwin was commissioned by a publisher to make a coffee table book of images of Canada. On the strength of a large advance, Darwin spent nine months crossing Canada to make his first book, *Darwin Wiggett Photographs Canada*. Of course, it's unfair to reduce that all to a couple of sentences. Winning a competition, having work accepted by publishers—it all sounds so passive and doesn't give Darwin credit for the hard work behind it all. Images don't enter themselves into competitions or submit themselves to magazines. That takes research—what do the judges want to see in an entry, what's won before, what do publishers want, and which publications would be a match for the images Darwin wants to submit? Contests and publishing credits are all well and good, but they're that iceberg tip—under which is the supporting bulk of hard work.

If you were to thin-slice Darwin's business and the areas from which he draws his income, you'd see he's drawing from several streams, working hard to build multiple markets that play to his strengths and passions. The bulk of his work is sold through stock agencies, and he's got a roster of photo buyers who regularly purchase his work. Darwin's secondary market is other photographers who join him for courses, seminars, and workshops; Darwin's desire to see his clients succeed, learn, and improve has given him a high rate of repeat customers. Darwin also works regularly for magazines; his informal and accessible writing style, combined with dramatic images, have made him a regular contributor to magazines like *Outdoor Photography Canada*, *Popular Photography*, and *Photo Life*. And while magazine work isn't his bread and butter, it adds importantly to the bottom line. Add book royalties, print sales, and assignment work to this mix, and it's not hard to see how the multiple streams all come together to feed a larger body of water.

The challenge for Darwin, in a market saturated with photographers wanting to make a living on beautiful landscapes, is to differentiate himself. He's done so by focusing on honing his unique style and flavor, and creating signature work that stands out for its quality, vision, and uniqueness, all of which allows him to sell his work for more. Darwin also holds back some of his best work from the stock agencies and directly markets those to selective photo buyers with whom he's built long-term relationships.

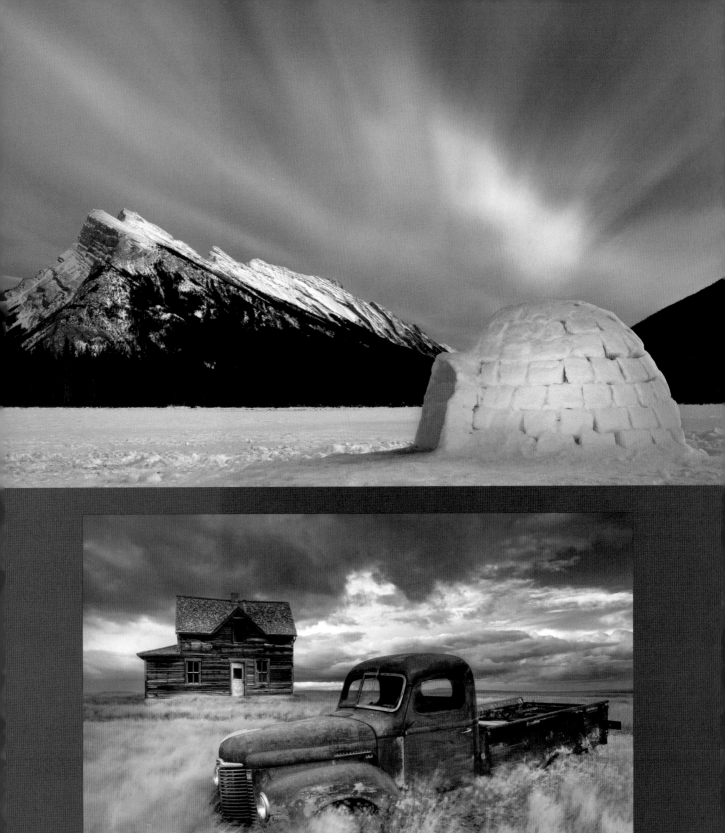

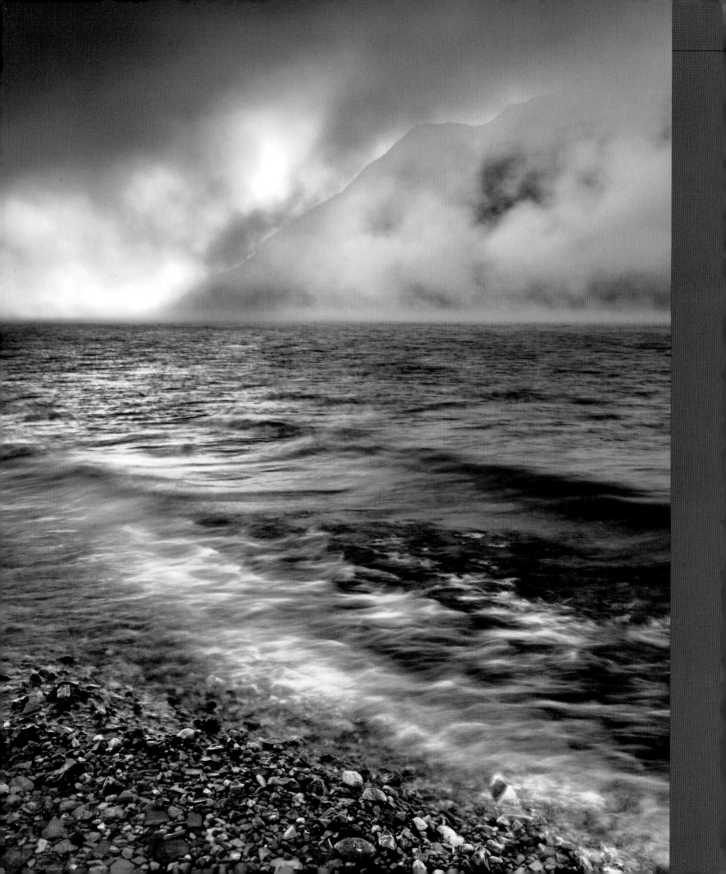

Early on, Darwin knew that he was wearing two hats—one as a photographer and one as a businessman. Photographers who deal with commercial markets and who learn this early on have a greater chance at making a living from their craft. Engaging the world of commerce can't be a hobby or sideline; it has to be a core competency, even if it takes hard work to learn it. I asked Darwin for his best sermon on becoming a vocational photographer, and without hesitation he pointed to honing our marketing skills. "I have seen incredibly talented photographers wither and die simply because they did not have any idea on how to sell their work. And I have seen really mediocre photographers flourish and become 'names,' not because they have great work but simply because they know how to market and they know how to convince people they are the right person or have the right photo for the job. Even if you are just an average photographer you can make it in this industry if you know how to get your stuff seen. The best thing a beginner can do is to master marketing."

The thing about marketing is that markets constantly change, and the technology at our disposal to reach those markets keeps changing, too. Darwin's marketing occurs largely through the internet. With no print book to represent his portfolio, he relies on his tightly focused website to represent his work. His blog plays a significant role in reaching the photographic community—to give back and establish his expertise. Like so many of us, he's learned that the more you give out for free, the more that investment is returned in referrals, contacts, and clients. As his marketing evolves, he's now taking time to re-tool his efforts with more intentional branding, including a new logo, and incorporating those new branding conventions into his website and public face. As we grow and change, it's important to keep our brand current, authentic, and relevant. Photographers without a business focus will let this slide, but thinking that "It's worked in the past, it'll work now" is unproductive for an evolving artist in an evolving market. Once in a while, you need to step back and evaluate the strength of your marketing. Does it still accurately represent your core values and key messages to your market? Is it still presented in the way that your market wants to see it? If your market has not called in a print book in five years, it might be time to scrap that book from your plans the next time you do a refining of your marketing, and spend the couple thousand dollars you saved on a website that offers better functionality to your clients.

For Darwin, this eye for the evolution of the marketplace doesn't apply only to our branding, but to our entire business model: "More and more I believe we should take our products and market and sell them ourselves. The world is our marketplace. Publishing companies, stock agencies, etc. use the old model, and this model is heavily biased against the artist. You know your work better than some corporation, and you believe in it more, and you will market it with your heart. If you want something done right, do it yourself. Don't expect people will come to you; knock on all doors, get your name out there, convince yourself you are good, and then convince others."

All images on pages 81–85 © www.darwinwiggett.com

Sounding Your Barbaric Yawp

MARKETING MAY BE THE LARGEST HURDLE any photographer looking to work vocationally has to overcome. In part it's a mental hurdle, one that looks larger the more you fear it. And in part it's a hurdle that's there merely because it demands an expertise we don't have. Either way, it's scary; the mental hurdles are the hardest to surmount, so let's begin with that.

The moment you decide to combine your craft with the world of commerce, you have decided to put your craft, for better or worse, out for public assessment—and it will be measured by the dollar. If you're like me, your subsequent reaction will fall somewhere between the following two extremes: The first extreme is the revulsion of the artiste. "I'm an artist, not a whore," you say. "If people don't want to buy my work, at the prices I demand, then stuff 'em." The second extreme is the greed of the salesman. His vision and passion are first for the dollar. One makes a lousy businessman, the other a lousy artist. And, in the broadest terms, neither is suited to a life in vocational photography, one that necessarily combines craft and commerce.

There will be times you feel like one more than the other, but you need to find that ground in the middle which exists in a balanced tension between the demands of craft and the demands of the market—that's the fertile ground where you can both serve your vision and make a living.

So at the risk of being overly blunt, if we have an aversion to selling our work, then we need to get over ourselves and find a paradigm that allows us to do what we are passionate about and still feed the family. That paradigm shift is one in which we move from thinking of sales as the repugnant effort to separate people from their money by convincing them to buy something they neither want nor need, and on to something healthier: a paradigm of service.

What Can I Sell You?

This is the question that drives craftsmen and artists in droves from the question of seriously studying marketing. It's the domain of the slick salesperson, and for most people who lean toward the artistic, it's the exact opposite of what they want to be doing and the motives for which they do it. Forget the question entirely. The question is ultimately only self-serving and doesn't assume long-term and mutually beneficial relationships. Its goal is to earn a buck and move on. It's soul-sucking and unprofitable in the long term, as it requires a stream of continually new clients—much more expensive than servicing the clients you already have and building a business around them.

How Can I Serve You?

This question has changed the way I do business. It reflects my ethic and the reason I do this to begin with. It lets the potential client know that what is foremost on my mind is hearing about, and meeting, their needs. I am not after their money; I am after a long-term relationship with them. Yes, some of you just rolled your eyes. So let me elaborate. Sure, I want to get paid. But remember, my first goal is to do my work. I love my craft and I want to use my powers for good. That is what propels me. Earning money makes that possible in the long term, and is the by-product of a job done right. But it is not, and never will be, my first question. My first question is, "How can I serve you?" If I can serve the client, then we discuss the budget it will take to do so. If I can't, then we part ways.

Idealistic? Unabashedly so. Life is too short. But bad business? Not for a minute. In fact, beginning a negotiation and any marketing initiatives with this question, even when unspoken, leads to work that pays better, fosters long-term clients, and is more gratifying. What else is there?

Why did I bring up this paradigm shift? Because shifting my thinking along these lines makes my marketing efforts a true extension of who I am. It allows me to make honest claims about who I am and what I am good at, because claims otherwise will only lead to work I don't enjoy or don't do well, and both of those are dead ends. It allows me to think of marketing merely as a means to finding clients who will give me a chance to meet their needs and form a long-term relationship that we all enjoy and that gives us both what we need. I need work I love, clients I enjoy, and paydays that allow me to keep doing this.

Once you've made the shift, the rest is simply education. To get over the hurdle presented by lack of expertise, take off the hat that says "photographer" and put on the hat that is most appropriate for the efforts needed to get on the roof-tops and sound your barbaric yawp (if this Walt Whitman reference from *Dead Poets Society* makes no sense to you, just move on). Tell the world about what you do, or you won't last long in the marketplace. Read books about marketing. Don't only look for ones that are specifically for photographers, but about actual marketing. There's much of that in the coming pages, but this only scratches the surface. To properly get the word out about your business, you must acknowledge that some things work well and other things do not, that there are

> "Beginning a negotiation and any marketing initiatives with this question, even when unspoken, leads to work that pays better, fosters long-term clients, and is more gratifying."

> "All of this marketing stuff, while important— even crucial— is only second fiddle to relationships and the personal touch."

people out there who know these things as well as you know your craft, and they can teach you how to sell your work without selling your soul along with it. Selling yourself doesn't have to feel like selling out. In fact, the most honest marketing—when the product is great—is the most successful.

So if it helps, get comfortable in playing multiple roles. When you shoot, you are a photographer. When you speak to clients, you are the owner of a company intent on serving its clients. When you negotiate finances, you are an accountant. And when you create your branding and get a website built, you are a marketing executive. After all, what does a photographer know about marketing or finances? Usually less than we'd like, and recognizing the importance of these activities is the first step in getting better at them. Let that marketing department slip and the photographer runs out of work and the accountant starts going all shouty crackers.

This needn't be as big a stretch as it seems. Marketing is about communication, as is photography. But it's a specialization, and the better you get at it, the more successful your efforts will be.

One more thing. There's a lot of marketing stuff in here. Some ideas you will use, some you will not, and others you'll adapt to your own personality and niche. Some of this applies to all markets, some does not. What cuts across almost every market, with the possible exception of stock sales, is that all of this marketing stuff, while important—even crucial—is only second fiddle to relationships and the personal touch. Every photographer I've talked to who is pursuing this field full-time has told me that relationships and the personal touch are not touchy-feely personal tactics they put on their marketing plans like icing on a cake; they are the meat and potatoes of their work. If you want the real goods on marketing as a photographer building a long career, there is no formula—you have to seek, nurture, and cherish authentic relationships in any way possible. Before you get deliriously distracted with the following discussion on logos and branding and social media, keep in mind that the most important skills behind your marketing are your people skills. At the beginning of this book, I set out a caveat that nothing I say here should be understood to be exclusive of having a fantastic product. The caveat for this section is that nothing herein should be read to be exclusive of this one immutable fact: it's all who you know. Every day I believe this more and more.

The Four Pillars

Before you begin to market yourself like a man on fire, there are some founda-
tions you must consider in order to make these efforts a unified group of initia-
tives that helps you reach your goals. While I generally avoid alliterations, think
of the following more as a poetic accident than an intentional thing. These are
the four pillars on which rest all your marketing efforts.

Creativity

As a creative professional, your marketing should be creative. Everything you
do, every piece you send, is a reflection on you. If your marketing is creative, it
speaks very clearly to your own creativity. Don't mistake this for being clever

> ## "It's not about being slick— it's about being professional and consistent."

or creative simply for appearance's sake, but approach your market creatively and in ways that reflect who you are. Most design magazines and some photo magazines like *PDN* do annual self-promotion issues that showcase the best of the year's self-promotional efforts in the industry. A read through one of these can be very inspirational. Look to *Applied Arts* and *Communication Arts* for their annuals as well.

Congruency

If your marketing is the communication of your identity and the benefits you offer to your marketplace, then every initiative needs to be congruent with who you are and the market to whom you are selling yourself. In other words, your website must jive with who you are, and who you say you are to your potential clients. Your logo must be congruent with who you are, as do your choices of fonts, the copy you write, and the images you choose to place in your portfolio and on sales pieces. Every element, every piece, must look as though it came from you, and it must communicate key messages to your intended market. Materials that are incongruent with who you are become misspent marketing dollars that give potential clients mixed messages. This is more than just confusing; it undermines their trust in you.

Consistency

Similar to congruency, which is matching your marketing to your identity, the principle of consistency requires you to match your marketing materials to each other. Every piece and each initiative should look like it came from the same place.

This is a big part of your branding mojo. Volvo is so consistent that I recently saw a TV ad and within the first five seconds identified it as a Volvo ad—simply by the font used. Consistency builds familiarity and confidence. It is a repetition of design conventions like fonts, colors, and styles that makes you more memorable to the market. Large companies have a strict branding guide to make sure this happens. It outlines which logos can be used where, which versions of the logo are unacceptable, which fonts are to be used for headlines, which fonts to be used for body copy, and so on. Deviation dilutes the branding effort and creates confusion.

Additionally, it means that once you have created a visual identity—chosen a font, logo, and so forth—you consistently use it. It should be on your cards, your letterhead, your envelopes, your invoices, and in the signature on your e-mails. Large corporations do this not because they're big and can afford to, but because it communicates consistency and builds confidence in the consumer. And it really costs nothing more. If you're printing envelopes or letterhead anyway, put the logo on it. If you're sending e-mails or electronic invoices, it costs nothing to take the extra few minutes to put your logo in there and bring it all in line with everything else you're doing. It's not about being slick—it's about being professional and consistent.

Commitment

You've got to stick it out. Marketing isn't magic, it doesn't happen overnight. Create a good plan, then stick it out for a year. Repetition and familiarity build confidence and top-of-mind awareness with your potential clients. Switching your logo every two months is a bad idea; it defeats the purpose of having a logo at all. Switching strategies mid-stream is equally damaging. If you start a mailing campaign of six mailings over a year, don't scrap it when the first mailing goes out the door and the phone doesn't start ringing. Clients usually need to see your stuff several times—up to 10 times, depending on what study you read—before you get the call. Come up with a well-thought-out marketing plan, then stick with it and give it a chance. It's easy to get bored with your own work, your own logo, your own website. But you see it a hundred times a day. If the client needs to be exposed to your brand several times before acting on it, it's because that exposure leads to a familiarity—each time you change the plan, the design of the website, or the look of your materials, you revert back to the beginning.

> "Repetition and familiarity build confidence and top-of-mind awareness with your potential clients."

This doesn't mean that you shouldn't scuttle a poor plan or a lousy logo, but the difficulty lies in knowing when to do it. You can't evaluate the strength of a promotional effort after one week, or usually even one month. Make a solid plan, check it with others, and then follow through on it. Evaluating it once it's done gives you information about what went well and what went less well, but you can't evaluate something that you don't run through to completion. Make a great plan, then stick it out.

Marketing is a long-term game. It's measured in weeks, months, or even years.

Branding Isn't (Just) for Cattle

Branding is the buzzword du jour in marketing right now. Used enough, a buzzword comes to encapsulate everything and becomes meaningless, so let's define our terms. Branding is a communications strategy. It's the collective, collaborative presentation of who you are and what you stand for, through tangibles—like a logo, collateral materials, a website, and mailers—and intangibles—like a vision or mission statement, and the way you treat your clients. Not surprisingly, it's like the brand a farmer puts on cattle—it identifies the cattle unmistakably as belonging to the particular farmer. But that's just the beginning.

A good brand is more than just a set of visual conventions. It's a concerted effort to clearly say, "This is who I am." Done right, it resonates with the market you are working to connect with. A good brand builds confidence and honestly represents the company for which it stands. It is built around a story—who you are, what you do, why you do it, and for whom. It's unambiguous and differentiates you from the crowd.

> "No branding effort can begin until you clearly understand your own story and vision for where you are heading."

The reason so many photographers lack a clear brand is that no branding effort can begin until you clearly understand your own story and vision for where you are heading. With so many photographers floundering while trying to serve a dozen markets, it's no wonder the bulk of business cards and websites representing photographers show the name of the photographer, followed by the cleverly nondescriptive word "photographer," and illustrated with clip-art camera drawings. If you don't know who you are trying to reach, or what key benefits you offer to a specific market, it's impossible to communicate without being ambiguous.

The best brands are unmistakable, and that's where you should look to explore the notion of branding as well as the benefits. Apple is brilliant at this. Apple knows exactly to whom they are speaking, and they know what key benefits they offer. Their advertising, like it or not, is clearly speaking to certain people. The brand has engendered consumer loyalty to the point that people identify themselves as "Mac people," and the more enthusiastic take on something nearing religious devotion to the platform, spawning "Mac evangelists." From a marketing perspective, the brand Apple has created—and the visual conventions it uses, from stark white to specific fonts and the unmistakable logo—is impossible to mistake for something else.

It's unrealistic to think photographers can, or even should, mount a branding strategy as comprehensive as the one Apple uses. But the model is solid, and the lesson is clear: without the principles represented by branding, you're just another generic photographer to your market.

What's in a Name?

When it comes to putting a name to yourself, your company, or your studio, there are advantages to using your own name, the first of which is that it's your name and it's unambiguous. I decided to market myself in two ways: the first as my company, Pixelated Image Communications, and the second as myself, David duChemin. I did this because I wanted my company to be able to grow beyond me, and it felt right for me. What matters isn't really the name; think about companies like IBM—most people no longer know what the letters IBM even stand for. What matters is how you brand and sell that name; doing it well creates positive associations, and the name comes to mean something. Most photographers use their own name, and I think that's probably a good idea—but not everyone's got a name that's easy to spell or pronounce—what makes it work is the reputation the photographer builds into that name. I chose Pixelated Image for a specific but personal reason. My primary work centers around my humanitarian efforts, and comes from the belief that we are all made in God's image, that we have worth and dignity, and even though that image may be worn and threadbare—pixelated—it remains. So I built on that. Is it the perfect name? No, far from it. But it's mine, and what matters is that my work and my professionalism build equity into the name. It's unmistakable and memorable, and the rest of it is up to me. Don't sweat about the name; sweat about making your name one that people respect and trust.

Your Next Step

Take some time to evaluate your brand. Is it distinct and unambiguous? Does it clearly communicate what you are about? Is it represented by strong, clear, and unique visual anchors such as a logo, a color, and/or a font? Does your potential market connect with it in some way? Don't discount this. People buy cars

like BMW or Volkswagen because they identify themselves with the brand, not because those cars are necessarily the best, and certainly not because those cars are the best value. The psychology runs deep here, and being aware of it so you can more clearly communicate is worth the time to wrestle with all this.

It's possible that you need to back up even further. Before you can begin branding as a marketing effort, understand your core values, your "distinctives"—those things that make you uniquely you as a photographer and as a business. Go back to the beginning and discover who you are to your market, and what you offer that is uniquely you. Then build a brand on top of that.

Perception Is Reality

Once you've started your thinking about branding, it's time to think in a parallel fashion about the notion of positioning. Similar to branding, positioning is intentionally placing yourself in the minds of your market—and in the place you want to occupy within that market. Your position is how your market sees you; positioning is what you do to help them see you that way. I know—I'm in danger of losing this thread to the fog of psycho-babble, but stick with me.

Positioning is generally seen as an intentional effort to occupy a specific place in the thinking of the marketplace, and I bring it up for this reason: everything you say about yourself—and everything others say about you—directly positions you in the minds of the market. You can do it intentionally or you can let it happen to you, but you will find a place in their minds. If that place isn't accurate or, worse, is the opposite of where you want to be, then you're in trouble because perception is reality.

It doesn't matter if you are the greatest photographer around; if you are perceived by your market to be a cut-rate hack who will take any gig around, then you are—to them—a cut-rate hack. It might not be right or fair, but the thinking of your market matters immensely.

The biggest thing you can do to affect your position in the minds of your market is to work with them. Firsthand experience and relationships with you will trump other impressions. But if you never get the chance to make those impressions because you've been sloppy with your positioning, you'll have to rely on the

> "Everything you say about yourself—and everything others say about you—directly positions you in the minds of the market."

reality created by that perception. Assuming you aren't a cut-rate hack, and are actually a very capable photographer, how else might this hurt you? Suppose what you most want is to be a high-end destination wedding photographer, but for now you're cutting your teeth on local gigs, the odd headshot, and some pet portraits. You begin putting those images on your website, and some people refer you to other people wanting pet portraits, while others see your work for the budget wedding. It doesn't take long before the mental space you occupy in the market is that of a generalist and a budget wedding photographer who does pet portraits. Before you know it, you're a long, long way from being perceived as the kind of photographer you want to be perceived as.

If you want the market to see you in a certain way, you must give them the evidence to convince them of that reality or they will form their own with what they see. I know my markets, and I do what I can to stay on message with them. The first is the international NGO community. My logo, my materials, my copy, and my website all take this primary market into consideration. Everything I put out tells this market who I am, what I do, how I do it, and why. I won't get asked to shoot the Indy 500 anytime soon because I've made an intentional effort to position myself through my branding and my other marketing initiatives, which tell my market how to think about me. Now, before you start thinking how arrogant this sounds, it's qualified by my work, my client list, and referrals from past clients. I'm not telling them anything that's inflated or untrue; this isn't an effort to deceive or manipulate, but simply an effort to provide as much clarity as possible.

My second market is within the photographic community itself—the one to which I sell my books and my teaching—and it's all wrapped up in my mantra: Gear Is Good, Vision Is Better. Why? I talk about vision and its primacy over the technology. That's my passion and my niche. My blog and my writing is, I hope, very unambiguous. No one is going to mistake me for a Photoshop Guy any-time soon. Scott Kelby and his gang are as unambiguous in what they do and how they do it; that's what makes them successful. They're very good at one thing—education—and they position themselves accordingly. What about other photographers? What places do Anne Geddes, Ansel Adams, Annie Leibovitz, Galen Rowell, Steve McCurry, or Joe McNally occupy in your mind? More than likely, it's a well-defined place.

Your Next Step

Where do you want to be in the minds of your market? An expert? A specialist? A budget photographer? A luxury photographer? Is this consistent with who you actually are and can be to the market? Take some time to consider how you can create, or hone, your marketing messages to enforce this positioning. Does your brand support it visually?

Though it's a bit dated by now, for further study you might consider reading *Positioning: The Battle for Your Mind* (McGraw-Hill, 2000) by Al Ries and Jack Trout.

Master Photographer?

At least once a week I stumble upon the website of a "Master Photographer."
I chuckle every time. I know why people do it. It's advertising, they think. You're
meant to boast big and boast loud. But markets are savvier than they once
were. They've become keenly aware that they're being marketed to, so unsub-
stantiated claims to be the best, the foremost, the favorite, or—God forbid—a
master, are not only eyed with disbelief but with suspicion. If you have to say
you're a master, you probably aren't. If you truly are a master, then your work
should speak for itself. Allow clients to speak on your behalf. But the moment
you claim to be something or someone totally without equal, you jeopardize the
one asset that you must never jeopardize as a public advocate of yourself and
your work: trust.

> "Trust is gained
> slowly and lost
> in the blink of
> an eye."

In the marketplace, particularly one that centers on a service and not a tangible
product, trust is everything. Without trust, every initiative to communicate your
core values and benefits to your chosen market will be nothing more than an
expensive, fruitless effort. Creating a logo, writing copy, designing and mailing
promo pieces, developing a website—it's all done to collaboratively build your
case before your prospective clients, and the moment you do something to
breach that trust, the case collapses. In markets saturated with photographers
all putting forth similar claims, you can't afford to lose trust by starting out of the
gate with a preposterous claim.

Trust is gained slowly and lost in the blink of an eye. There's a reason they say
you don't have a second chance at a first impression. Okay, there are two rea-
sons. The first is because it's just so clever. The second is that your first impres-
sion is the one that immediately establishes trust or distrust. Complete trust is
built over time and experience, but we make initial decisions in an instant. The
look of your logo, the design of your website, whether your copy is competently
written and free of spelling mistakes. Those all contribute to whether I do or do
not trust you. Who your clients are and where you've worked—those, too. And I
haven't even looked at your work yet.

So clearly this is a bigger issue than whether you do or don't make preposter-
ous claims about your competence. This is also the biggest argument for a
good logo and great materials. "But," you say, "I want my work to speak for

itself." Sure. Don't we all? And it will. But if the prospective client loses trust in you even before looking at your images, then either you've lost the chance of them seeing your work or you've got to reestablish their trust in you. Sure, you shoot nice work but if, from the moment you make your first impression, you don't build their trust in you as a competent professional who understands your craft and their needs—and how to connect the two—they'll move on to another photographer in the time it takes to close a browser window. Click.

Master photographer? Perhaps, but unless your work truly backs this up at the highest level (that's what a master is) you could be damaging your reputation more than building it. Stick to claims that you can prove—that appeal to their needs and not your ego—and you'll build a client base you can be proud of. The same goes for any claim to being the best, the favorite, or the foremost.

> "If you have to say you're a master, you probably aren't."

Make Them Love You

There is a great line in Ridley Scott's movie *Gladiator*. Maximus's mentor, Proximo, turns to him and says, "Make them love you." That was the sum of his wisdom. Nothing about separating opponents from their limbs? No sagacious insights into strategies? If you want to last in the arena, he was saying, make the audience love you. It's the same in the marketplace, which can feel as adversarial as the arena. If you want to last in the marketplace, make them love you. But maybe leave off with the gore and gratuitous slaying.

With a little savvy marketing, almost anyone can get the gig once. A shiny display ad or some mailers with lofty promises and you're in, baby! But getting the gig again, and gaining repeat clients, takes more than savvy marketing. Furthermore, it takes more money to get a new client than it does to get repeat work with existing clients. The math is easy—putting some effort into securing repeat clients is important.

I can't overemphasize the relational element in your marketing. Plenty of photographers out there have a rep for being divas, and some of them get hired despite that—because they're brilliant. But be brilliant *and* likable and you'll be a step ahead of the diva. Your clients are normal people and, like all normal people, they hire people with whom they identify, trust, and enjoy working with.

Remember, the core assumption in this book is that first and foremost you are offering an outstanding product. Other than that, how can you make them love you? Just give them a reason.

Always overdeliver. Find out what your client expects, then exceed those expectations. Go beyond the call of duty and just see if your clients don't keep coming back to you. Here are some ways you can do that:

- Be the best craftsman you can be without cutting corners. Give them a better product than they expect. This means always working on your craft and sharpening your skills.

- Serve them relentlessly. Make their needs your absolute priority. It's not about you.

- Return calls and e-mail immediately. Ask questions that make them aware that their needs are your first priority.

- Provide great catering—even if that's just bringing a cooler of cold bottled water and some fruit to a location portrait shoot.

- Provide free wireless in your studio so producers can stay plugged in to their world.

Whatever perks you can think of—make them happen. How fast can you get proofs to your client? Do it. In the first few weddings I shot, back in the film days, I had the ceremony proofs developed and in a small album for the couple to see during the reception—they absolutely loved it and were astonished I would do that for them.

Overdelivering also means sucking it up if you fail to meet their expectations. We all have bad days. We all make mistakes and have sessions where we can't seem to focus straight, let alone compose an inspiring image. Be honest with clients, and if your work is substandard, apologize and ask for a chance to reshoot it or make amends. I'm constantly amazed by corporations that blow it and mask their mistakes in lawyers, press conferences full of double-speak, and smoke screens. Just apologize and make it right.

> "Go beyond the call of duty and just see if your clients don't keep coming back to you."

Keep Going

If it takes more time, energy, and money to acquire a client than it does to keep a client—and it does—then it makes sense to put intentional effort into showing some love to your existing and past clients. Your contract may be over, but your work is not. Following up with clients after you've overdelivered on the project is the best way to keep them in the fold. Here are some ideas.

Send thank-you cards after the shoot, tell your clients how much you enjoyed working with them, and ask them if there is anything else you can do to serve them. Asking them for feedback and honest evaluation at this point will not only help you see your blind spots but will communicate to your clients that what you care about is overdelivering, that your ability to serve them begins with your desire to listen to them.

Keep a client list and send personalized holiday cards, as well as occasional updates or gift certificates. Kevin Clark does a customized Christmas card every year that features his kids (all of them gorgeous), and they showcase the creative photography and post-production work he and his team are capable of. They also remind clients that Kevin is out there, and it builds on the growing relationship he has with them.

Send a client a print, either from a shoot you've done together or perhaps something that client has commented on while visiting your website, viewing your portfolio, or sitting in your studio. A personal, "just because" gift is a strong way of maintaining relationships with clients.

Have an open house once a year and wine and dine your clients from the past year or two. Do whatever it takes to stay in touch. I know some of these suggestions are too expensive for the little guy—so scale it down. It doesn't take much to let your clients know that you appreciate them and would love to work with them in the future. Can you do this with all clients? Probably not. Some follow-up will happen with all clients. Other initiatives will be for the ones you most want to win over with more work, or those with whom you just genuinely connect. However it makes the most sense to you, stay in touch with your client base. If you spend eight hours on a mailing list to woo new clients, then you'd be well advised to put in a few hours lovin' on the clients already on board. They already like you, and getting repeat work with them absorbs fewer resources and generates more word-of-mouth than finding new clients.

> "Following up with clients after you've overdelivered on the project is the best way to keep them in the fold."

More Conversations, More Opportunities

The best opportunities in my life have come as the result of a conversation. That conversation might have been initiated on the internet—through a blog or Twitter or some other social networking platform—but it's a conversation all the same. A point of contact. They have a way of sneaking up on you. A random contact made through a friend of a friend becomes someone you connect with, you have lunch or a conversation over Skype, and suddenly you're discussing a venture together that takes full advantage of your overlapping market and complementary skill sets. The fact that these opportunities can't be predicted means we should be open to as many conversations as possible.

If most opportunities begin with conversations and connections, the best path to those opportunities is to actively pursue more conversations with more people. Take your prospective client to coffee and talk with her. Have a photographer you respect and want to learn from? Take him out to lunch and talk. Part of my monthly budget includes a beer and coffee fund. There is almost no one I won't treat to a coffee or a pint if they're willing to have a conversation with me. I've made friends, found collaborators, sealed mentoring relationships, and opened the doors to book deals, lectures, workshops, and assignment work by having a simple conversation.

I'm not suggesting you do this in a mercenary way; that's exploitive and you're likely to find this approach backfires. But being genuinely open to meeting new people, being proactive in doing so, and happily picking up the tab if they'll let you—it'll open more doors, and it'll open opportunities to work with people you enjoy and click with. I encourage you to connect with someone you've been wanting to connect with, even if that's another photographer—tell them honestly you want to pick their brains or introduce them to your work and that you'd like to meet them, take them to coffee, or share a meal. I did this recently with a local photographer; we had a pint, talked shop, and got to know each other with no hidden agendas or ulterior motives. By the end, we were hatching plans for some new opportunities that will both be a lot of fun and put some bread on the table. Not to belabor the point, but this is how the rest of the world works, too. My wife and I met online, talked on the phone, then met in person. Then we got married. One conversation at a time.

Your Next Step

I know this doesn't sound like cutting-edge business acumen, but I'm going to go on record and suggest that if you want more opportunities you need to have more conversations. Put it on your marketing calendar—make the time for two new conversations a week—and see where it leads. Make a list of everyone you deal with, or want to deal with, in your work, and find a way to connect with them. When you clear away all the smoke and mirrors, at the most basic level it comes down to two people—a photographer and a client, both people looking for something. The more conversations you have, the greater the chance of discovering, and communicating, how you can fill the needs of the other. That's all this whole marketing thing is—finding the right people and communicating with them. Once it's in their court, there's nothing to do but hope it's a match and remind them once in a while that you're there to serve them when the time is right.

One of my best jobs came through someone I met in Kathmandu. She was a colleague of a friend who knew we'd be in the same place at the same time. We met, had chai, had a wonderful conversation. And then she returned to the orphanage where she was volunteering and I returned to my work. A couple of months later I had a call from someone to whom this woman had referred me, and that began an excellent business relationship. It's one thing to trust referrals to come from clients, but we sometimes forget how ready friends, fans, and new acquaintances are to be our advocates. These referrals and connections happen in the same way life does—randomly and out of our control. But this should encourage us to be more open to conversations, no matter how random. It should also encourage us to make fans and cheerleaders of everyone we know. People who like you and who are inspired by your work and your passion will refer you to others for the pure joy of being part of that.

Grace Chon

ShinePetPhotos.com

GRACE CHON is a privately commissioned pet photographer based in Los Angeles. The owner of Shine Pet Photos, Grace has been making her living from photography for a very short time. I include her here because she is, of all the photographers featured in this book, the most recent to having successfully made that transition. She also comes from a background in advertising and, as such, brings an expertise to her business that few of us have.

Grace never intended to become a full-time photographer. She was well into a successful and award-winning career as an art director at an ad agency when the pressure and stress began to take the fun out of it. To get some soul food, Grace began taking photographs of homeless dogs for a local rescue group, and word of mouth began to spread. Four months later she launched a part-time business as a weekend hobby. For nine months Grace worked hard to build her business, establish her brand, and get the word out. As her business grew, she found herself booked two months out, shooting full-time, and still working full-time for the agency. Something had to give, and it was the job at the agency. Remarkably, Grace's transition took less than two years from being a hobbyist to working full-time as a photographer. Not everyone's journey will be so accelerated, but it powerfully illustrates the Back Door approach.

Within a year of setting out to shoot full-time, Grace was being hired to shoot cover images for national dog magazines like *The Bark* and creating commissioned portraits for people like Perez Hilton.

So what was the turning point for Grace? "I think quitting my day job after nine months of working both in advertising and as a pet photographer was a *huge* turning point for me. Up until then, I hadn't even started advertising my business because I was already booked two months in advance through client referrals and word of mouth. Once I quit my advertising job, I had so much more time to invest into my business and pursue opportunities that I previously had to turn

away because I just didn't have the time to do it. Quitting my advertising job was a huge risk, as I quit in the midst of a complete economic meltdown and right after I had launched a well-received ad campaign. I got a lot of raised eyebrows when I announced I was quitting my job to pursue a career in pet photography. But as I look back on all my accomplishments over the last seven months—doing things that would have been so challenging to do with a day job—I have zero regrets."

Like all of us, Grace's success is a unique mix of who she is and the blend of skill sets she brings to the table. It begins with excellent work. Coming from a career at an L.A. ad agency has the strong advantage of training her eye to not only what is excellent, but to what aesthetics are currently in demand. When Grace started, there was no point at which she was not shooting for, and marketing to, a specific niche in the market. Having a powerful sense of who you are and what you shoot—and don't shoot—has a defining effect that trickles into every other aspect of your business. In Grace's case, it informed who she would shoot for, what she would name her business, and how she would present that to the market through her branding. Knowing who she is and who her market is make it easier to know how and why they come to her. "Many of my clients come from very creative backgrounds and have a very keen design aesthetic, and one of the most consistent things I hear from them is that they really like how my pet photography looks different—a little more modern and more artistic than what you might expect from pet photography. My goal is to take photos that are more than mere snapshots that happen to look better because I have a fancier camera than my clients

do. I approach my photography with a discerning art director's eye and strive to create photos that are well designed, modern, and artistic. I say that I approach my pet photos from a 'commercial point of view'—meaning photos have to be 100 percent *perfect* before I show them to clients—the composition,

expression on the pet, and the technical aspects of the photograph must all be impeccable."

It's tempting for most of us to jump straight to making a logo, building a website, and trying to be clever without marketing, but the fact that Grace was fully booked and taking bookings two months out all from word-of-mouth referrals should be an encouragement to those of us who did not come at this field from a career in advertising. Still, looking at the way she markets herself, there are no secret techniques here.

"Believe it or not, I do almost all my marketing through the internet! I ask all my clients how they heard about me, and more often than not they say through the internet. Who doesn't turn to the internet when they're in search of a new service to check out these days? I'm a huge proponent of social media and interacting with clients—so I consider my blog, Facebook fan page, and Twitter pages all essential tools in my marketing efforts. They're free and absolutely crucial to my business. We live in the digital age, and with the incredible rise of social networking, consumers have come to expect a dialogue with brands. It's not a one-way conversation anymore, with brands disseminating their message and that's that. I use social networking tools to communicate with other photographers, others in the pet industry, and, most importantly, with people who are interested in my photography. It's a great way to inject your unique personality into your brand—what a way to help stand out from the clutter of competitors! Social networking is free, and it's easy. If you're not doing it, you're missing out on a huge opportunity for your business."

Her marketing efforts are tightly choreographed, and they revolve around solid branding, a distinct logo, and materials and a website that are consistent with her brand and her photographs. "My target demographic is extremely design savvy—so I have to ensure that every piece of communication I put forth is very well branded and designed in order to convey that my photography style also matches their design aesthetics. I stay away from the cutesy look that might be expected from the pet industry, and have created a look that's modern, simple, and sophisticated. Defining my target audience right at the beginning of my business was crucial—every move I make is calculated so that I'm communicating directly to them."

All images on pages 107–111 © Grace Chon / Shine Pet Photos

Word of Mouth

We've all heard it said that the recommendations of others via word of mouth is the best form of advertising. Why it is, then, that making word of mouth an intentional part of our plans is so seldom done, I can't imagine. It's generally left to chance or serendipity, as though we ourselves have no way of influencing whether or not our clients tell others about us. Not so. Creating a profoundly positive experience for our clients and making their lives easier in the product we deliver—and how we deliver it—is a no-brainer. So should translating the resulting client enthusiasm into more leads and more work. The ideas here flow immediately and naturally from the previous discussion about making your market love you. If you're doing your job right and living beyond the hype of your own PR, then you already know what it means to wow the client so much that they talk about you long after the session is over and the contract is done.

Make it Easy

The easier it is for clients to recommend you to friends and colleagues, the better. You're already planning on thanking your client in a fashion relative to your gratitude for having worked with you, right? If they've given you $10,000 worth of business, a nice bottle of wine is a small price to pay to express your gratitude. Include a thank-you card and a couple of business cards and ask them if they'd pass your name along if an opportunity arises to serve their friends or colleagues. If you give them the materials, they're much more likely to speak highly of you and pass out your cards.

Make it Beneficial to Them

They already have a reason to recommend you, but they might need a reminder once in a while—a little extra push to get out there and proactively promote you. If you get a referral, send them a gift certificate and a thank-you card. Or movie passes, or a framed print you know will look great in their office and generate conversations. Or a nice coffee table book. Don't be slick, and don't make it merely a marketing effort. Your gratitude and kindness, and the offer to serve their friends, is more powerful than a slick coupon or a kickback for making referrals.

> "It's generally left to chance or serendipity, as though we ourselves have no way of influencing whether or not our clients tell others about us. Not so."

The idea is to transform a client who might otherwise recommend you passively into a client who will be a little more intentional about it. There are certain markets where you could offer an incentive/referral plan, but played wrong this can come off sounding desperate and opportunistic. However you do it, be classy. A referral might give existing clients a discount on their next shoot. These kinds of incentives work best when the client is paying from their own coffers. When they're spending company money, they care less about the discount; it's classier to send them something that they can use personally. Be creative, and be sure to go above and beyond. After all, how much does it cost to acquire one new client? Much more than treating your current clients like gold.

Make it Last

Ask clients who have had a particularly good experience with you to put their experience in writing. It's one thing to write glowing copy on your website, but it's another thing to use someone else's words. Getting it in writing extends the shelf life and reach of word-of-mouth marketing.

Word-of-mouth marketing is based on a simple facet of human nature—we trust our friends before we trust a stranger. The claims a client makes about you carry more weight than any claims you can make about yourself—for good or for bad.

So wow them. Knock their socks off. Give them way, way more than they expected. And then make it easy for them to spread the good news, make it beneficial, and make it last.

He Said, She Said

In an industry so singularly about image, it stands to reason that your photographs should speak for themselves. If only this were so. I imagine if you were selling fine art prints as your sole means of income, this would be the case, but I can't for the life of me think of a market where that's all that matters. A picture might speak a thousand words, but there are thousands more it can't say.

Assume for a moment that you are a wedding photographer. You show your client a dozen images. What do those 12 great photographs say? They say that you are good enough to take 12 great photographs. They do not say how many images a client might expect from the wedding, or how many moments you

> "Client testimonials are worth more than those proverbial thousand-word images."

missed because you were fussing with a flash or just unprepared. They don't say whether you showed up on time, or stuck around a few minutes later to accommodate the bride and groom's late departure that they wanted captured. In fact, when you think about it, those 12 images say nothing more than you got lucky 12 times. You might be an extraordinarily consistent photographer whose work is creative and compelling; you might show up with a second shooter and backup gear; you might arrive early and be the paragon of professionalism. You might not. You might show up late, leave early, drink too freely from the open bar, and flirt with the bride for all I know. That's not the point. The point is that 12 images don't bring the client closer to knowing the truth.

Client testimonials are worth more than those proverbial thousand-word images. They speak to the realities that an image cannot. They cut through your own hype, which, true or not, is suspect because it comes from you. By all means, show your 12 images, but include a few great client testimonials that give your prospects the confidence to book you because you're trusted by others. Let others do the selling for you. This is word of mouth captured in a bottle. While it's true you'll be showing these personal quotes to people who have no idea who the testimonial came from—unless they're celebrities—it's also true that a bride will trust another bride more than she'll trust an unknown photographer and risk the day she's dreamed of all her life.

Collect your testimonials. Pull them from thank-you cards and the comments on evaluation or feedback forms you give to clients. Or try the sneaky, old-fashioned way and ask for them. Taking a moment to thank a client for the session or the contract is a great way to keep the relationship moving; so is asking them for feedback. Don't go fishing for compliments, but if they rave about you show genuine gratitude for that and ask them if they'd put their opinions into writing to make it easier for future clients to make an informed decision. If necessary, prompt them—let them know a testimonial about your professionalism or value or some other aspect of your work would be helpful.

If you offer key benefits or a unique sales proposition you use in your other marketing efforts, then getting and using quotes that reinforce those and keep your messaging simple, consistent, and honest is a great idea. You don't really need them to tell future clients that they loved their photographs and that your images are the best. You need them to speak to the things your images can't say. I always chuckle when I am looking at websites that feature glowing words

about the photographer's image. Clients don't need to be told how to think about your images; in fact, some of them will resent it. They want to be told what your images alone can't say.

"Selling out can be done with or without a logo."

You Need a Logo

Not every photographer has a logo. It's conceivable that they don't all need one, not in the traditional sense of the concept, anyway. But unless you're Annie Leibovitz—and trading solely on the strength of your fame and undeniable talent—you aren't merely a photographer; you're a photography supplier to your chosen market. So, for a moment, forget you're a photographer. You are an entrepreneur looking to establish trust and recognition in your chosen market.

Why You Need a Logo

There's a reason every corporation and successful company has one. Can you think of a company without a logo? No? Neither can I. A logo is a visual representation of who you are. It's a type treatment, a symbol, or a combination of the two that says, in visual language not unlike photography, "This is who I am." It says things about you in one glance that you might not have a chance to communicate otherwise. It is both your first impression and the hook that keeps you memorable to others until—and after—they have a chance to meet you and see your work. A good logo establishes confidence, even an affinity, between the consumer and the supplier. The combined psychological power of the logo and a good brand strategy can bond consumers to a brand for life, making the consumer overlook the most heinous of commercial sins. A rabid fan of Apple will not be put off by one bad computer. Why? In part because they identify with the brand and its visual incarnation, the logo.

A logo doesn't need to be fancy, but with few exceptions I can think of, if you're operating in a commercial environment without the power of celebrity, your company needs a great logo. I can hear the die-hard artists moaning now. Isn't this just selling out? No, it isn't. Selling out can be done with or without a logo. Selling out is an issue of artistic integrity, and you can do that long before or long after you decide to combine your craft with commerce. If you want to succeed in the commercial arena, and play by the conventions of this arena, you should have a logo. There are exceptions to every rule, but kicking at the

conventions might make you a visibly principled person with no clients. I can refer you to a wonderful bankruptcy attorney if you like.

Your logo should simply and intentionally represent who you are. If you hate your logo, you need another one. This has to be a visual representation of you. Remember the four Cs: Consistency, Commitment, Creativity, and Congruency. Your logo needs to be congruent with you and your work. You should be able to put it on every piece of marketing collateral and be proud of it. If you aren't, it means you need a better designer, someone who takes the time to understand you, your work, and your market.

Your Logo: What Are You Trying to Say?

Assuming for a moment that you've bought into the notion that you need a logo, where do you begin? Like every effort connected to your marketing, it begins with you, your market, and that potentially confusing part in the middle where the two meet and circle each other. The logo is a piece of communication; as such, it can be as simple or as nuanced as you want. It can be merely a consistent choice of fonts or an icon or symbol of some kind, or a combination of the two. What's important is that you understand that it's going to say something about you, and that this is not the time for a one-hour effort in Adobe Illustrator. This will be the mark that defines the visual conventions of your brand. If you do it right, it will be the one common denominator on all your materials, and it will give your market a visual handle by which they remember you.

Like a photograph, every element within a logo contributes to its mood and feel. Every element says something. Look at the type treatments here. I've used fictitious photographer Justin Focus, and by changing up nothing but the fonts used, the logo says something different about the photographer it represents. Don't get distracted by whether or not you like the logos; that's not the point. What does each of these logos say about the photographer and the market he intends to serve?

One of these photographers is an equestrian photographer in Montana; one specializes in children's portraits in a small town. One of them is a commercial photographer working with high-end clients in Oregon. The other is a wedding photographer in Toronto. And one of them, well, he's just trying to be edgy or something. In each of these markets, there are visual clues. And while I'm not

> "Like a photograph, every element within a logo contributes to its mood and feel. Every element says something."

suggesting you aim for clichés, which these treatments have in abundance, I am a strong advocate for logo design that's unambiguous—or at the very least is careful not to communicate the wrong things.

The two additional logos here represent the same photographer. One reflects his professionalism, the other just the opposite. The photographer who chooses the first will draw certain clients the other will not. He will instill greater confidence in his clients and command higher fees. The second logo communicates a jarring lack of sophistication—it's missing even an acknowledgement that design and visual language matter. Not every client you work with will be visually literate, but by virtue of being exposed to hundreds, if not thousands, of logos every day, they'll have enough familiarity to be affected by a poorly designed logo.

If the thought of shelling out $500 for a logo (and that's a good deal) makes you curl up into a ball, remember this is the foundation of your branding efforts. It's the one thing everything you produce—from a website to a business card—will share. It is the reason corporations spend ludicrous amounts of money on a good logo, and even more defending it. Why? Because a good logo is memorable, and it represents the brand without words. Is it the be-all and end-all? No, it's not. But it can be the first thing people see, and therefore the first thing to influence the way they think about you. Are you professional? Can I trust you to deliver a high-quality product? The first hints I might get of that come from your logo. Now is not the time to stick to the artsy yearning to be judged only by your work. There are plenty of struggling photographers with excellent work.

Your Next Step

Aside from designing your own logo (which I urge you not to do unless you're a competent designer), don't rush out to hire a designer. The next step is to sit down and think about what you want your logo to communicate. Don't get carried away; a good logo doesn't communicate too much. Look at 10 of the most recognizable brands out there—pick any 10. Do these logos tell you much about the product or service? Probably not. But they're memorable and communicate something about the brand, in part because of the association we've built over the years. The BMW logo is excellent, and so are their cars, so that logo has come to represent the quality of those cars. Had BMW been making inexpensive junk for the last 30 years, the logo would still be good but its associations for us would be very different. So don't task your designer with the impossible. You need to like it, it has to say something about you—even if that's merely the suggestion of your style and professionalism—and it must be memorable.

Spend an hour with a couple of major magazines and you'll find hundreds of logos. What do you like about them? What do you not like? Which fonts are you drawn to? Which ones do you not like? What about colors? Your preferences are likely to be good clues as you go into this process. After all, they're the same preferences that are at play in the background when you are making photographs, and if you take this into consideration you're more likely to get an image that you not only like but one that is congruent with you and your photographic style.

My Logo

My logo has had a couple incarnations, and apart from one failed experiment for which I quickly repented, it has remained consistent for a couple of years now. But it's been an evolution. The unifying commonality in every slight change has been the emblem or icon that I use. The woman-and-child icon is a silhouette created from an image I shot on my first assignment. I had stopped at a gas station in Haiti and I shot one frame of a mother and her daughter. The light was terrible, and the framing wasn't so hot. But what drew my eye was their forms, and I've used their outline ever since. It speaks to the market I serve and implies that I work not only with the poor, but that my work happens in the developing

world—which, for the most part, it does. The font is Gill Sans. Here's the style sheet I created to keep me consistent. I now use only these fonts and these colors, and having it all on a document prevents me from getting overly creative with it.

Hey, Cool Card!

The ways in which you get the word out about yourself will vary from one photographer to another and from one market to another. Some photographers serve markets where printed collateral materials like business cards, postcards, or other mailers are unnecessary, but at some point most of us will have a reason to move our marketing from just a website to something a little more tangible.

My primary collateral is a business card and quarterly postcard mailers; whatever suits you best, consider the following.

Impact and Information

Part of the balance you need to consider in creating any piece of marketing—whether that's a logo or a mailer, a website or a business card—is the ratio of impact to information. We're talking here about the content you choose to place in a piece and where you place the elements. Each piece needs to have a specific purpose, and that purpose will not only balance impact and information, but it will also put each in its appropriate place.

In general you will want to start with high impact/ low information and move through the piece until the ratio is reversed. Practically speaking, this means using a benefit-oriented headline or a great photograph to create impact, and pulling the reader into the piece with increasing amounts of relevant information. It makes no sense to put your phone number (high info, low impact) before the elements that will make them care about the phone number in the first place. Give them a reason to call you, then give them the number.

Make Them Rock

When you hand someone your business card, the first thing they say should not be, "Thank you." It should be, "Wow, great card!" or "Hey, this is cool." There should be impact. Business cards tradition- ally do one thing: give information. If you leave it at that, you're missing a chance to leave an impact. Have them professionally designed, keep them focused, and don't cheap out on the card stock

or the printing. Put your best foot forward. Your images should create an impression, right? Why would you settle for a card that doesn't create some kind of impact? A boring card implies a boring photographer.

Furthermore, this is a chance to show your work. I'll never be sure why some photographers have a photograph of themselves on their business card. You know the shot—the one with the photographer posing with his camera, his longest lens, and his best contemplative pose. I'll also always wonder why photographers would choose to give out a card that doesn't show their work. You might have a reason, and if you do, that's great. For most of us, though, a card that doesn't show our work is a missed opportunity. When I produced my latest cards, I couldn't decide on which image I wanted, so I created three cards that I could give out all at once—they get three cards and three times the impact, and there's a chance they'll pass one of them to someone else.

Make Them Targeted

Remember all that stuff about figuring out who you are, who your market is, and how to bridge the two? This is part of it. Printed collateral materials are a chance to show your work and communicate key benefits. The more targeted these pieces are, the more able you will be to craft specific communications to that market. Choose a great picture that is relevant to the market you are dealing with. Craft benefit-oriented copy that shows you understand their needs and have the ability to meet those needs. Make them care. Write clean, focused, tightly edited copy.

This postcard series I created recently is targeted to my primary market—and the one I care most deeply about. I used some of my favorite images, photographs that reflect the benefits I bring to my market. I also used a benefit-oriented statement, my logo, and a back filled with relevant, tightly written copy asking them to look at my website and consider me for assignment work. The back copy was written in a narrative style, a more personal look at one of my assignments. The more connected the client feels to you, the more they'll want to keep reading your pieces as they come in. And assuming you have the goods and they have the need, the more likely they are to hire you when the time is right. Here's another of my postcards and the copy from the back.

Nepal, October 2008

I spent time with, and photographed, this girl while on assignment with World Education Nepal. Sixteen years old, she is a child-laborer in a brick kiln in the south near the Indian border. The day I shot this was unyieldingly hot, and without the kilns firing I was already near melting. This gal, and others like her, some much younger, worked in one hour harder than I suspect I have worked in my life. The courage and determination I saw in her eyes echoes those same things in the eyes of women around the world...

Emotionally compelling photographic resources give extraordinary strength to fundraising and advocacy efforts. David duChemin specializes in working with the NGO community to tell your story, in visual language, in the strongest way possible. A team player with years of international experience, David will work hand-in-hand with your organization, collaborate easily with field staff, and treat your partners and those on whose behalf you labor with kindness, dignity, and respect.

We welcome you to look through images from David duChemin's past assignments, at his website here: www.pixelatedimage.com. If we can serve you or discuss your photography resource needs, please call us at 604.209.5900 or email us: info@ pixelatedimage.com

COURAGE
WITHIN THE STRUGGLE

Postcards are one of the most economical ways of reaching a small, niche market. They are easily printed, cheaply posted, and have a good balance of impact and information. Not all markets need them, but bang for buck I'll choose a postcard anytime over a brochure. Companies like Modern Postcard (Modern-Postcard.com) create exceptional postcards in multiple sizes, from simple 4- by 6-inch cards to jumbo threefold cards guaranteed to wow the most cynical client. I've found Modern Postcard's quality, service, and pricing to be exceptional.

"Who says your portfolio needs to be a conventional one?"

Make Them Creative

In fact, make them creative, consistent, congruent, and then commit to using them for a while. We discussed this earlier, but here's where that rubber meets the road. These pieces need to be creative communications that are consistent with your branding, and congruent with how you are positioning yourself within the market. Don't let an exciting new idea derail you. Adapt that great new idea to your plan, but don't let it distract you.

Make Them Different

Who says your portfolio needs to be a conventional one? Who says that the mailers you send out to key clients have to be normal? You're a creative professional, and I just know at some point you've broken the rule of thirds. So don't be hemmed in by the It's Always Been Done This Way police.

When I travel, I get into conversations about what I do and why. Being over the Atlantic on a midnight flight to Delhi, it's not so easy to whip out a laptop and internet connection, but what about a self-published book of my images? I recently created one called *Nomad* (right) that I keep in my camera bag. Now I'm ready to show my work at a moment's notice. The cost? $20 through Blurb.com. I also show my work on my iPod, but if I make a real connection I'd rather give away a $20 book than my iPod.

Why not create some nice picture books once a year to send to clients as a thank-you, or to prospective clients as a way to show your work? Food photographer? Why not create a cookbook showcasing your work?

Why not make a portfolio on DVD and create a great cover that doubles as a mailer to send to prospects?

Do it Right the First Time

The temptation to overestimate our design skills can blind us to the actual quality of our promotional work. We, of all people, should understand that visual language is a specialty. If you are just one of those instinctively good designers, make sure your instincts appeal to more than just yourself. Money spent on a good designer is money well invested. These marketing pieces go out into the world and take on a life of their own. Who knows where they'll go or for how long they'll be out there? You could design it yourself to save some money, but no amount of money is going to recall work that gets hastily designed, printed, and distributed only for you to decide in six months that it's not professional enough and represents you poorly. Seriously. It's worth the money. Hire a designer if design's not your thing. Talk to your printer about your options, and go with the better stocks and processes. I can't stress this enough—this is a visual business, and if you can't make your stuff look hot, then your prospective clients have no reason to believe you'll make their stuff look hot.

> "Money spent on a good designer is money well invested."

Benefits Are King

One of the key concepts anyone hoping to engage in any level of marketing needs to understand is the role of features and benefits. I mentioned this earlier in "Know Thyself," but it bears repeating here. Clients don't care about the features you offer; they care about the ways in which those features make their lives easier or meet their needs. To most clients, "We have lots of experience and big computers" might elicit a yawn, but "We deliver perfect files, on time, and on budget" would certainly get their attention.

What you need to remember is this—for every claim you make, there must be a "So what?" implied. Don't make your potential clients connect the dots; do it for them. Tell them all about you, but tell them *why* that matters. Benefit-oriented statements outshine feature-oriented statements every time. Remember, this is about them, not you. You matter to them only inasmuch as you can meet their needs.

Dave Delnea

DaveDelnea.com

DAVE DELNEA is a commercial photographer based in Vancouver, Canada. He shoots full-time, primarily serving the resort industry with lifestyle images of people and places. His clients include Ritz Carlton, Trump Development, Raffles Hotels and Resorts, Fairmont Hotels and Resorts, and Johnson & Johnson.

When Dave was 20 he picked up a camera, fell in love, and two years later he was shooting full-time. In those two years he took a variety of jobs, slept in his car and on friends' couches, and spent every minute dreaming of photography and scheming his way to his next photographic adventure. Toward the end, he was working 12-hour shifts at a water-bottling plant, driving a forklift, and saving his money. When he had enough saved up to take him through the summer he quit, packed his bags, and started pursuing every opportunity, large or small, that presented itself. The opportunities never ran out: they just built on each other, one after the other—small jobs, free jobs, a chance to work as an assistant for a year. If something came Dave's way, he took it.

Seizing opportunities is a thread running through Dave's career—like a mantra that floats in the back of his mind and guides his decisions. Where other photographers plan their careers in minutiae, Dave's career has followed a more organic path. Not unintentional at all, it simply has unfolded from opportunity to opportunity and each has led to something bigger. Dave's client list isn't small potatoes, either. He's worked for some top-shelf clients, and every one of them has come not from cunning marketing but from relationships. His first assignment came through his brother-in-law, a fan who applauds Dave's work and who has introduced Dave to colleagues at the creative agency where he works. When an assistant ducked out of work at the last minute, Dave was called in to fill his shoes, did his job well, and was liked by the image resources person at the agency. One gig led to another, and eventually one of the designers left for another agency, taking Dave's name with him. The bulk of Dave's work now comes from seven clients represented by five creative agencies and a handful of corporate clients. All of them resulted from existing relationships and referrals.

It's this intentional nurturing of relationships that Dave attributes to his growing success. That desire to listen to clients and overdeliver on his assignments begins with a genuine enjoyment of his clients and the collaborative relationship that can form when you're not blinded by the need to look out for number one. For Dave, overdelivering means knowing what the client's needs are—not only by listening to the client, but by learning from past experiences and pushing clients for honest feedback. Taking a client for sushi after the deliverables are in—and where other photographers might begin pushing a client for more work—Dave presses them for feedback and ways in which he can make their working relationship even smoother.

I hope I haven't given you the impression that Dave's a freewheeling hippie who relies on luck to fill his calendar. His commitment to his craft and the care of his clients is the foundation of his business. But he takes a decidedly more personal approach in his marketing, which serves as a good lesson for those who take their marketing so seriously that it becomes a distraction. When we met for this interview, Dave was in the middle of refining his branding—working on a refinement of his current logo, a new website, and limited collateral materials, including business cards and packaging for deliverables like branded DVDs and boxes for hard drive delivery—but when I asked him about it all, he was quick

evidence that these changes will make him more money, let alone pay for themselves. "Stay out of debt," he said. "My success has largely been built on being in a place where I can take full advantage of the opportunities that come my way. I wouldn't have been able to do that if I had a lot of debt to manage."

Unlike Chase Jarvis (see page 225), Dave's presence online is less prominent. He prefers to use the internet to learn and work on his craft, and to save connecting with the photographic community and clients for face-to-face encounters. Dave also spends less time in front of the computer than others do; even his time working on his craft is usually spent corralling a bunch of creatives—a stylist, a model, a make-up artist, and an assistant—to go somewhere to play for an afternoon. He pulls images and inspiration from magazines and the internet, then plays with them, reverse-engineers them, and tries to re-create them or put a new spin on a look. Filling up the well so there's something there to give to clients is key.

I asked Dave about making the transition, if he ever asked himself, "Am I even good enough to do this?" He smiled. "I still do. All the time." What pushed him through the fear wasn't waiting until the fear went away; it was knowing that he loved photography so much he didn't want to do anything else. "There will always be some fear, and while you don't want to be controlled by it, it can certainly be motivating. Wondering where the next gig is going to come from, when I'll get to play next, that keeps you from getting complacent. That's when I know it's time to call a client and go for lunch." He recently called up a client he's been working with for three years and

to swing to the other side. "People get so caught up in materials and spending big money," he said, "that it becomes a substitute for what they should really be paying attention to—working on their craft, connecting personally with clients, and managing their money." It's a sermon I feel like I've heard, but before he lets me move on he reiterates it.

Dave cautions people to avoid debt, and while I do so because of a bankruptcy in my past, Dave does it because of the freedom staying out of debt gave him—and continues to give him—to pursue the opportunities that come along. He told me of a colleague who's heading into a $50,000 loan to upgrade computers, rebuild a website, and purchase a bigger camera, all in hopes of getting ahead, while his current market gives him no

said, "Hey, let's go for lunch and talk about your needs," bought them sushi, and drilled them about ways in which he could better meet their needs. A couple of good ideas came out of it, and the relationship continues to grow. The client told Dave later that no photographer had ever been that invested in the needs of the agency. It doesn't end there. Dave hands off deliverables in person, drops by the office himself to collect pieces made with his images, and to touch base. If a client mentions, for example, loving wine, Dave drops off a bottle of wine for Christmas. Not every photographer can tend to his clients in person, but all of us can do it personally.

All of Dave's activities surrounding his blend of craft and commerce revolve around his passion for his work and his clients. In fact, he's even hesitant to describe his current market niche as a defining factor, preferring to look at it

as concentric circles. The core is his identity as a creative person, always growing and learning. Surrounding that is his visual style, the evolving way in which he expresses that core, and then surrounding that is his current niche, the market he best serves right now. But he cautions against the danger of too quickly settling on a niche without first having had real time to explore your creative gamut. He prefers to be known by how he shoots, not only what he shoots. Generalist shooters who don't commit to one thing over another have said the same thing, but from Dave it rings true—his style is solid. When I first discovered Dave's work, it didn't make me envy his images or his clients. It was better than that. It made me *feel* something—a desire to be in those places and meet those people. And the clients in the very specific niche he currently occupies are reaping the benefits of his vision.

Dave's path, like the path the other photographers in this book have taken, may be very different from your own, but his almost fanatical devotion to working, playing at his craft, and personally connecting with and serving his clients should inspire us to be mindful of the role of intangibles like passion and relationships.

All images on pages 127–133 © Dave Delnea

Marketing 2.0

With the advent of social media tools like Flickr, Facebook, LinkedIn, Twitter, and whatever app is king in the few short months between writing this and the book being published, marketing has changed forever. Recall at the very beginning of this book I said the rules have changed? Well, this is one of the areas in which change is most apparent. Only a few years ago photographers were still wondering whether a website was a necessity. Now the internet is the undisputed arena where most of our marketing occurs. But whereas a website was once a piece of unilateral communication, social media tools have introduced an interactive and relational element that photographers would be crazy to ignore. Can you do business without these tools? Yes, you can. But when relationships are so powerful a means of building a client base, it seems crazy to swim against the stream on this one.

This isn't a primer on marketing with Web 2.0; that belongs in a book of its own. But it's a good introduction, and it should give you some ideas on how and why to implement social media tools into your marketing.

> "People will do anything to get more and more people to their website. Most of them are missing the point."

Playing in Traffic

One of the most discussed topics in the world of Web 2.0 is generating traffic. People will do anything to get more and more people to their website. Most of them are missing the point.

Ask yourself why you want to generate traffic. If it's just to inflate your stats, then write things like "Keira Knightley naked" and...*boom!* The stats on your blog just went up. But do you really want that traffic? They won't be clients, and they likely aren't photographers interested in being part of a learning community. They'll probably never buy your books, prints, or workshops—unless you promise to include photographs of Keira Knightley naked. In all likelihood, you don't want just traffic, you want *specific* traffic, so don't get distracted by strategies that miss the point.

Knowing what you want and why you want it will help you choose the best tools to get you there. Most of us want to be found quickly by prospective clients looking for us specifically or for what we offer. The first thing you need to know is that while Flash sites are popular for ease of use, search engines have trouble

finding them. Nothing beats a simple HTML site, or at minimum an HTML landing page into which you can place well-written HTML-based copy about who you are and what you do, so Google can find you and direct people to your website or blog. Tell people who you are, what you do, and where you do it. Put yourself in the shoes of a prospective client sitting down to find a photographer like you—what search terms are they likely to use? Seattle? Pet photographer? Make sure those words are included in your copy.

The web works simply: the more you are out there, the more people are talking about you, the more people are pointing back to you, then the more Google will recognize you, the better your visibility, and the more people will find you and talk about you, point back to you, and on and on. It's a spiraling vortex of cause and effect.

So what can you do to increase your visibility? Whether it's a portfolio or a blog or a combination of the two, create something with the user in mind—not your ego. Avoid bells and whistles. Create a website that's easily navigated and full of content that's created and written with your market in mind. It begins with creating a place that's worth pulling people to, a place that will serve your market, and to which others will want to refer friends. From there, here are some key things to keep in mind.

> "Knowing what you want and why you want it will help you choose the best tools to get you there."

Great Content

There's no point getting people to your site if there's no reason for them to stay. One of my goals is to create a community of like-minded people with whom I can share what this industry, and this craft, has so richly given me. If you're slick and have no content, or if you're overly self-promoting, people sense that and move along quickly. It's got to be about the client or the market, and that means relevant content. Content is king, as they say, but king of what? Content is king of the pull—it alone will draw more people over the long haul than gimmicks.

Interact

If content is king of the pull, then interaction and relationships are kings of the keep. This is the heart of the Web 2.0 movement—a deepening of the online experience and a chance to do more than share information; it's a chance to create impact. Adding a blog with content relevant to your market, and a chance to interact through comments or a discussion board, is a great way to build

small communities of people who are invested in your brand—and who will not only be loyal to you but will be loyal advocates as well.

But interacting goes beyond your own blog or website. Participating on other blogs and forums—and here I mean actual participation, not employing comments as spam—is an excellent way to draw people to your own site and enlarge your circle. People who read and like the content or tone of your comments will follow the trail—assuming you leave one.

Leave a Trail

Create a signature that's memorable, consistent, and full of the kind of information that you want Google to pick up and index, along with a text link back to your site or blog. For me, on the most basic level that could be: "David duChemin, Vancouver-based Humanitarian and Travel Photographer. Visual stories told from the heart. http://www.pixelatedimage.com." The more you leave these calling cards, the more your name and the words in that line of text will get linked with your URL. Be specific. If you want people to look at your portfolio, link them there. If you want people to read your blog, link them there instead.

Share the Love

The internet is full of self-promoting "takers," and if you're a giver, you shine like gold in a pile of coal. Generously creating great content and generously linking to others always comes back to you tenfold. Make it your mission to connect people to other people who are creating great content. It's counterintuitive, I know. Starting out, people generally feel that their task is to plug themselves, but that approach fails in the long term. Why? Because it's not about you. It's about the people out there, the prospective clients in your audience. And they want to read things that matter to them. You only matter to them if you have something to offer. Content and community are the big draws here.

Join a Portal

Consider joining a portal site like Viisual.com. A portal site is essentially a directory of photographers and their portfolios, not unlike a specialized internet version of the Yellow Pages. Where it differs, of course, is in being far more specific than the Yellow Pages is, while also being less geographically bound. A good portal can represent photographers from around the world, and represent them

by specific areas of specialization. Being in a directory site like this is no more a solitary marketing effort than putting your business in the Yellow Pages used to be, but it can be helpful. You'll find lots of portals out there. Some charge quite a fee, and some are by application only, but a directory, or portal, site can send qualified traffic your way. Or they can be a waste of money better spent on other things, so do your research and be prepared to evaluate the results after a year, before you renew. If it doesn't cost much, there might be no harm in sticking it out. But any marketing effort that isn't evaluated and known to bear fruit after a reasonable amount of time should be reconsidered. For some photographers, portals and directories are invaluable. You should at least see what's available, especially if that's where your market goes to find photographers.

Go Where the Crowds Are

Ask yourself where your prospective clients are. Do you shoot pet portraits? Where do pet lovers congregate online? Get active in the forums for the local, provincial, or state dog-fancier groups, and do what it takes to participate, contribute, and become known and loved. Join industry-specific photography communities like the Travel Photographers Network, and be active. Post images, leave valuable comments, and make sure everything you leave behind points back to you with a text-based URL. Mix and match with conventional marketing methods. Want to get more studio photographers to your blog about studio photography because a year from now you're releasing a book and you need to do some legwork? Send a postcard to 500 of the top studio photographers in the country inviting them to visit your website, read your blog, and consider contributing articles to increase their visibility.

Be Open to New Technology

Investigate Web 2.0 phenomena like Twitter, and be open to new technologies and new ways of connecting. Twitter might not be for you, but judge that based on results, not on a first-glance appraisal. I put off using Twitter because the name sounded stupid. Not the best reason to dismiss a tool that's as powerful as it is. The same is true of Flickr, Facebook, Digg, and blogging. In fact, there seems to be an inverse relationship between how silly the name is and how useful it can be. Look into them, and give them a try, but don't get too loyal to any of them because the life of these tools is often measured in months, not years. Remember, they're tools to serve you; you owe them nothing. The moment the tool no longer serves you, find another.

> "The business applications for these tools are immense if you use them with intent, and use them well. Not easy."

Everyone's All a-Twitter

Social networking, Web 2.0—whatever you call it, it's nothing more than a set of tools. The business applications for these tools are immense if you use them with intent, and use them well. Not easy.

So, because it's the preeminent tool of the day, let's talk Twitter. I use it because it can be whatever you want it to be. It can be a chat room, a newswire, a polling service, a micro-blog. It can be a tool to connect you to more people faster, and give you opportunities to go deeper. But it's not magic. You need to learn to use it. Here's what I've learned after initially dismissing this particular tool and then becoming a convert: Whatever tool you use, the Why drives the How. Figure out what you want the tool to do for you, then use it to that end.

If you are unfamiliar with Twitter, go to Twitter.com to explore it. In short, it's an internet-based micro-blogging and social networking tool that allows you to follow people—and be followed by people—of similar interests, and to communicate with them in 140-character messages. As inane as it sounds, it can be a powerful way to supplement your other online activities.

Be Relevant

Ask yourself this one question before micro-blogging or "tweeting": Who cares? Seriously. If the answer is limited to you and your cat, keep it to yourself. If you're micro-blogging as a professional, then inane tweets about absolutely nothing will only dilute the way your market thinks about you. Perception is reality, and if your Twittering makes you *look* vapid and silly, sorry, you've just *become* vapid and silly to your readers.

Know Your Audience

Who are you talking to? Professional photographers? Clients? This guides what you say and how you say it. If you're talking to clients, then speak their language. And speak to photographers in their language somewhere else or through a different account.

> "Be yourself. But be a carefully edited version of yourself."

Be Yourself

But be a carefully edited version of yourself. What you say on the Twittersphere and the rest of the internet ripples a long way. You can't control where it goes or how it gets used—you can only control what you say. So be mindful. Careers have crashed and burned.

Know the Limits and Move Past Them

Twitter can only do so much. It's like an internet dating site. You find the girl, then you chat with the girl, but if you don't graduate from the online service to a face-to-face encounter, you aren't dating. Twitter is great for meeting and chatting, but you can't live life at 140 characters all the time. Don't be afraid to take it beyond Twitter. I've already had coffee with folks I've met on Twitter. And the more conversations you have, the more opportunities you find.

Remember Your Purpose

If your purpose is to direct people to your blog, then do that—intentionally point people to new posts. But consider this: if you come off as too self-promotional, as more of a taker than a giver, the community to which you appeal is likely to be smaller than if you also point to great related content on other blogs. If your purpose is just to make a name for yourself, then the usual rules of celebrity

management/leverage apply, but here's another one: be a fan, not just a celebrity. The more you point people to others, the more valuable you are to others. People like folks who are givers.

Extend Your Brand

If I go to your Twitter page, will I find your logo? Do you have a great avatar? Your Web 2.0 activities are marketing activities, little chances to say, "Here's who I am!" The usual rules apply—be creative, consistent, and congruent with your brand and core values.

Signal-to-Noise Ratio

Where tools like Twitter need particular attention is in balancing the signal-to-noise ratio. There is so much noise out there on the internet—so many conversations about nothing at all—that if you use the tools well, you can cut through the noise and really stand out. But if you use them poorly, you'll be contributing to the noise. People want signal—content and community—not noise. Whichever tools you use, be mindful that you will either draw people or repel them based on how effectively you use these tools.

> "Be mindful that you will either draw people or repel them based on how effectively you use these tools."

www.makeyourwebsiteawesome.com

Having a website has become the primary marketing strategy of photographers. With the easy availability of online photo galleries, HTML and Flash templates, and the export-to-web functionality of Photoshop and Lightroom, more photographers than ever are getting their images online on a site they can call their own. The advantages of this are obvious, and how we'd ever live without it, I have no idea. It also comes with a hazard—the proliferation of poorly designed and ill-conceived web efforts.

Let's look at a few of things to consider as you build or rebuild your website to better reflect who you are to the market(s) you hope to work in. This isn't a long section, and I've intentionally kept it to the heart of things, in part because to create a book that's relevant beyond the quickly passing life of any given technology, I need to be fairly broad. But more importantly it's because this is a huge topic, and while the Whys can be answered briefly, the Hows could take several books. Unless you have a background in design and coding, find a

designer to work with or put in the time to really study this. As a photographer, you're probably better off putting that time into learning your craft and budgeting for a solid site created by someone who really knows their stuff—preferably both a designer and a coder working together. Remember, that site may be obsolete in a couple years, so don't take out a second mortgage. You might also look into some of the excellent templates and services marketed specifically to photographers.

Keeping in mind the Four Pillars, consider the following.

Best Foot Forward

If you want a professional website and not merely a showcase of all the great cat pictures you've taken, then you need to edit your selections tightly. Showing your potential clients fewer images—your very best stuff related to the market you're wanting to work in—will give each of those images more impact. Don't show them the B-roll stuff.

In addition to choosing the best images, you should be showing them in the best way possible. Flickr is not the place for an online portfolio. That's not to say Flickr has no use, but it's simply not a professional place to show your images. Spend the money on a great piece of gallery software that you can update easily. There are many options, but I urge you to choose something that strongly reflects who you are, that's free from bells and whistles, and that's professionally designed with simple, logical navigation. Flash-based portfolios are popular right now—and I'm using one—but for some markets the inability of an editor to easily pull or reference images is a trade-off you make with Flash and may not be what you need. Some of the third-party galleries available now for Lightroom are pretty amazing. Whatever you do, do it well, and with the client in mind.

Impact vs. Information

Keep your website in a strong tension between providing information and impact. The design and the content should work together to create a seamless presentation that leaves the client with a strong impression of your work and the basic details they need to proceed with you. Too much information doesn't get read and dilutes the strength of your entire site. But without enough information, you'll have missed a chance to tell your clients why you're the right choice.

Be Intentional

Your website should have a purpose. If you intend for your site to be a strong marketing tool, then you need to have a focus and stick with it. Narrow your market down, keep your message tailored to that market, and make your image selections based on that market. Every choice you make with regard to your site should be done in consideration of your market. If you're looking to build a business as a wedding photographer, then create a website full of images that say, "This photographer is a great wedding photographer." That means leaving out your images of baseball games and air shows. Put those onto your Flickr page, but keep your portfolio targeted to your intended audience.

Be Web Savvy

I talked about this earlier, but it bears repeating: the more easily your website is found by search engines, the more traffic you get and the better the chance that someone looking for you is going to find you. The question is, what are they looking for? If they know your name, they'll Google it and find you. But if they already know your name, this is hardly a victory over the intricacies of the web.

Be sure to put the same keywords into the copy of your website, along with others. Gone are the days when you can fool Google with white words on a white background so no one but the web spiders see them. Keywords in the HTML/headers aren't as helpful as they once were, either. More and more, you need to earn your Googleability the old-fashioned way. Write it into the copy. Get others to link to you using the same kind of words. The more active you are online—participating in forums, writing articles, posting comments, writing blogs—the more your name will come up. A little effort goes a long way if it's aimed in the right direction.

This isn't rocket science, but it is an effort to think this stuff out and be intentional about your marketing. Intentionality is something fewer and fewer people are practicing as they do their marketing. The best website is the one that can be easily found and navigated, and that shows your carefully chosen images along with tightly edited information about you and the benefits you offer. Make it easy to find and make it easy to contact you.

"Intentionality is something fewer and fewer people are practicing as they do their marketing."

Your Next Step

There are some excellent resources marketing themselves to photographers, and they cover the gamut of budgets.

Fluid Galleries (Evrium.com) is a Flash-based software that's easy to use and to keep updated. There are some built-in search engine optimization (SEO) tools, but they're minimal. Still, the software—which is installed on your server and used via your browser—allows you to create some great-looking sites. My current portfolio was created with Fluid Galleries.

liveBooks (liveBooks.com) is a more complete service for custom, great-looking websites. liveBooks builds and hosts your site; they aren't cheap, but their sites look great.

A Photo Folio (APhotoFolio.com) builds great-looking sites and also provides consulting services, backed by experience in the commercial and editorial markets.

Adobe Lightroom's Web module can create some stunning galleries using templates from the simple to the complex. Best of all, they're either free or inexpensive. They require some tinkering, but for the budget-minded they're a great place to start. Do a Google search for Lightroom galleries, or begin at LightroomGalleries.com. The Turning Gate (Lightroom.TheTurningGate.net) is also excellent.

Blogging

The blog has risen to such prominence as a form of communication and branding that it would be crazy not to give it more than a passing consideration. Blogging has been one of my biggest marketing tools. It doesn't reach into every corner of my marketing plan, but it covers such a wide swath that I'd stop just about any of my other marketing initiatives before I stopped blogging.

Three years ago I got an e-mail out of the blue from someone who'd been reading my blog, lurking in the background for months. One minute I had no idea she was even out there, the next minute I had an e-mail on my desk asking if I'd be interested in a high-profile assignment in a couple of African countries.

I wasn't angling for work; I wasn't writing my blog specifically for clients. But something in the way I wrote and the common interests and values we seemed to share made her think I was the photographer she wanted. We still work together, and that account is both my largest and my most enjoyable. Gaining my best client through my blog made me a believer but, on a broader scale, all my best professional opportunities have come as a result of conversations that were initiated on, or because of, my blog. Without exception. I have booked lectures, workshops, and assignments solely from my blog.

Should every photographer blog? I suspect not. A blog is a tool—and like all tools, whether you should use it or not depends heavily on what you want to accomplish. Here are some compelling reasons to consider blogging:

Blogging is relational. Blogging is a higher-touch use of technology than your conventional website. The more people get to know and love you, the more they'll be inclined to hire you.

Blogging can make you famous. Or infamous. Or almost famous. A great blog stands out in a sea of really mediocre ones, and even if you're not getting 10,000 visits a day, a good blog can provide a growing platform from which to launch your fame. Consider your blog your in-house PR firm. Blogs are the new fame-makers. If one of your goals—and all of this must be driven by specific goals—is to be seen as an expert in your field, then blogging is among the fastest ways of getting there.

Blogging is about connections. A good blog connects you to other photographers or to your chosen market, and it increases your access to people you can serve with your particular expertise. Connections in the viral world lead to more connections, and they multiply exponentially. If more connections is what you're after—and it should be—a blog can get you there.

Your so-called competition is blogging. I don't really believe in competition, but if another photographer is blogging and you are not, it's more exposure for them than it is for you. If you're working in similar markets, this is a way to keep your visibility up, or if other photographers in your area or market aren't blogging, it's a way to be first and more visible.

"All my best professional opportunities have come as a result of conversations that were initiated on, or because of, my blog. Without exception."

Blogging forces you to keep current. It can help keep your paint stirred. Like teaching, it can be an excellent way to learn and solidify your photographic thoughts and practice.

Blogging makes you a producer. Blogging allows you to produce and not merely consume—it enables you to give back to the community, and that's a karmically cool thing to do.

Blogging is a form of conversation. If you buy into the notion that all opportunities in life begin with a conversation, the benefit here should be obvious. The more conversations you have, the more likely you are to encounter new opportunities because opportunities come through other people, and our primary connection to other people is conversation.

With all these reasons taken into consideration, it should be said that blogging is not for everyone. It's a tool, and in the right hands it's currently a very powerful tool. But it might just not be you. In the wrong hands, tools can do more damage than good. If you think that describes you, keep reading. Here are some reasons you might want to give the world of blogging a miss:

You have nothing to say. Some people just aren't there yet. I think everyone has an opinion—some of them even informed—but not everyone has the confidence to express their opinions (which in some cases is good). If you don't have anything to say, your blog is dead before it gets off the ground.

You can't write. Let's face it, some people choose photography as their medium because they're better with images than words. If this is the case, don't force a square peg into a round hole. I do suggest, however, that before you jump ship and abandon the idea of blogging entirely, you consider publishing an image a day. We don't always need words, and there are other ways to blog than to write.

You're a shameless self-promoter. If you insist on plugging your latest achievements and ego-drivel, the blog may not draw the audience you hope it will. People come to your blog to *get* something, not to give it. If you suck the life out of your readers with the All About Me show, you'll find them dropping like flies. Unless you're Paris Hilton. Or Angelina Jolie. There is never enough Angelina.

You don't have the time to commit to it. If you publish a personal blog to keep family updated with the latest pictures of kittens, then how frequently you publish is not much of an issue, but professionally a blog must publish with reliable frequency. Sure, take a hiatus once in a while, take a no-blog day, or publish only on Mondays. But make it reliable and consistent. If your readers can't rely on new content they'll go elsewhere.

You just really don't want to blog. Fair enough. Don't blog. If you hate blogging and do it resentfully, it'll come across in your writing and eventually you'll be blogging as bitterbloggerwithnoreaders.com. We all have to communicate with our markets in the way that works best for us.

No one is forcing a blog on you. But there are compelling reasons to consider it. It's good marketing, it's good to give back to the photographic community, and it's good for the soul. If you do it right, a blog can be a real asset and a real blessing.

If I've convinced you there are good reasons to launch, or relaunch, a blog, here are ten noncanonical blogging tips for running a blog that's a solid resource for the community or clients for which you are writing:

1. **Pick a target.** Making some intentional decisions about who you are writing for and why you are writing will keep you focused. The best blogs appeal to a specific audience and serve that audience well. Know who you are writing to and why, and that determines what you write and how. I write specifically to the photography community because teaching is one of my passions. If you only want to keep current with your studio clients, the blog is equally powerful. I've seen blogs that are clearly written only for clients; there are great giveaways and studio news, and the whole thing is done very beautifully, low-key, and with content designed to interest the reader. If you photograph children, your clients are potentially parents. Why not do giveaways in conjunction with a local children's boutique and make this a chance for the boutique to promote you? Add a weekly tip for improving point-and-shoot candid photography of the children, throw in links to great parenting articles, and you've given clients a good reason to keep coming back. Look at it as a small in-house magazine with the goal of being perceived as an expert who knows and understands children and their parents.

> "Making some intentional decisions about who you are writing for and why you are writing will keep you focused."

> "Losing a reader's trust, or worse—a potential client's trust—because you were too lazy to proof the article makes your blog a liability, not an asset."

2. **Post daily.** The most successful blogs are the ones with the most consistent readership, and you get that—in part—by blogging consistently. I haven't always done that, but I notice a significant increase in traffic during those consistent once-a-day stretches. The more you post, the better. One of the best pieces of advice Scott Kelby ever gave me was to blog consistently, daily if possible. Why? Hardly anyone else is, and when the reader surfs to a blog that hasn't been updated for a week, they'll head over to my blog instead.

3. **Make it look great and easy to read.** You are a photographer—you specialize in visual communication. The better-looking your blog, and the easier it is to read and navigate, the more people will settle in and read it. My previous blog was harder to navigate, but it was still fairly easy to read. Space things well, give lots of white space in margins, and don't make your column widths too long. People tire quickly—so make it as easy to read as possible. Photos and graphics help, too, but only if they're relevant or particularly nice.

4. **Edit your stuff tightly.** Use spell-check. Trim the fat where you can, and give us hints that your grasp of the language includes a working knowledge of grammar and syntax. Readers can forgive much, but it's unprofessional to hit Publish without checking it over. Losing a reader's trust, or worse—a potential client's trust—because you were too lazy to proof the article makes your blog a liability, not an asset.

5. **Interact.** Comments provide an excellent mechanism for exchange and conversation. Be sure to provide this level of dialogue for readers. You needn't reply to every comment, but the more you engage your readers and make them part of things, the more readers will stick with you. Besides all that, you'd be amazed how much readers can add to the value of the blog for others. Foster that community and guard it jealously.

6. **Link to others.** Be a giver, not a taker. The more links you have out, the more links you'll have back in. I know; it's counterintuitive. The instinct we all begin with tends to be a protective one. After all, I just got them here, why would I send them out again? Because linking is part of the game. It's part of what makes you a valuable hub on the information highway. There's a danger of linking too much—the moment you link to everything

it's impossible to wade through your links to find the good stuff, and your credibility becomes suspect. Link to the good stuff—and not just because someone else linked to you.

7. **Write with your brain *and* your heart.** Scott Kelby has been, and probably still is when you read this, the planet's best-selling computer book author across multiple categories for several years in a row. Why? Well, he's just an incredible educator. But it's more than that; he writes with his heart as well as his brain—both of which are sizable. People want to feel

connected to you, and they'll feel that more if you let them in a little. No need to share the deepest secrets of your life—in fact, we'll thank you not to most of the time—but writing on the things you're passionate about will attract and hold more readers.

8. **Engage with other bloggers.** Share the love. Connect with other writers. Tip them off when their blog has a broken link. Be a positive part of the conversations taking place in their comments. In fact, leave some good comments and you'll find people adding you to their blogroll. Kind of like going to someone else's party, being your fun, easy-going self, and meeting others—soon they'll be coming to your party, too.

9. **Be yourself.** Bloggers with their own unique voice get read. Have an opinion and share it. But only be yourself if you're a generally likable person. If nobody likes you at all or you tend to start street fights, you might want to adopt a persona and write from that perspective. Or be yourself and attract the belligerent clients the rest of us live in fear of.

10. **Write solid content.** Connecting people to resources and news, and writing solid content that educates or inspires, is what brings people back. Resist the temptation to toss in filler. Not everything you publish will be helpful or appeal to everyone in your target audience, but most of it should. In the world of the internet, relevant and reliable content is king in terms of drawing readers.

Your Next Step

Technology changes all the time, but if you're interested in blogging and have no idea where to begin, head over to TypePad.com or WordPress.com and look at their easy-to-use templates. My first blogs were up and running in no time. Blogging, like any marketing tool, needs to be done intentionally and with your target audience in mind, but the rewards, even from a purely pragmatic perspective, are worth it. Assuming you use the tool well, blogging is one of the fastest, easiest, and cheapest ways to get yourself out there.

Gavin Gough

GavinGough.com

GAVIN GOUGH is a Bangkok-based full-time travel photographer and a good friend of mine. I asked him to be part of this book because I thought it would settle an embarrassing old bar bet involving an elephant, but mostly because I think his story is important. I think too often we assume those who are doing well at something had the inside scoop, or found the hidden door in the wardrobe that led to this magical place. Gavin's story, much like my own, should disabuse us of that notion. Gavin had no idea what he was doing when he began this journey, and that ignorance (his word, not mine) worked in his favor, allowing him to make the transition unencumbered by realistic expectations. That naiveté, combined with his passion to pursue his course, fueled his journey through the discouragements and setbacks. He now makes his living entirely from shooting what he loves and teaching others to do the same. Represented by Getty Images and Lonely Planet, his stock sales include clients like *National Geographic*, American Express, Tommy Hilfiger, Siemens, Sony, and 3M. Gavin leads photo tours in Asia and is co-founder of the Bangkok Photo School.

Gavin has been a photographer since childhood. He began with a Kodak 126 Instamatic before moving on to 35mm film and the allure of the wet darkroom. Eventually settling into a career as a systems analyst for 12 years, Gavin began to wonder if there was a way to escape the daily commute up and down England's M3 motorway in favor of something more satisfying and less predictable. He put in a request for a 12-month sabbatical, and was instead offered 3 months, so he thanked his bosses very kindly, then quit and booked a round-the-world ticket.

In the background, Gavin's photography had been growing, giving him a distraction and a world to escape to on weekends and holidays. He describes his growing interest in the notion of following photography professionally: "There was a kind of slow-burn effect where my interest in professional photography grew and grew. I began to contact stock libraries, posing as a potential buyer in order to persuade them to send me their glossy catalogs. I soon had a library of beautifully printed catalogs from Getty, Tony Stone, Eye Ubiquitous, and any other library where travel photographs were featured. I studied styles, looked for similarities in technique, and marveled at the exotic locations shown. Those libraries eventually started replacing their glossy catalogs with CD-ROMs, and now it's all internet-based, which makes much more sense, but I do miss those thick books filled with pages and pages of thumbnail photos."

Twelve months, five continents, and countless countries later, Gavin returned to England. The seed of an idea about being a travel photographer had germinated, flowered, then taken over the greenhouse. On his return to England, Gavin began shooting local towns and English summer festivals while marketing his archive of images from his year around the world. When he first approached the agencies he had no online presence, no website, and no profile; all the serious agencies ignored or rejected his work, but assuming rejection was

part of the process, he plugged on. Those rejections forced him to study the market more closely, to see what editors were buying, and to understand what had influenced their choices. The more he learned, the more he fine-tuned his approach. "I worked on creating a profile for myself within the industry, writing for trade magazines, and joining trade associations. About a year later, I was contacted by Jupiter Images, the third-largest library at the time. They offered me a contract over the phone, and it was the first time I'd spoken to an editor in person. A few days later, on the morning I was going to sign the Jupiter contract, I had a call from a picture editor at Getty Images, asking if I'd like to meet her at her office in London to discuss signing a contract with them. In the same week, Lonely Planet Images also offered me a contract. All of them had come across my work through different means, but with a professional-looking website in place and a portfolio of images that would suit their markets, I was

presenting the image of somebody who was doing what they needed. A friend of mine suggested the following strategy to me: 'Fake it 'til you make it.' He meant that you should act like a pro, work like a pro, present yourself as a pro and, guess what, people will think of you as a pro, and you'll be employed and rewarded as a pro." Stock sales now constitute 50 percent of Gavin's income, while the remainder comes from direct image sales, magazine articles, and teaching.

When I asked Gavin for his best bit of advice for photographers wanting to make a living in a field similar to his, he had this to offer: "Don't do it!" And yet Gavin wouldn't trade what he does, so assuming others are as hard-headed about it, I pushed him to elaborate.

"Pitfalls are many and varied—and it could be a long list—but if I had a magic wand to wave at aspiring pros I'd bless them with the skill to be realistic. Harshly, bitingly, gruesomely, honestly realistic. It's easy to be beguiled by the notion of stepping off a jet in some far-flung location with a trolley-load of juicy camera gear and a commission to shoot eye-catching, sun-kissed resorts, but the reality is far different. You have to manage your expectations. Ask working pros what it's like, get them to dish the dirt, and don't be satisfied with their pretty word pictures. Find out how competitive the market is, ask yourself what you can supply that will be different, what you can offer that will set you apart from the crowd. If you can't answer that question immediately, then you've really got to rethink it. I don't mean to make it seem unappealing, because I love what I do. But that's the crucial thing—I love it when it gets tough, I love it when it's a struggle, and I love

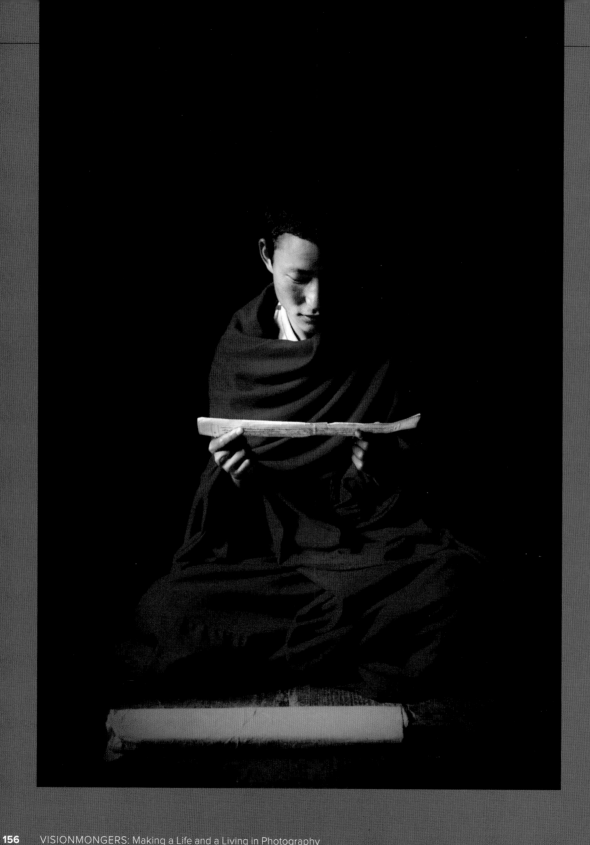

it when everything's gone pear-shaped, when my confidence has been beaten down and is lying in a quivering mass in the corner. I'd still get up the next day and want to do what I do. I know it may seem wildly pretentious to claim a passion for something so joyously fulfilling as photography, but that's the truth. I just can't think of anything else that I'd enjoy nearly as much, and if, in all reality, you can't honestly say that you'll love the tough times as much as the good times, then it's not for you.

"Steven Pressfield, in his book *The War of Art*, likens being a professional to being in the Marines. He says that those guys love to be miserable. They love to know that they eat the worst chow, have the most unappealing accommodations, have the highest fatality rate and the highest expectations. While it's a great big leap of an analogy, I can see the truth in it. If you don't love the challenge of having to work your butt off when you're in the mire and the outlook seems bleak, then, in all seriousness, don't even think about it.

"Be realistic. Get your portfolio appraised by somebody in the industry, preferably someone who is buying photos for an ad agency or magazine or whatever your market is likely to be. Ask them not to pull punches, ask if they'd buy your work. Friends and family will boost your ego, but no one will give you a more accurate reflection of your prospects than someone in the industry. However, use one of the many official appraisal workshops to do this. Don't go sending your portfolio to a busy art buyer on spec; it's unlikely to get looked at."

Gavin's marketing is a tight, intentional effort. He has a logo that he had designed through a crowd-sourcing website, a site he designed and maintains himself, and a well-read blog, and he's also active on Twitter. While social media and blogs are seen by some as frivolous and self-indulgent, Gavin has used them as tools to connect to his market. "I've been contacted by magazine editors via my blog on several occasions, sometimes asking to use a specific image and sometimes asking if I can contribute an article of both words and pictures. The blog has prompted the start of several long-term relationships with editors and buyers, and I know that several picture editors pick up the RSS feed and respond when they see something they can use."

Still, these efforts play only a supportive role to carefully targeting and connecting with buyers and working to establish long-term relationships. "I think the personal touch can be very important, and relationships are only ever cemented by one-to-one communication. Consequently, I've only sent out mass mailings on a few occasions, and although these have produced some interest, I'm sure that recipients understand that you're just throwing a lot of mud at the wall to see what sticks. I'd rather think of a specific project, pick a market that would suit that project, and then get in touch by e-mail or, preferably, on the phone to pitch my idea. I'll have a small online gallery ready to show and go from there. I got my first cover shots for a local English magazine this way. I shot some pictures that I knew would fit the style of their publication, put together a few paragraphs, and sent them over. They became one of my first regular clients and came back to me consistently until I moved to Asia."

Five Things You Need to Know about Stock Photography

There's a misconception that stock is the low-hanging fruit and is the fast track to quick income. The market represented by stock sales is large and varied, and it requires the same research and specialization that any other market requires. This is Gavin Gough's Top 5 overview of stock photography. For more on stock photography, consider looking at the excellent articles published by PhotoShelter.com or talking directly to photographers working in the areas you'd like to pursue. Knowing the difference between RF and RM images is only the beginning; do your research and find out what's selling, what the large agencies are looking for, and, in the spirit of "going where they ain't," find out what the holes in their library are.

1. Submitting to stock libraries won't give you a quick win. It's a long-term game, and it will be at least 12 months before you start seeing a return on your investment—and more likely two or three years.

2. The best stock libraries will ask for exclusivity for your rights-managed images and will tie you in to a two- or three-year contract. Libraries need to do this so that they can get a return on the investment they make cataloging, captioning, keywording, and marketing your images.

3. Some libraries will take everything you submit, provided that your image files meet their technical criteria. Others will ask you to make a tight edit and will then select the images that they think they can sell. Trust the judgment of longstanding libraries; they know the market and understand what editors and agencies are looking for. One or two of the bigger, more ubiquitous libraries are so influential that they can even sway market trends, introducing new styles and creating a demand that they already know they will be able to meet.

4. You're going to have to share the honey if you want to work with a reputable agency. Although you put the initial work in and created the images, a good library will do its share and get your images into the marketplace. The best percentage you are likely to see is 60 percent of sales revenue, while the bigger libraries will only give you between 40 and 50 percent of usage fees. You may be asked to subscribe to a third-party agreement where libraries sell your

work through a secondary agent; in this case, your slice of the pie will shrink to 30 percent. It might seem that you're giving up a lot, but 30 percent of a lot is much better than 100 percent of nothing.

5. Libraries vary enormously. Adopt the Groucho Marx philosophy of being reluctant to join any club that would have you as a member. Submit tight edits of your best work initially, and be cautious about libraries that promise the earth and seem overeager to recruit you. The libraries that will give you the greatest rewards are the ones you have to fight to get into. Find out which libraries long-established professionals work with, and follow their lead. Libraries might not get back to you very quickly, but when they do, whether you are accepted or rejected, politely ask for feedback on your work. Learn why they selected certain images, and ask what you can do to improve your work and make it more salable. They'll be pleased that you asked.

Making Contact

Once you have the foundations laid for your marketing efforts, you've really only just started. In a perfect world, you'd put your website up, your potential market would feel a tremor in The Force, and your phone would ring. But then you'd also have an Evil Empire to deal with, so you can't win either way. It's time to talk directly to your market.

How you contact your market, and how you convince them that you are the one they want, is a little like asking, "How do I order the veal when I travel to a new country?" Well, it depends on the country. Knowing your market is the first place to begin. With any luck, your advertising efforts won't bereave the world of baby cows, either.

Market Research

So you've settled on a market based on what you love to shoot, what you're good at, and—I hope—what you've got experience shooting. Let's assume for this discussion that you want to shoot food. The first question is, "Who is buying

> "Beginning with smaller, local magazines gives you the experience an editor at a larger magazine will look for before they trust you with an important assignment."

food photography?" You know *what* market you want to work in—now find out *who* your market is. And there's nothing like some basic research to get a mailing list started.

I'm not going to lie to you—market research can be overwhelming. So here's a starting point: make a list of the top 100 clients you want to work for. These might be corporations if you're a commercial photographer; it might be magazines if you're a travel shooter or edibles photographer. Picking 100 forces you to dig deep and fine-tune your Google skills. It's also a manageable number for your first forays into direct marketing.

How do you choose these clients? I know you want an easy answer, but there isn't one. You get online and use your Google-ninja skills. You look in trade magazines and directories. You look at who other photographers are shooting for. I'm not suggesting you poach the clients of your colleagues, but surely this will fire up your imagination and suggest similar potential clients in your area or at your level. By that, I mean a photographer who has always dreamed of shooting for *National Geographic* is not likely to find their first paying gig with them. You have to fight your weight. Beginning with smaller, local magazines— learning the trade and cutting your teeth—gives you the experience an editor at a larger magazine will look for before they trust you with an important assignment.

Now find out who within that organization buys media resources or hires photographers. It might be a VP of communications, an art director, or a senior editor. Who it is and what title they go by are key pieces of information usually acquired by a phone call or two. I put all this information into a spreadsheet that I can keep updating, and from which I can make mailing labels. It also allows me to keep track of responses, notes, and the results of phone calls.

Not every market will benefit from this approach, but the wisdom is the same. If you're a high-end pet photographer, you might apply this same approach to the luxury pet boutiques within the area that you're willing to travel. Meeting the owners and developing relationships with them will lead to future work. Photographing their own dog in exchange for their consideration and word of mouth might be the best hour or two you've ever spent, but it begins with a list.

Beginnings Are Hard

At some point you need to take that research and act on it. You need to connect first, and then begin a relationship. There's a fine balance between keeping your name in front of someone and being a pain in the ass. Aim for the first; it will get you more work. A simple way to do this is a postcard or classy mailer, or a series of postcards mailed every quarter.

Before we go any further, I want to remind you that marketing is a long, slow, intentional road. The best postcards might get you some immediate work. *Might.* If they hit the right person at the right place on the right day. More often, and certainly in my case, they serve as soft-sell introductory pieces that show potential clients an image, make them familiar with my experience, and let them know that when the time is right I'd love to serve them. I do it so when the time comes they remember me. When a colleague refers me they've already seen my name and my work. I don't rely on a postcard or other mailer, especially one exposure, to do any heavy lifting.

The heavy lifting is done by personal contact and by existing relationships that lead to referrals. Again, every market is different, and while mailers are good, the personal touch is better, stronger, and longer lasting. At some point, you will probably need to connect. I've never made a cold call in my life. I'd rather clean my sensor with my tongue than make a sales call. But a call to simply ask if they got your mailer, if there's anything further you could send them, or even if they would allow you to take them to lunch to pick their brain doesn't have to be painful or out of place. I hate selling things, even if it's something I believe in, like my own work. But offering to help, to get to know someone, to listen and learn while paying for a meal? These I can do.

Direct Mail

I once sat down with a top advertising executive for breakfast. He said if he had a dollar to spend on advertising, he'd invest it in direct mail. If he had two dollars, he'd invest it in direct mail. If he had three dollars, he'd invest two of it in direct mail and think carefully about spending the third on something else. It's been solid advice.

Dollar for dollar, direct mail is the most targeted nonrelational marketing you can do. If you decide to go with direct mail, remember it's only as strong as the combination of the elements involved: a great mailer, a targeted and reliable mailing list, and the commitment to see it through. This is a long-term strategy you're working on. If you want gigs tomorrow, direct mail isn't for you. If you want to establish yourself in a market and build long-term relationships with prospective clients, it's excellent. But it's still only the beginning.

A Word about Reps and Agents

As a comedian, I had an excellent agent in Nashville. It took me years to get to a place where representation made sense for me, or a place where an agent would even look at me. I don't think it's a coincidence that I hear talk of reps and agents only from people starting out. "Maybe I should just get an agent…" is the phrase I keep hearing. And here's what someone once told me about agents: agents only want you when you no longer need them. Now that's only partly true, but if you want an agent because you're just starting out and want to hand off the marketing to someone else, they won't want you. That's not what agents do. Agents deal with established photographers—marketable brands—that already have some demand. If there is no demand for you, they have to work extra hard to get you work that won't pay as well. It's not generally a winning proposition for them. Are agents and reps helpful? They can be. But starting out, there is no one as invested in you as you. No one will work as hard at getting where you want to be as you will. When you get so busy with answering calls that you can't focus on your work, then revisit the idea. For now, consider yourself your own agent.

Hard copies of mailers aren't the only way to connect to potential clients in some markets. Services like ADBASE (ADBASE.com) make it easy to find and connect with potential clients by attaching extensive mailing lists to easily designed and great-looking HTML-based e-mail mailings. When they reach the right people in the right places—and don't get filtered out by spam filters—they can serve a similar purpose as traditional mailers: making a first impression and

introducing them to your work. They have the advantage of costing less per unit because there are no printing and mailing costs, but they are also easily dismissed and filtered out. I have clients—even clients for whom I have not yet worked—who tell me they have my postcards pinned up around the office, that they draw attention and have made me an office favorite. And yet they've not yet hired me. Why is that? Because timing and budgets are out of my hands, and often out of the hands of the client. But I talk to them, I keep sending them my work, and I trust that when the time is right and the budget is there, I'll work with them.

Book 'em, Dano

One thing that is without question in any market in which you want to work is that you will have to show your work. Clients will need to see what you do and how you do it. They will be looking for technical skill, but as that's something most photographers provide—and right or wrong, it's assumed—what clients are really looking for is vision. Clients want to see your vision and the means by which you express it—usually what we refer to as style.

The single most important thing you can consider as you begin to build a portfolio, either online or in print, is not how many images you include or how you will present them—it's you. Your portfolio should be a strong representation of your best work, the stuff you are most passionate about, and the stuff you want to be shooting. If you want to shoot destination weddings, your portfolio should show your work in destination weddings in the style you work in. If you want to shoot travel editorial images, you need to show a portfolio of travel editorial images in the style you want to be shooting.

In Selina Maitreya's *How to Succeed in Commercial Photography* (which I recommend for all aspiring commercial photographers specifically but all working photographers in general), Maitreya comes out clearly on the side of having not only a web portfolio but a printed one. For the commercial market, I have no doubt she's absolutely right, but most photographers I know outside of the commercial market do not have a print portfolio book to present. I have one that I have yet to show. And while I aim to change that, it's not for laziness or lack of work that it sits on my shelf unseen; my market doesn't require it. The

"Clients want to see your vision and the means by which you express it— usually what we refer to as style."

commercial market may be initially attracted to your work through a website or mailer, but they'll want to call a book in to look at as a team or to see the images in print. If you want to work in the commercial market, it's a good idea to create a print book that mirrors or complements your website. They didn't call your book in to see different work; they want to see the same images in a different setting and format. To explore this further, I suggest you pick up Maitreya's book.

Clients in other markets will have different needs, but here are some questions to help guide your plans to put your best foot forward.

What Do I Want to Shoot and for Whom?

The images you present must reflect the kind of work you do and the kind of work you want to do—simple as that. A portfolio is a piece of communication, and through it you say to the prospective client, "Here's what I shoot and how I shoot it." Your portfolio will either give them something on which they can base their trust or it won't. It'll either be a fit for them or it won't. Remember, this is not necessarily about whether they like your work. They might love it, but if they're looking for a photographer who interprets things in a particular way, perhaps because they have branding of their own that they are trying to remain consistent with, it will be the photographer with the right visual style who wins out. The downside of this is that it's easy to get frustrated. The upside is the freedom it gives you to be you. Put in the work you love.

What Do Clients Want to See in a Portfolio?

Prospective clients want to see your vision. They want to look at your work and get a sense for how you shoot. They want consistency because that's what will let them trust you with their work. They don't want to see bells and whistles and quotes about how great your photographs are. They want to see your best work that represents your visual style. And they want to see your work relevant to theirs. If you want work as a still-life shooter, build a still-life portfolio. If you want work as a portrait photographer, build a portrait portfolio. If you want work doing both, build two carefully crafted portfolios for each market, or find a way to creatively combine both if the visual styles complement each other. There are no rules.

Karl Grobl

KarlGrobl.com

KARL GROBL was 40 years old when he left a career in the medical industry to pursue a life as a photojournalist for the international NGO community. Among his clients now are World Vision, World Relief, World Emergency Relief, Freedom From Hunger, and USAID. His images have appeared in *Newsweek*, CNN, *Geo*, *Town & Country*, and *The Chronicle of Philanthropy*. After saving for six years before making the transition, Karl had enough money to travel, shoot, and find his place in the market for two years. His first year was spent as a volunteer for Health Volunteers Overseas to build a portfolio of images and to gain further experience. Low-paying jobs began coming in, and as relationships built with clients and they saw his value, his rates began to increase. Now Karl has a roster of 80 clients, 10–12 of them providing the bulk of his work and income. The 80/20 principle, well illustrated in Karl's life, states that 80 percent of your work will come from 20 percent of your clients, and this has led Karl to concentrate his marketing in that direction.

While Karl's primary marketing is his website and e-mail newsletters, he's decidedly low tech/high touch, preferring to connect with clients personally by phone, e-mail, or in person. Karl attends an annual convention for the NGO community, and takes that time to connect with clients and make new connections. His initial connection with this conference was a photography contest. When Karl won the contest, he attended the conference to be presented with the award. That initial award, and subsequent awards in the following years, gave Karl a high profile within the community he was working for, and connections that led, and continue to lead, to strong working relationships.

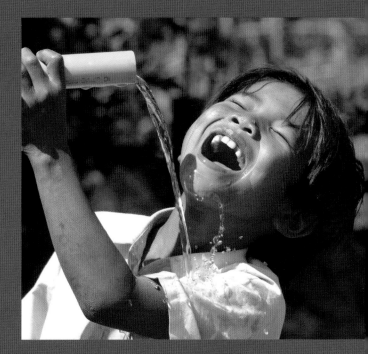

In 2004, Karl's portfolio on the National Press Photographers website caught the attention of an advertising agency working on an ad for Sandisk. Initially the agency was interested in only using Karl's images, but they persuaded Karl to be the poster boy for the new Sandisk Ultra II memory cards, appearing in full-page ads in photography and travel magazines. That one ad significantly raised Karl's visibility and credibility, and while it's not something he proactively pursued, it's an excellent example of the value of collaborative efforts, and the reason I've sought sponsorships with leaders in the imaging industry.

It's opportunities like this, and receptivity to pursue every chance that comes down the pipe, that gives people like Karl an edge. After the 2004 tsunami in Indonesia, Karl contacted the country director for Catholic Relief Services and asked if CRS would be needing photographic resources. The answer was an immediate yes, and Karl and the CRS director hopped a plane for Banda Aceh. Once on location at the site of the tsunami, Karl shot for CRS and other NGOs. After a month in Indonesia, Sri Lanka, India, and Thailand, Karl had formed relationships with many new contacts. He didn't go to build a client list; he went to do his work and serve the victims. But like all of us, doing his job with excellence and passion, as well as being open to serving others and meeting their needs, brings more opportunities.

Karl's business sense is consistent with the niche he serves. The NGO market is one you serve for the passion of it, not to get rich. There are few markets, if any, that have shallower pockets, and each dollar they part with has to be clearly justified. So Karl, from the beginning, has organized his finances around this reality. Karl spends cash on everything and goes into debt for nothing. Two things inform this. The first is the knowledge that debt will limit his future options to travel and shoot, and it will hamstring him financially. He's also guided by another characteristic I keep seeing in the so-called pros I admire—they aren't swayed quickly by new gear and the promises made by the camera makers. Karl's gear has been through war zones and looks the part; I don't think I've ever seen gear that looks so beaten and worn. His older Canon 1D Mk II bodies look like hell, but they still create great images and that's what his clients want. If a client can't tell that the image was made with a shiny new body, then the money's better spent on further travel or put into savings.

There are a couple lessons to draw from Karl's success and the path he took to get there. Karl is a perfect example of the Back Door approach to becoming a vocational photographer. In the years before he took the leap and began his initial two-year plan, Karl traveled and shot relentlessly, turning volunteer assignments into future clients and looking for opportunities wherever he could find them. While still working full-time in the medical industry, Karl contacted Freedom From Hunger and asked if they were in need of some photographs. To his surprise, they said yes. Karl bought a ticket to Haiti, and while his compensation wasn't much, it was a beginning. Today Freedom From Hunger is one of Karl's most loyal clients; he's traveled the world documenting their microfinance programs.

The second lesson in Karl's story comes from the way in which he's dovetailed expertise and experience from his schooling and career into his current work. Karl was a master's student in kinesiology and biomechanics when he was drawn away by an offer of work in the field. His subsequent experiences in the medical world and his time in operating rooms have allowed him to pursue work for which other photographers would be a liability, and they've given him contacts in the same world he left in order to pursue photography. That expertise, and the experiences they led to, offer strong benefits to Karl's client base that not many other photographers can offer. Karl has found his niche within an already small market, and he's busy excelling in that niche.

Another skill Karl retained and leveraged from his previous career is an ability to sell his services. "You need to be able to overcome objections. Nobody wants to spend money on photography, but you need to be able to show them why they need those images and how those photographs will benefit them. The best salesmen I've ever met are the little kids in India selling flutes and things. You say no, and they counter every objection. You say you don't play the flute, and they say it's for decoration. You say you don't want one, and they say, 'Well, if not for you, perhaps for your wife? Your girlfriend? Your daughter?' They are skilled at overcoming objections, and without being a nuisance that's what sales is. It's persistence."

It hasn't all been easy. He's been robbed and scared witless at times. He travels on a shoestring and eats street food that most people would never consider. But it's his passion, and by the way he's

financed and marketed himself, he's able—debt-free—to live the life he wants in order to pursue that passion. Five international photographic workshops annually give Karl a chance to give back and teach, and those workshops subsidize his NGO work, representing about a third of his annual income and creating a market he can serve when the rigors of international assignment work begin to get too much.

I asked Karl about defining moments. "One day while shooting a job in Sudan, I had an epiphany. I was sitting in the front of a land cruiser, one of two in a caravan. We were speeding across the open desert for hours, heading for a remote village where the drug company and NGO that I was shooting for had a malaria program. I was sitting in the front seat, while the drug company executive and the country director for the NGO were sitting in the back. I could hear their conversation. One asked the other, 'If you won the lottery, what would you do?' The drug company executive talked about

upgrading his villa in Spain and spending more time there; the NGO country director talked about retiring and enjoying time with his family. Although I was not part of their conversation, I thought to myself, if I were asked what I would do if I won the lottery, I would have said, 'I would be doing exactly what I am doing now—shooting pictures of humanitarian stories for NGOs. The only difference being that I would do it for free.' I guess you could say that I had already won the lottery!"

When you can craft your career in such a way that you can answer that question honestly in the same kind of way, you know you're truly following your passion and have made not only a living, but a life.

All images on pages 165–170 © www.KarlGrobl.com

How Many Images Do I Need to Include?

As many as it takes to give a solid representation of your work. Five is probably too few. Fifty is probably too many. But how you choose to present the images, and to whom, will determine this. My own portfolio online is larger than conventional wisdom says it should be, and despite constant efforts to cull images out, it keeps growing. In part this is because I want to show the extent of my work, but in part it's because I want my online portfolio to also be a gallery of my work. It's not an approach for all, but for my markets it has worked well. Wedding photographers will want more work representative of the weddings they've shot than a food shooter is likely to have. Different markets, different needs.

When I was still doing pet portraits, however, that work was not only in a separate gallery but on a separate website under a separate domain, all with its own branding. I encourage you to follow conventional wisdom and begin with only 12–24 of your very best images—not the images you worked the hardest to get, and not the ones for your best clients, but a tightly edited selection of your best work. Remember, this is not show and tell. This is visual communication and marketing. For each image you include, ask yourself, "What am I telling people with this image?" If the answer is, "Hey, look who I shot!" then make sure they care, because most of the time they'd rather know you can work with light, color, composition, texture, and other matters of visual importance than merely that you got a shot of the Dalai Lama. And if you got a shot of the Dalai Lama, make sure it's a *great* shot of the Dalai Lama.

How Do I Want to Present My Work?

If it's a print book, consider what it will look like from the moment you carry it in and deliver it. Consider how it will look in a couple months after weekly book drops to clients who are less inclined to treat your book with the care you do. Put it in a great book that's built in a way that enhances, or is consistent with, your brand. Consider embossing or etching your logo on it, or putting it in a custom delivery case. Just as a well-built website is easy to navigate, make sure the book is easy to open, read, and pass around. Don't make clients turn the book to look at a horizontal image and then again to look at a vertical one. Don't make it so heavy or large that it's a nuisance to pass around. Forget the bells and whistles; put your energy into a great-looking book that's easy to look

at and that contains your best images printed to the highest standards. When a page gets dog-eared or smudged, replace it. Take pride in your book and take care of it; it's there to represent you when you aren't, and if you can't take care of your book what does that say about your ability to take care of the work a client entrusts to you?

If it's something other than a print book, then your options are limitless. I have small on-demand books of my work in the satchel I carry around town and the one I carry onto the plane. I have my work on my iPod, my website, and some DVDs. If there is a way I can give it away or show it, I'm willing to try. However you do it, keep it congruent with your brand and of the highest quality. Update it as often as you need to in order for it to always represent your vision and your visual style as it is now. Images shot ten years ago are fine if they continue to reflect your vision and style, but one has to wonder why you're not growing in your vision and the ability to express it.

Your Next Step

Take some time to look at the options out there. I've already discussed options for web presentations of your work. In some markets, you might be well served by a great portfolio presentation in PDF format that's presented on a branded DVD in great packaging and mailed to a new prospect. Take a look at JewelBoxing (Jewelboxing.com) for a great way to create fantastic-looking DVD packages. You should consider them for packing your deliverables, too, if you give clients files on discs.

Other markets like the commercial/advertising market are much more likely to call in a book, so take some time on sites like Lost-Luggage.com or CaseEnvy.com to see the options available to you. That's the presentation. The hard work is in narrowing down your work to the best stuff. Take it slowly, don't be afraid to make some gut-level decisions, and test the final selections by running your work past several people who know your work and your market. If all this feels far too overwhelming, ask for help. Consultants like Selina Maitreya have been doing this as their only line of work for years, and they know the markets better than we do. She can be found through her website at 1PortAuthority.com.

Go Where They Ain't

One of the easiest and best ways to cut through the endless crowds of other photographers—all offering similar products and services to the same markets while trying their best to look different—is to avoid them entirely. I've long forgotten where I read it, but one of the defining principles of niche marketing is "Go where they ain't." Without resorting to the language of competition, it's a given that only so many similar photographers can service the same market with the same offerings and still all make a living. Something's got to give. But switching paradigms and thinking in terms of niche marketing presents new opportunities, and new challenges, that just aren't there when you're one of the crowd.

Niche marketing removes itself entirely from the crowd and concentrates on a small, undeveloped market to which you are uniquely suited. It relies heavily on expertise, experience, and a skill set that's a perfect fit for a smaller market. If you've got these, then it's far easier to establish a reputation as a leader in your market than it is to set yourself apart from the crowd in a market already heavily serviced. Even by being one of the best and most unique among a field of wedding photographers, it's harder for your market to distinguish between apparent similarities and separate you from someone with similar branding or a similar style. At best you are sharing the market.

But go where they ain't and that niche is yours. You'll be serving a market that generally looks to be served with customized solutions but that can be fiercely loyal when they've settled on a vendor they love. The downside, of course, is that you're putting your eggs in a much smaller basket. But following the simple rules of supply and demand, the baskets in niche markets tend to pay more. Doing work you enjoy at higher fees per contract can allow you to make a better income—or to work less and maintain the same income, letting you focus more on other elements of your craft and personal projects.

So while the obvious question is, "Where are the niche markets?" you'd be looking for the right answer to the wrong question. The best niche markets are undiscovered. A better question might be, "Given your particular skills, expertise, and experience, what niche might you carve out of an existing market? In a perfect world, what are you most suited to photographing?" Now find a way to discover that niche, create it, and then make it yours.

If you shoot weddings, come from an Indian heritage, and speak Hindi, you could develop a very loyal following as a wedding photographer specializing in serving the East Indian communities because you understand the culture, the values, the language, and the rituals. You are perfect for that.

A background in zoo keeping might give you the opportunity to become a commercial photographer specializing in promotional and fundraising photographs for zoos and game parks.

A background in prosthetics and the medical industry might give you, like it did for Karl Grobl, the access to operating rooms and the contacts in the medical NGO world that has allowed him to take his career in the direction he has.

Generally speaking, people hire—and pay more for—professionals in a field of endeavor in which they are considered an expert. The more specialized that field, the more the need for an expert presents itself. Your past experience might be in a job you hated, so there are limits to this advice. But few of us are one-dimensional; most of us have multiple areas of expertise and interest, only some of which are connected to a past job. My past as a comedian could give me an upper hand in a market serving comedians and entertainers, but I have no interest in that. However, there are multiple ways in which that past career informs this one, and many areas of expertise I bring that come from more than just the hat I wore as a comic.

Not everyone will service a niche market, and some who do will serve both a niche and a broader market. If you choose to go this route, then you'll want to make sure you own that niche. Do what you can to be honestly perceived as an expert, if not *the* expert, in the field. If you opt to serve both a niche and a broader market, then you'll most likely need to separate your operations and your marketing. The gains made occupying a niche and being regarded as an expert can be immediately lost if your target market suddenly perceives you as a generalist. One website advertising that you serve two niche markets just tells people you aren't proficient at serving either. It may not be true—you may, in fact, be able to serve both better than some people ever manage to serve one. But perception is reality and niche marketing carries an element of exclusivity. Once that element is lost, it ceases to be a niche market and becomes merely a small market—not at all the same thing.

> "The gains made occupying a niche and being regarded as an expert can be immediately lost if your target market suddenly perceives you as a generalist."

Three (Bad?) Metaphors about Competition

The notion of competition is old-school, obsolesced by a better paradigm. It's built on the notion that anyone with a camera and the technique to use it is on a level playing field from which clients in similar markets have their pick. The winner, in our arena, is the one that out-markets and under-quotes the others. It's a purely Darwinian viewpoint—survival of the fittest. And the best photographers I know don't buy it for a minute.

Reducing yourself to being merely a button-pushing technician is a fast way to lower rates and unsatisfying work. It's the opposite of creating a brand built on your unique skills, experience, visual style, and passion. It reduces you to a commodity, and in a commodity market the lowest price always wins. I'll discuss this further in the next chapter on finances, but for now all you need to know is

> "Reducing yourself to being merely a button-pushing technician is a fast way to lower rates and unsatisfying work."

that there's a better paradigm out there, one that offers you a more satisfying path, better fees, and the ability to have both without selling your artistic soul to the lowest bidder.

The new paradigm—a newer school of thought, perhaps—is built on the notion that where all the photographers bring different levels and kinds of experience, vision, and creative methods to the table, the buyer has the opportunity to partner with the one who best serves her needs. It's not unlike dating. Dating is generally not a competition. Just because the blonde didn't pick me doesn't mean she'll pick you, and vice versa. Of course, there are exceptions, and the metaphor's a thin one at best, but it's about the chemistry—not about who wants it most and is willing to lower his standards the quickest. A great client brings a whole mix of wants, needs, values, and personality to a project and is looking for a photographer with whom those things mesh well. There is a certain market that is, in fact, not looking for that. They do want the cheapest, and vision isn't so important to them. If it were, they'd pay for it. So at some point you need to determine which clients you want to work for and what you'll do to get them. But make sure you first read the section about pricing in "You Are Not Wal-Mart" (page 205).

Why I mention this at all is because I see competition as an intrinsically destructive force in a creative person. There is a sense in which competing pushes you harder, that comparing your work with others encourages you to hone your craft more aggressively or inspires you to move in different directions. But more often it pulls our focus from where it ought to be—on our vision, our work—and on to others. It encourages us to dilute our vision and thin ourselves out as we chase a carrot we probably shouldn't be chasing. It encourages us to forget that it's okay to be an individual. You can't shoot for every market, you can't produce images in every style, and when you try to do so you create a moving target for potential clients who look, not for a jack of all trades, but for someone whose vision and visual style matches what they're looking for. Clients need to trust me, and if they don't know which photographer I'm trying to be this week, they'll go to someone they can trust to be consistent.

Another ill-conceived analogy: U2 doesn't compete with The Dixie Chicks. Neil Diamond doesn't compete with Kenny Rogers. Neil Diamond doesn't even compete against the countless Neil Diamond impersonators out there. It would be

ludicrous to suggest he try. People like or don't like Neil Diamond based solely on his own merits, or lack thereof. I happen to like the guy, but we can't all have taste. U2 doesn't succeed because they try to be better than others. They succeed because they put their efforts into being the best band they can be. Trying to be "not the other guy" can lead you in a hundred different directions. Working on being you can lead in only one direction, and it's there you should put your energies. There are thousands and thousands of potential clients out there, and you can't serve them all. The one who doesn't choose you doesn't matter if they understand who you are but are looking for something else; you weren't going to get that gig anyway, and that's okay.

Can you stand another metaphor? The apple doesn't lose out when someone chooses an orange instead. Why? Because the guy who wants an orange was never going to choose the apple in the first place. The apple never had a chance, and where there was no chance, there is no loss. And if the apple paints himself orange in an effort to be chosen (I know, where would an apple get paint?), then the only potential outcome is a very disappointed person who got a funky-tasting apple instead of an orange. Know who you are and work at honing that, and then communicate it in the most compelling way to your market. Never forget the core of who you are and why you do what you do. Competition will encourage you to be like others, and in so doing you'll only disappoint your clients and miss out on the potential for being a truly unique presence in the market, and in the world. Your marketing should be about you, not about how much better you are than others.

Consider the power of collaboration. Find other photographers, work with them, play with them. Lead clients who are looking for a visual style different from your own to their door. Imagine the power of a community of collaborative photographers, all working for the good of other photographers, and the amount of potential work—great work for which you are uniquely suited—that might come your way. Happier photographers all doing their best work for the right clients, sharing their ideas, and moving their businesses and their craft forward faster than they ever could by being competitive and self-preserving. Counterintuitive? Sure it is. Bad business? Not even close.

> "Your marketing should be about you, not about how much better you are than others."

Business and Finance

I SUSPECT THE PART OF THE BRAIN that gets engaged when creating photographs is on the exact opposite side of the brain that deals with numbers and logistics. The challenge for all creatives who would combine their art with the business realm is to exercise the two in the right way and at the right time, to find a balance between them. It's no secret that a staggering number of small businesses fail in the first few years, and if it's not for a lack of marketing, it's more than likely from a failure to pay close enough attention to finances. Your business will not thrive because you're a photographic genius; there are lots of excellent photographers with failed businesses behind them. Your business will thrive if you take it seriously as its own thing, subject to its own rules— and those rules include contracts, taxation, pricing, negotiations, and being wise with your money.

Contracts

This is not about how to write a contract. That kind of thing falls well outside the limits of my expertise. Damn it, Jim, I'm a photographer, not a lawyer. So consult with a lawyer when it comes to actually creating a contract. The other thing you should do is get a copy of John Harrington's excellent *Best Business Practices for Photographers*, which goes into great detail on matters like legal issues. I cannot recommend this book highly enough as it addresses issues that you need to be aware of, about not only contracts but also the wide scope of your business. It's an ideal next-read after this book.

What follows here explains *why* you need a contract, and I'm writing it hoping that I can convince even a few people out there to take it seriously. A contract is not only for the paranoid; it's a written agreement of the terms to which client and vendor agree, and to which either can appeal when things get fuzzy. Why should you have a contract, written and signed, before beginning work?

Professionalism demands it. Clients expect that a professional will use a contract, and meeting that expectation is important if you want to remain a professional in their eyes. Professionals can be relied on and trusted, and they are worth the fees they ask. Of course, that's not always true, but better to reinforce that belief and allow it to work in your favor than to work against. You negotiate, you agree, you put it in writing.

Clarity of communication is important. No one likes ambiguity, and a written record of all the details of your negotiation keeps everyone honest, prevents scope creep (addressed later in this chapter), and prevents misunderstandings and assumptions. And when misunderstandings and assumptions happen anyway, the contract clears the matter quickly.

To cover your ass. The bottom line is not everyone is honest. We all like to think we can spot the bad apples, but they come out of nowhere and will take you for what they can unless you've got things spelled out and have a legal means of recourse. A verbal agreement is very hard to prove in court. Generally speaking, having a clear contract signed by authorized signatories gives you faster, easier legal recourse in the event of problems.

All of this goes both ways, too. A contract should not be an imposition on a client, but a service to them. It keeps communications clear in both directions

> "Clients expect that a professional will use a contract, and meeting that expectation is important if you want to remain a professional in their eyes."

and protects your client as well. My intention is to convince you of the necessity, and desirability, of a written contract. If I've succeeded, your next question will be, What should I put in my contract? Well, that answer is for a lawyer to give, and it depends entirely on the market you work in. A contract for a wedding photographer will address different concerns than one for a commercial photographer. But here's a short summary to give you an idea of the scope that a contract ought to cover.

A good contract will specify the parties to whom the agreement pertains, when the agreement is activated, and in what jurisdiction resolution will be pursued should there be a breach. It will contain a detailed scope of work and related exceptions. It will spell out payment information—including how much, for what, when payable, and to whom—and will address kill fees, deposits, and the responsibilities of both parties should the work not be completed. It should be clear on issues of usage (license) and copyright for both photographer and clients. And it should outline specifics related to deliverables and deadlines, limits of liability, and definitions for any potentially confusing words.

In short, any issue you discuss with a client regarding the specifics of a job should be part of the contract, including understandings such as a wedding photographer being the only professional photographer at an event, if that kind of thing is important to you. If the contract is attached to an offer, you should specify for how long that offer is valid.

This is not limited to paying clients. Photographers working pro bono or in trade need the benefits of a contract as much as photographers working for a fee. If you are working for an NGO or a charity and have decided to work without a fee (see the section "Take Me, I'm Yours," later in this chapter), a contract will keep things clear and prevent a job for which you are not getting paid from becoming one that is full of misunderstanding and the potential to jeopardize your reputation. A fee pushes a client to take you seriously; so does a contract. Without either, there's a good chance you'll be seen as a volunteer and be treated as such. I don't want to be cynical, but many is the organization that will take what you give, spit you out when they're done, and leave you without so much as a thank-you. If there are specifics to the work you want to do for an organization, or regarding the use of the images afterward, put them in writing.

> "If a company you respect and see as a leader in the industry endorses or collaborates with someone, then generally speaking, some of that reputation will rub off onto those whom they endorse."

Remember, this is just a short summary. What I hope it will do is push you to make a personal policy that states no work is done without a contract of some sort. Large clients and big accounts will require contracts that are significantly more detailed, while clients who ask you to do headshots will require shorter ones, but having a contract in a culture of morbid litigiousness will protect you, your business, your family, and your mental health. So be sure to read Harrington's *Best Business Practices for Photographers*, and then go for a consultation with a lawyer.

Sponsorships

When I returned to photography and made the decision to pursue it as a vocation, I began to actively seek sponsors. Those sponsored relationships have become tremendously important to me and have become a significant part of my business and marketing plan. Before I discuss how these relationships work, you should know why I consider these so important.

When I first joined the fray, I had two problems for which I saw a possible solution in sponsorship. The first was simple: either nobody had ever heard of me, or those who had known me as a comedian were hung up on that ("The guy was a comedian for the last 12 years; what does he know about photography?").

Associating myself with companies like Lowepro or Lexar, my first two sponsors, had a legitimizing effect. If a company you respect and see as a leader in the industry endorses or collaborates with someone, then generally speaking, some of that reputation will rub off onto those whom they endorse. Sponsors allowed me to place their logo on my website, thus adding further legitimacy. It was no smoke-and-mirrors show; they liked my work and were pleased to associate themselves with it. It simply gave me more exposure and legitimacy than I'd have had straight out of the gate. They placed my name, bio, and images on their sites along with links to my own website, raising my online visibility for nothing—and faster than I could have done alone. In the case of Lexar, they asked me to write content for their website—for a photographer who loves teaching and writing, I could hardly believe I was getting all this for free. No, wait, not even for free—they were giving me product I would otherwise pay for. From a marketing perspective, being connected in the right kind of relationship to the right kind of sponsor is golden.

The other problem I had was a financial one. I have not chosen the easiest market in which to follow the call as a photographer. My primary clients are organizations that work for the protection and development of orphans and vulnerable children. These organizations don't have deep pockets with fat wallets, and I have neither the means nor the desire to get rich from this work. But I do need to make a living. I need to stay current with gear, and I need to remain financially accessible to organizations that can afford barely more than expenses to gain the advantages my photographs can bring them in their fundraising and advocacy work. Sponsorships keep my overhead lower—for every thousand dollars of product I am given as part of a sponsored relationship, it's a thousand dollars less income I need to make, and I remain more accessible to clients I want to serve. My sponsors know this, and it's one of the reasons they work with me. So that's why I do it. Over the last couple of years, I've fielded literally hundreds of questions about sponsorship, so let's take a closer look at the other details.

A number of variables go into a successful sponsored relationship. No matter what the nature of that sponsorship, there have to be good reasons for them to get into bed with you, among them the following:

- **The quality of your work.** Companies want to associate themselves with quality. In fact, it's the same reason I want to be sponsored by some companies and not others. Association is a powerful thing, and companies want to—need to—associate themselves with work they perceive to be of the same, or higher, caliber as their own branding.

- **Humanitarian or other charitable focus in your work.** Companies like being connected to something bigger than themselves. They like being a contributor to the photographic community and the world at large.

- **The size and credibility of your platform.** Do you have a blog with an audience of other photographers? Is your readership and influence growing? Is your audience comprised of people within your sponsor's demographic? This is a marketing investment on the part of most sponsors. They give you cash or product in exchange for honest representation and endorsement of their product. The more pull you have within their market and with their consumers, the more appealing you are to them.

- **The return on investment.** What will you give them in return? Every sponsor finds something different of value. Some will want logo placement and product evangelism. Some will want photographs of product in action, articles, or a tutorial video of some sort. They'll leverage this, and if you do it well, you can, too.

There is a downside, a danger that you become merely a shill. My sponsored relationships are open and honest, and they have no contractual strings attached. I work with them because I like them, believe their products make my job easier, and am happy to tell others. Without exception, I choose my sponsors—not the other way around. The moment a sponsor began to create junk and was no longer the leader it once was, I'd bow out. My value to the people who read my blog or come to my workshops is in my honesty and my integrity. If they doubt my motives for recommending a product, then my value—not only to them but to my sponsors—would also drop. Keep it in perspective. They're exchanging photography gear you already use and trust for some marketing push; they aren't buying your soul or your credibility.

If finding and developing sponsored relationships makes sense to you, here are a few more thoughts:

- Assuming you have a blog, start tracking your blog traffic. Knowing how fast you are growing and the status of your traffic is one of the first things a potential sponsor will be wooed by.

- Make your blog the most professional, unique, easy-to-read, content-rich blog you can possibly make it.

- Find an angle. What are you uniquely about? The more clearly you can identify this, the more easily you'll be able to identify potential sponsors and sell them on the benefits of being a part of the team.

- Start teaching or in some other way reaching out to the photography industry. Sponsors want to be part of the larger community, and a photographer who's doing so and can help them extend their reach is more appealing than one who isn't.

- Consider approaching manufacturers, not retailers. You might very well enter into some mutually beneficial agreement with a retailer, but remember that their costs are higher than the manufacturer's costs. When a manufacturer gives you product that has a $100 price tag, that might only cost them $20, and there's a marketing budget for freebies and comp items. A vendor has to pay $50 for the same item before he gives it to you, and likely has no similar marketing budget from which to draw the funds.

- Look for ways to make these relationships strongly mutually beneficial and look at them as that—relationships. Check in with sponsors about new products, and find out how you can help spread the word.

- Remember that timing is everything. Asking a potential sponsor to team up with you at one point in the year might have budget ramifications they aren't ready for. Try again in six months.

- Be creative in seeking potential win-win scenarios. Cooperation is a powerful force in marketing.

So how do you make the connection? Find the right person and initiate a conversation. I've sent e-mails, made phone calls, and sent letters. I've been referred to some by friends and colleagues, and others I've had to really dig for to find a name and a number.

It's Not My Job, Man

Being a photographer in the strictest sense means you are passionate and, it is to be hoped, increasingly skilled at the craft of photography. Being a photographer in the vocational sense means having an expanding skill set that includes, but isn't limited to, photography. Your ability to express your vision photographically is the epicenter of your activities, and it's why I began this book with the assumption that you're no slacker at your craft. But the moment you decide to pursue this vocationally and take your craft to the marketplace, a whole new series of skills needs to ripple out from that epicenter.

What those complementary skills are depends on your chosen market, but within those chosen markets they are generally not considered optional—they are key features of who you are as a photographer, and they bring key benefits that mustn't be overlooked in either your development or your marketing.

If I were a commercial photographer specializing in serving clients that make outdoor adventure gear, those complementary skills might be certifications in certain water sports or rescue techniques. At a minimum, they would be key competencies like basic safety or wilderness first aid.

In my chosen market serving humanitarian organizations, these transferable skills might be less tangible, but no less important—offerings like bilingualism, diplomacy, the breadth of my travel experiences in unstable countries, and even multiple citizenships permitting easier travel. On top of these particular intangibles, there are others.

How are your listening skills? The better you can listen to a client, the more clearly you will understand their needs.

How are your multimedia skills? When a client throws a last-minute request for a multimedia presentation into the scope of the brief, can you roll with it?

What about your interview skills? If you hope to take your vocation to areas with a more public face, one that benefits from public exposure, then the ability to do a solid interview is important.

How's your time management? Being there on time, budgeting enough time for the gig, and being able to roll with it when the project's scope expands but your time limits don't will serve you well in the eyes of the client.

Don't underestimate these core competencies. As a wedding photographer, your ability to deal diplomatically with mothers-in-law has a huge bearing on the impact you make with the client.

Of course, this is all just the logical extreme that comes of the desire to over-deliver for your clients. There are times you'll be tempted to shrug it all off with a dismissive "It's not my job, man," but while that may be very true, you need to pick your battles carefully or you'll be absolutely right—it won't be your job. The job will go to someone who understands that the ability to create a great image is at the very center of this vocation, but it isn't the end of the matter.

Scope Creep

Scope creep is what happens when the willingness to overdeliver becomes assumed on the part of the client. There is a difference between overdelivering on a current project and allowing the scope of the current project to grow into some entirely different entity. It's human nature to get as much bang for the buck as possible, and it's your job to draw the line. The further you allow a client to scope creep, the harder it will be to draw that line, and as I've got an extreme aversion to conflict I generally draw it right at the beginning. Knowing what you will and will not do for the price you've quoted, and communicating this clearly in an agreement up front, is what makes this easier. When a client asks for something that's outside the scope of our contract, I reply the same way every time: "I can do that, and would love to talk to you about how I can meet that need for you, but those changes will affect the budget. If you'll give me specifics on what you need, I'd be happy to get you an updated budget." Or words to that effect. I'm enthusiastic, and I make sure they know I'm there for them 100 percent; I also remind them gently that this "small addition" has an effect on their budget.

> "There is a difference between overdelivering on a current project and allowing the scope of the current project to grow into some entirely different entity."

Firing Clients

At a certain point, you may have to fire a client. The thing about pursuing a business where decisions are not made primarily for financial considerations is that you determine which clients you want and which you don't. But if you're a stickler about attaching decisions to a dollar figure, remember that the client who takes more time than you've budgeted for and pushes you harder than you want *can* cut into your budget enough that the job begins to cost you money. The costs of high-maintenance clients, both emotionally and in terms of time and money, can be too high. If that happens, it's time to let them go. Letting a client know that you appreciate their willingness to work with you but that you no longer feel you're able to meet their needs is sometimes the best decision you can make, freeing up your calendar and creativity for clients who will be a better match. Not every client is an asset, and while client management is important, not every client responds to subtle hints or even outright discussions about the parameters of your relationship. If you can bring a client back on track and redeem a difficult situation, great. If not, run diplomatically for the exit. Just be sure to do it carefully and not burn bridges. A slighted former client, even one for whom you no longer wish to work, can be a liability. Seeking win-win situations is always to your advantage.

This clear communication ensures clients know your value and your professionalism. You don't want to nickel and dime them to death, but you giving your time away for free at the demand of your client is not unlike giving customers the products off your shelf. Most of us can't afford to do business for free, and if you make a habit of it your bottom line will suffer and become an obstacle to you doing what you are passionate about.

If it seems like these last two concepts—"Scope Creep" and "It's Not My Job, Man"—contradict, consider this: when you overdeliver for a client, it's because you've anticipated that overdelivery and built it into the costs. Yes, they get their files on branded DVDs in boutique packaging, delivered overnight. But it's not *free*. You've made a choice ahead of time to assume your clients want the best

service, and you've made it part of your cost of doing business. It's built in. But when they begin making demands that lie well outside the original budget, then it is they who pony up for the additional scope, not you. Doing it once in a while might be a wise marketing expense—if you pick your occasions well. Making a habit of it is bad business.

Finances: How Not to Be a Moron

Few events will make you completely overhaul the way you look at your finances like a bankruptcy. When I returned from three weeks in Ethiopia in 2006, I walked into my trustee's office and signed away my debt. I hadn't intended it to go that way and had tried every other option available to me. After credit counseling, I tried to do a credit proposal, a legitimate means of asking your creditors to take pennies on the dollar on a strict repayment schedule, but my self-employed status made it easier for them to write off my debt as a loss and simply send me straight to bankruptcy. I recommend you do everything you can to avoid getting to this place. Bankruptcy isn't the end of the world, though it makes things complicated; what makes it so undesirable is the road you need to take to get there. Generally, we start businesses to build something, to make a living—not to drive our finances and all we've worked for into the ground. Arriving at the point of bankruptcy usually means taking a stressful road full of bad choices and circumstances—many of them avoidable.

Going bankrupt was a bit of a dehumanizing process at first, but I was forced through a reprogramming process in regard to money. And when I made the transition that would allow me to pursue my photography full time, it put me in the position I should have been in the first place—debt free and with a solid plan informed by some actual financial wisdom. Since then I've been amassing a list of ideas for an imaginary course called *How Not to Be a Moron with Your Money*. This is the syllabus.

Go In with Capital

If you're looking at this as a transition you will make—and not something you're already up to your neck in—then the single best financial advice I can give you is to make the transition with the most amount of capital you can possibly arrange. Save a little longer if necessary, but go in with more money than you

think you need. Sit down after you've read the rest of the financial stuff here, and figure out what you really need for a year in business—bearing in mind that launching a business can be exponentially more expensive than simply maintaining one. Depending on the kind of market you decide to work in, you could have marketing costs, setup costs, accountant costs, new gear, new office equipment, and a new facility lease. Not to mention the possibility of employees.

Go In Lean and Trim

If it makes more sense, rent instead of buy. Talk to your accountant and consider leasing as an option because it lowers your initial cash outlay and can bring tax advantages that purchases can't. But above all, make sure you've got money in your pocket. Going into a new business with an unproven track record and financing it with credit is nothing short of gambling. One of the best ways to keep your overhead low, and your nights restful, is to avoid debt. A line of credit can be a helpful thing at points, but even then I suggest you talk to your accountant about it. The world of money is complex, and a good financial advisor is key. If you don't have a good advisor, find one. Consider also finding a financial or business mentor.

Keep Your Overhead Low

One of the effects of financing your business with a credit card is the gradual increase in your overhead. The income you need to earn to make the same amount of profit increases monthly. It sneaks up on you. Credit has its uses, but its abuses are much more common; in effect, you are borrowing against future income, which is neither predictable nor guaranteed. Furthermore, borrowing generally guarantees you'll always be borrowing, never giving you a chance to get ahead. On the other hand, lower overhead means you need to bring in less income to make ends meet, and you have the freedom to pursue travel opportunities or that pro bono gig in Bali without being tied to higher monthly obligations.

Credit is not the only way to drive your overhead up. Leasing a space that is more than you need, or at the top end of what you can afford, means you have less room to wiggle when the economy gets tough or your market dries up. If

> "The single best financial advice I can give you is to make the transition with the most amount of capital you can possibly arrange."

you specialize in shooting actors' headshots and the Screen Writers Guild goes on strike, your revenue could drop significantly. But overhead never does. You still have credit to service, employees to pay, and a studio to pay for. Weathering that can dry you out; keeping your overhead as low as you can keeps your belt tight, and it means you can move faster, change directions quicker, and compensate for the ups and downs of business with fewer casualties.

So how do you keep the overhead low? Begin by intelligently assessing your credit spending, and don't carry a balance. If you must finance with credit, do it with low-interest credit, not a credit card. Then look at your monthly recurring costs. Do you really need a landline, or would a cell phone with a good package be smarter? Do you need that large studio? If so, do you need it all the time? Could you rent it out one or two days a week and allow that rental fee to take a chip out of your overhead? Are your employees making you money? I'm not arguing that you should fire someone. In fact, hiring one more employee is the better decision if you pay him $2,000 a month and he makes you $5,000; just know how the numbers add up. Then take a look at all the gear you own and get rid of the liabilities—consider selling the stuff that doesn't make money and free up that storage space. Selling a piece of gear that you don't use so you've got the funds to buy gear you will use and make money with is trading a liability for an asset, and is a smart move.

Assets and Liabilities

Simply put, an asset is something that makes you money, and a liability is something that costs you money. That fancy macro lens you bought just to play with is a liability to your business. If one day you make money on it—more money than you paid for it—then it becomes an asset. For now, it is not. If an extra computer means you can grind through your digital workflow faster and therefore take more work, then it's an asset if and when it has paid for itself.

Too many photographers—and this is a hazard of the craft and the types of people drawn to it—get lured into believing that the more gear we have, and the more expensive it is, the more professional we are. Unless that sexy expensive gear pays for itself and makes money for you, it is a liability. I don't think I can be clearer about this. Decide whether you want a tightly run business with money in the bank, or gear that will make you feel more professional but costs you money and keeps you from spending money on projects that truly matter.

"Keeping your overhead as low as you can keeps your belt tight, and it means you can move faster, change directions quicker, and compensate for the ups and downs of business with fewer casualties."

Remember that most technology will either wear down or obsolesce within a predictable timeframe. I expect to get three years of use from my computers. More is great, but unlikely. So if my MacBook costs me, for example, $1,500 and lasts three years, it costs me—and must make more than—$500 per year. Does it do that? Absolutely. If I bought a $2,000 tilt/shift lens, it's unlikely that lens would pay for itself, let alone make me money, no matter how long I owned it. So what do you do when you want gear but can't truly afford it? Rent it. More convenient in some places than others, the ability to rent a lens for a project and charge that cost to the client means you can create the work you need to with the tools you require but without making purchases that will only become liabilities.

Stay Debt Free

This one bears repeating. There is smart debt, even necessary debt, and there is crippling debt. Usually they look the same at the beginning when you desperately want that new—shiny!—laptop or lens. One of the best ways to stay out of credit debt is to avoid impulse purchases. Simply not making unplanned purchases is a good way to keep the emotional aspect of a purchase at bay. Planned purchases can be thought through intelligently and paid for with savings. Unplanned purchases are often the ones that go on the card. Don't do it. If you see something you "just can't live without," there's a better chance than not that if you leave it for a month, you'll realize you don't need it after all. If you really did need it, you probably would have felt that need before you saw it in the catalog and your impulse kicked in. There will be times when your impulse puts up a fight. "If I don't buy it now, I'll have to spend more money on it later," you say. Maybe. But again, if you're in this position you probably weren't planning on this purchase in the first place.

Plan your major purchases ahead of time. I generally sit down at the beginning of the year, at the same time I'm making plans about my marketing and my business development. I look at my need/desire for new technology, and I plan it out. Do I need a new lens this year? What about a new camera body? New laptop? New hard drives? Of course, some purchases creep up on you; these things happen. How can you possibly plan for unexpected purchases? Easy: Plan for the reality that the unexpected will happen and save for it.

Prepare for Contingencies

You can't plan for your hard drives to fail, but you can plan for contingencies to occur. You don't know which piece of gear will break or die an early, just-out-of-warranty death, but you do know something will. Consider putting 5 to 10 percent of your gross receipts into a savings account for contingencies. Not for urges or to buy that new Leica you just have to have, but for actual emergencies and unplanned necessary expenses.

Unplanned contingencies lead to unplanned spending, and unless the money's there that expense goes on the credit card or the line of credit and then these things just spiral higher and higher. You know it's going to happen, so save for it.

Prepare for Taxes

Speaking of the unavoidable, tax time comes around at the same time—or times—every year. It's not a surprise, and if your accountant is doing books regularly the amount you need to pay shouldn't be some mystical number derived by throwing rocks at a circle of candles while standing on your head. Ask your accountant how much you should be tucking away and then do it. Create an account that is for taxes only and be faithful with it. It's boring. It's not glamorous. That money could buy a nice new lens. Don't do it. Save for the tax-man. You're running a business, and this is just one of those realities you need to live with; pretending it won't come around again this year won't make it so. In fact, the less you acknowledge and plan for these realities, the more stressful things will be when the time finally rolls around. Stress is a terrible companion to creative work, so do your emotional and creative life a favor and put money away faithfully each time money comes in. Make it a non-negotiable.

Save for You

I'm guessing you don't want to work 365 days a year for the rest of your life. There will be vacations and the needs of your children and family, and the inevitable point at which you can't, or choose not to, work anymore. Saving for these eventualities is a choice you make based on your needs. It took me years to get around to this, primarily because I was servicing a huge debt; putting money

"Stress is a terrible companion to creative work, so do your emotional and creative life a favor and put money away faithfully each time money comes in."

aside when I was paying 18 percent interest on credit debt just didn't seem like the best place to put my money. I now put a set amount of money each month into a registered savings account. It's withdrawn automatically, and with my permission that amount is increased by a certain percent each year. It's not much, but it adds up, it isn't something I need to make a decision about each month, and it keeps my taxes a little lower at the end of the year.

Price Your Work Wisely

So far we've talked about spending and saving, but not about earning; talk about putting the cart before the horse. This one's impossible to write about with specific numbers—there are so many markets representing so many demographics and areas, and economies rise and fall. So let me skirt the numbers and talk about a couple principles.

Creative people hate talking about money with clients. I think there's a feeling among creatives that talking about money borders on prostitution and sullies the dress of the muse in whose influence we work. But even muses need to eat, and taking on a false nobility on issues of money will make you broke. So I'm going to be blunt. If you intend to make a living from your photography, you need to embrace your multiple personalities; you are both a photographer and a business manager. When you are shooting, you are a photographer. When you are discussing business, you are a business person. No exceptions.

The first step is knowing your cost of doing business (CDB). There are online tools for calculating this, but you should probably first understand the principle. Take all your annual expenditures, including the salary you pay yourself, your savings for retirement, taxes, and contingencies, and add them up. That's how much it costs you to do business. If you do it right, the number should shock you. This is your cost of doing business, and it's the number you need to determine before you begin to know how to price your work.

Now that you have your annual CDB, step back and look at your calendar. How many gigs can you realistically take? I couldn't tell you what this number should be, but if it's international assignment work, as it is for me, your spouse might be able to. Divide the big number by the small number and you've got a pretty good idea of what you must charge. This number can be offset by other

> "When you are shooting, you are a photographer. When you are discussing business, you are a business person. No exceptions."

income-generating activities. Selling prints or other activities that do not require your presence is a good way to pull down the number you need to charge to stay afloat, and we'll discuss that in the section "Dig More Streams," later in this chapter. You might also consider that some markets can subsidize others; clients with big pockets and big contracts can pay you more, while charities and small clients can pay you less. If you do the math right they can balance out, allowing you to make the money you need to meet your CDB and still remain accessible to the markets you want to serve.

The other option is guessing and quoting the number you feel comfortable with. I can tell you from firsthand experience that this is a strategy reserved only for those with "Drive this business into the ground so I can work at the local coffee shop" in their business plan. Take the time to crunch the numbers.

Finances are not something most creative people love to talk about, preferring at times to hope for the best or trust the talent fairy to hit them on the head with the wand of profit. Don't be mistaken about this—you wear two hats, if not more, and when it comes to your finances the creative hat needs to be stuffed in the closet and the door locked.

Your Next Step

If some of this is still a bit too abstract, try this: Take your current salary and add it to the calculations for your cost of doing business. This should give you a quick way of seeing what you'll have to make to both pay for the cost of running a business and still maintain your current lifestyle. If it looks intimidating, that should further build a strong case for solid financial management.

I suggest you take a couple of hours and look at your CDB. Search for an online calculator, or follow this link to a calculator on the National Press Photographers Association (NPPA) website: https://www.nppa.org/professional_development/business_practices/cdb/.

For further reading on this topic, consider checking out these two excellent books: *The Wealthy Barber* (Three Rivers Press, 1997), by David Chilton, and *Rich Dad, Poor Dad*, by Robert T. Kiyosaki (Business Plus, 2000).

Photo: Lucas Brown

Zack Arias

ZackArias.com

ZACK ARIAS is an Atlanta-based music photographer with a successful studio and a full shooting schedule. Although he's increasingly well known in the photography world, you'd be forgiven for thinking that Zack's journey has been a smooth ride. In fact, it's been anything but smooth, and his story's a reminder of the power of perseverance. I mention this paradigm elsewhere, but it's worth remembering that while so many people talk about becoming a vocational photographer in terms of taking a leap, it's more like walking up a hill. You take one step at a time, and when you slip and lose ground, you get back up and keep forging ahead. There's not a single working photographer I've met who's decided to pursue his or her passion with abandon, and after putting a business card under their pillow they wake up the next morning with a viable business shooting the work they find most gratifying.

Zack took a photography class in college to keep from flunking out. His teacher saw talent and suggested he go to art school, which he did, flunking out within a year. He took some time off, traveled for six months in a VW van in 1995, then entered a two-year commercial photography degree program at Gwinnett Technical Institute. It was there Zack won a large photography competition and got his

brother's basement, selling his gear piece by piece on eBay. The alternator went on his car, and he sold his 70–200/2.8 lens. Piece by piece, it went out the door until he was left with an old camera bag and a beat-up Vivitar 285.

By the end of 2003 he was working at Kinko's, having given up on photography as a career, when his friend, photographer Marc Climie, asked him to be a dedicated second shooter at weddings. Marc loaned Zack enough gear to shoot the weddings, and Zack began shooting again. He left Kinko's soon after, still borrowing a Nikon D100, some glass, and CF cards from Climie. Zack began his return to photography through the back door, shooting "anything but porn" and taking $25 gigs on Craigslist.

When he left Kinko's, Zack accompanied some musician friends to a show they were playing. Zack shot the gig for a couple bottles of Newcastle, but shot some images that captivated him and sparked an interest in music photography. The next day, he got on Google and began a couple of months of music photography research. At the beginning of 2004, he stripped his website of all his portfolios except the work related to music, and painted himself in the niche of his choosing. He posted his name as Zack Arias—Atlanta Music Photographer, and began going after local bands. Since then, he's worked with over 400 solo artists and bands.

Zack's research made him aware of his market in ways many photographers never do. One of the main challenges has been building value into press kit photographs, which is the work Zack most actively pursues and shoots. Local musicians knew a photograph was a key element of press kits, but

first taste of the potential in pursuing photography as a career. He graduated and moved his young family to Dallas to pursue photography while working at Starbucks. In 1998, he left Starbucks to take a job managing a JCPenney corporate studio, then bounced around from gig to gig, eventually landing at Apartments.com in 2001. It wasn't sexy work, but it paid well and gave Zack the chance to shoot and work on his craft and freelance business. He got absorbed in his work. His family fell apart, and within two years he was back in Atlanta in his

inevitably had a friend with a camera shoot them against a brick wall. Very edgy. Very cheap. Spending anything more than a six-pack of cheap beer is out of the range of most budgets. Zack's task was to convince them to change the budget and give them a reason to do it.

Zack treats each gig like a shoot for *Rolling Stone*, in part as a clue to his standards, and in part because he shoots for the gigs he wants, and Zack wants to shoot for *Rolling Stone*. Zack began shooting images of higher caliber than what local artists were used to, the images were posted on MySpace artist pages, and comments about the images began to increase. These comments have huge value to musicians, and as more bands took notice, Zack got busier. Booking agents were taking images more seriously, and that too had value for musicians. Zack spent a year hustling the streets and venues in Atlanta, shooting for $25–$100 for press kit photos until he got busy. When his calendar was full of $250 shoots, he increased prices again, and again, until he was still booked solidly at rates in the $850–$1,000 range.

Zack's success has come not because he knows the secrets but because he's been tenacious and undeniably good at what he does. He's learned from his defeats, and now operates a tightly run business with a clear picture of his market. He shoots what he loves and is not distracted by projects that don't appeal to him. He knows why his clients come to him, and he delivers a great product and service. Zack focuses on building relationships with his clients, and invests himself heavily on the internet. "I really have no idea how anyone did this before the internet," he says. "You can buy a domain for $8, get a template website for another few hundred dollars, and then get out there and hustle work. There were phone books, source books, and brochures before that, but they all had setup fees that were 10 times more than the purchase of a basic website."

Zack leverages his presence on his website, as well as his popular blog, Twitter, and Facebook, all of which help him connect with current and prospective clients, and serve as the watercooler he uses to connect with peers in the industry. His clients keep up with his latest work through his blog and stay in touch through social media and blog comments. Like other photographers looking to diversify, Zack's a passionate teacher and uses his blog and Twitter to advertise his workshops.

For Zack, the key to social media is to keep it social. "I'm not trying to win a popularity race in social media right now. I see too many people trying to get their followers and friends numbers up like there's a race to win. There are iPod giveaways, free this, free that, just to get numbers up. That, to me, feels disingenuous, an obvious attempt to

begin a marketing campaign or feed an ego. There is no race to win; no one is handing out trophies when you hit your Facebook 5,000-friend limit. Just be genuine, and contribute work, ideas, and techniques that have real value to them, and you will slowly build a strong community of like-minded individuals that you will be proud to call friends instead of sheep."

Zack's advice to photographers making the transition is twofold. First, put away the credit cards. "I know the pressure of having to have all the gear. At one point, I was $20,000 in debt. I owned a ton of gear that I knew I had to have, yet I barely knew how to use all of it. Debt created a lot of pressure in my life, and I ended up selling all that gear before it was even paid off. That's a pretty terrible position to be in."

Second, he says, find your niche. "Dig deep into your visual soul and find out what you *really, really, really* want to shoot and just go after that market. You may find you have to spend your first year or two shooting a lot of different things until you find that specific niche you want to fill in this industry, but find that niche as soon as you can. The fear of the niche is that you will be leaving all of the other kind of work you do on the table. The problem with being the jack-of-all-trades photographer, though, is that *everyone* is your client—and you can't market to everyone. When you find your niche, you find your market; you can identify where your prospective clients are, and market directly to them. The goal is to become so busy working within that narrow market that you don't worry about all the other jobs you could be doing."

All images on pages 199–204 © Zack Arias (www.usedfilm.com)

You Are Not Wal-Mart

It is very tempting to think that price alone gives us a competitive edge. If I just price myself low enough, the thinking goes, I'll get the gig. It's not surprising we think this way, given the proliferation of big-box stores and the "lowest price is the law" mentality of the discount retail market. The problem is in transferring this line of thinking from one based on thousands of units of cheap widgets to one based on a unique talent that can only be in one place at one time and has a specific cost of doing business. You can't compete on price alone, nor should you. In fact, doing so can harm you and the industry. Here's why.

You have set costs, and unlike a department store, which can lower their prices to only pennies above cost—sometimes even going below cost, creating what is called a "loss leader"—you can only sell one of you. A loss leader is an item sold at a loss in order to pull customers in with the hopes of selling them other items at a higher profit margin. They lose $5 on one item with the hopes of making $20 on another. You, on the other hand, can only be in one place at a time.

Furthermore, if you and other area or industry photographers begin a price war you sabotage your own branding and value. There is only so far a competition waged on prices can go before no one can afford to go on, and there are no winners. And when you finally come to your senses and return to charging what you need to make (to cover your costs and make a profit), you have to *retrain* your clients and convince them of your value. And that's an uphill battle.

There is also one more thing to consider. Value is not determined by price. Value is about what a client gets for the price paid. If I pay $100 and get nothing, that's not value. It's cheap. If I pay $1,000 and get much more than I expected, that's not expensive; it's value. And when you consider this way of thinking, it's easy to see how competing on price can lead a client to look at your pricing and ask the question, "What's wrong with their service? Why are they so inexpensive?"

Repeat after me: "I can't compete on price alone." Is pricing important? Yes. Will clients consider the price? Yes. But if you need to lower your prices until you are bankrupt, then these are not clients you want, and you should find a new market or register as an official not-for-profit. (At least that way you can get a tax break.) The clients who are worth keeping want value, and that's defined differently according to the market.

> "Value is not determined by price. Value is about what a client gets for the price paid."

> "Negotiation is a concept that involves both parties getting what they need, not one party making expensive concessions."

What clients want is bang for the buck. The hard reality is that there will be clients who want the world for nothin', and when that happens, they aren't clients at all—just people or companies looking to exploit you. So let me try to say this without coming off as a jerk. Ninety-nine out of a hundred clients like this should be avoided without a second look. They'll promise free promo; it's not promo you want. They'll promise future work if you do this on spec; it won't happen. A client who doesn't recognize your value now won't recognize it later. You'll think that these clients will be a step up the ladder; they aren't—there are no rungs on the ladder they're asking you to climb. If you really must work for free, do it on your terms, not theirs.

What gives you the strength to say no to clients who insist that you compete on price alone is knowing what your CDB is and knowing that these aren't cheap or free gigs. They cost you, and you can't afford to take them. There are plenty of occasions when negotiating a lower fee is in your favor. There are even occasions when working for no fee at all is in your favor. In both those situations you'll be looking for something specific out of the exchange. Shooting for a worthwhile NGO in exchange for access to a story, a tax receipt for a gift in kind (check your national tax laws on this), or as part of a personal project can be a win-win situation. I'm a fan of win-win situations, but in these circumstances it must be you who is calling the shots. Negotiation is a concept that involves both parties getting what they need, not one party making expensive concessions.

So how do you compete, if not on price alone? By building a business that listens to and serves the clients within that market. Not everyone can afford a Ferrari, and the local Ferrari dealer doesn't lose sleep over the hundreds of people buying Chevrolets at the dealership around the corner. They weren't going to buy from him anyway. He focuses on his market. The other guys are busier. The other guys are selling way more cars. It doesn't mean the other guys are more profitable; the moment that Ferrari dealer begins to lower prices so that a Chevrolet customer can get into a red Italian car, he's lost the game and will shut his doors forever. Don't get into the trap of taking on work where you will lose money. Let it go. Spend your time on the clients you have now. Take those two days working for the client with empty pockets and pour that time into current clients.

You've established a brand and a unique selling proposition (USP) within a market; don't sabotage it. To return to my earlier analogy, there's a greater danger to the Ferrari dealer than he thinks. Even if he managed to offset the losses made by slashing prices to make Ferrari more accessible to the Chevy crowd, he would not survive the loss of his current market. Part of the Ferrari USP is its exclusivity. The moment the Chevy market can afford a Ferrari, Ferrari has become a commodity and not an exclusive brand—and Ferrari owners and potential owners will jump ship immediately. They want exclusivity, and if Ferrari no longer offers it, Lotus will. You don't offer exclusivity, fine, but by diluting the strength of your brand in order to serve the deep-discount crowd you'll be trading away a good market in exchange for one that won't pay you.

Your Next Step

If you haven't already done so, figure out your actual CDB and what you need to earn in exchange for your time. If you suspect your market contains a certain segment looking for deeper discounts than you can afford, but for whatever reason you don't want to lose them, find a way for all sides to win. Is there a day your studio is usually quiet into which you can book discount clients and then make money on the back end with print sales? Is there a way you can incorporate their needs for photo resources with your stock library so you make money in residual stock sales from the shoot? Photography is a creative craft—so is business. Look at these negotiations as a chance to exercise that creativity. Finally, if you have current clients who are losing you money and not offering other returns you don't mind paying for, then you need to find a way to cut them loose. They might be wonderful people, but they're picking your pockets.

Negotiations and Love Songs

With a nod to Paul Simon for unknowingly lending his lyric to the title of this section, let's talk about negotiations and setting—or raising—your fee.

No one likes talking about money—at least not most artists. Start talking about money and artists shuffle their feet and hem and haw and look at the dirt and hope the whole thing just goes away. Sometimes it's false modesty and an effort not to appear like—forgive the crass analogy—a whore in drag as an artist. Other times it's just that we haven't done it much and have no idea where

to begin. But we must. If we are going to make a living by fusing our craft with commerce, we must get good at speaking comfortably about money. So first things first: get over it. You can't live on love. You have rent to pay and groceries to buy, and have you seen the price of lenses, insurance policies, and web hosting? It adds up, and when a client asks you the terrifying question, "How much?" you need to be able to look them in the eye and quote more than most of us think we have a right to without batting an eye. If you believe in your work and want nothing more than to do it sustainably, then you must get good at doing this.

Last week my financial advisor called me up and asked to buy another print. He collects my work; in fact, he is the largest collector of my work. I quoted him a price, and he agreed to pay it and put a check in the mail that day. Then he said, very seriously, "We need to talk about your prices. You aren't charging enough." And he gave me this formula—as a client of mine who would have to live with the actions I took based on his wisdom: he said, pick a number that makes you uncomfortable (in fact, what he said was "a number that scares the hell out of you") and then add 20 percent.

We are terrible at talking about money and that needs to change. Yes, stay humble, approachable, and open to negotiation, but figure out your worth and then charge it. I'll discuss this at greater length in the coming pages, but here I want to talk about negotiating.

Negotiating is the art of finding ground on which both parties can find a win-win solution. They must get what they want; so must you. Keep the following in mind when negotiating.

First, if this relationship is going to be a productive, long-term relationship you need to keep one eye on the long term. Going into a negotiation with a reluctance to compromise and seek a win-win solution may win the battle for you but lose the war. Keep it friendly and with a focus on getting the client everything she needs.

The more information you have, the more informed your negotiation will be, and the greater your ability to find a path through what may seem like conflicting needs. So listen carefully and ask as many informed questions as possible. Asking questions may also help distinguish between client needs and client wants—not always the same thing. Remember, a client hires you for

> "Pick a number that makes you uncomfortable and then add 20 percent."

> "When you
> know what
> a client's
> priorities are,
> you are better
> able to hold
> your ground
> on a quote."

your expertise, and there may be times when she assumes she needs certain things when you know from experience you can give her something more or something better.

The 80/20 rules says spend 80 percent of your time listening and 20 percent talking. It's good advice.

Keep an ear open for the non-negotiables and discuss the big issues first. There's no point negotiating a price if the bigger issues are deal breakers. If the client wants you to provide an elephant and dancing bears but you know it's not possible or worth the stress, now is a good time to bow out. When you know what a client's priorities are, you are better able to hold your ground on a quote.

Not every negotiation is about money. If there is no way the client can work within your budget, see if there's a creative means by which they can still make it worth your while. If they can't pay you exactly what you want but you'd like to take the gig in Bali, then consider taking a pay cut but ask them to leave you down there for an extra few days on their tab.

When the money question comes up, consider asking for some time to come up with a quote. Time gives you some objectivity. This is why I never provide pricing online or without first making sure we've covered every angle. Even if it's a request that they give me from an hour to 24 hours to look at some details, it provides the time needed to do some research and come up with an intelligently considered budget. Budget is important to clients, but for most of them it's not the only consideration. Don't be rushed into a price.

Being accountable to a spouse or a manager also gives you some time, and an appeal to a higher authority is a time-honored negotiation gambit. Take the time to talk about the client's needs and then let them know that you'll run the details past your business manager or your spouse and get back to them. This tells the client that you are not the final authority and makes it easier for you when they start pushing the budget.

In the end it has to be a respectful, relational process. There is nothing wrong with saying no. I've advocated that you underpromise and overdeliver, but make sure you get it right because the opposite—and the risk in negotiations—is to overpromise and underdeliver.

As for the issue of pricing, the best I can tell you—given the broad markets in which photographers operate—is that it begins first with knowing your cost of doing business, listening to your clients, doing some research, and then learning by trial and error. Our approach needs to be driven by us, not the market; it's the same with pricing, and it's equally counterintuitive. Yes, there is a point at which one market will no longer pay your rates. But that does not mean there isn't a similar market that will. Some photographers could get no more than $200 for a headshot session. Another one in the same area could get $800. They aren't the same clients. To borrow a fishing analogy, you catch what you're baiting for. A $200 photographer will attract $200 clients. An $800 photographer will attract $800 clients.

When I was still entertaining I learned a valuable lesson. I was getting busy doing $500 shows early in my career. I doubled my prices and didn't lose half my clients. More income, less work. Newer clients came on board for whom the $1,000 price tag was more standard. The next year I raised my prices to $1,500, and again didn't lose half my clients. I was now working about 30 percent less but making more than 100 percent what I was two years earlier. I had more time to work on my craft and pursue other clients, and I was happier and healthier. Don't overlook the math on this kind of thing.

> "Have a new conversation every year and discuss how much you will raise your fees. If it doesn't scare you—and if you don't lose at least a few of your clients, and get some push-back from others—then you haven't raised the fees high enough."

Pricing is a tricky game for the very reason that we often begin with the question "What will the market bear?" with no sense of the answer. For example, while some people will look at a $200 headshot photographer and think the price is just a little high, others will wonder if they're going to get decent quality and service, and they might prefer to spend $500. Value is not in how little we spend, but in how much we get.

If you're like me at all, this kind of thing probably makes you break out in a cold sweat. It's not easy, I know. There will always—always—be risks in business. Finding appropriate pricing is among them. Talk to your clients, talk to peers in your city and beyond. Survey the landscape. But if you do the math and you can't do one thousand $100 headshot sessions in a year, then you need to charge more.

There are online tools for determining pricing and license fees for various markets, so I won't duplicate that here. The numbers change so fast that they'd be out of date too quickly anyway. But I encourage you to think about this issue often, and consider running it by someone else. A spouse might be more objective, so you might want to ask your better half to help you set a fee structure. Have a new conversation every year and discuss how much you will raise your fees. If it doesn't scare you—and if you don't lose at least a few of your clients, and get some push-back from others—then you haven't raised the fees high enough.

Let me finish this section with one more thought. Like so much of what I say, it might sound crazy, but it works for me because I'm honest and have the client's interests truly at heart in a negotiation. Many times the issue of money has come up. Most times—and remember the market I work with: international development agencies—I've bounced the ball back into their court with the simple question, "What's your budget?" There's nothing anywhere written that states they have to ask the question first. Furthermore, it's an honest question. I'm committed to doing what I can to work with clients on this. I know what I need, but I also know there are lots of ways to make everyone happy. In many cases, the client already thinks they can't afford me, so when I ask them what their budget is it opens a dialogue for them and makes the whole thing much easier. By being the first one to bring it up, you communicate not only concern that you can serve them, but you place the ball in their court. It's a proactive move. But here's the kicker: several times I've been paid more than I would

have had the guts to ask for, and each time it confirms my value. Over time I've learned my value in each of the markets I've served, and every year I diligently raise my prices to accommodate for the growing value I offer. Asking about budget so bluntly won't work with every client; they all work differently, and when they issue an RFP (Request for Proposal) the ball's back in your court. But for many photographers it's a good start because it addresses the issue of value. If they plan to spend $2,000, this is your chance to let them do that, and to give them the most bang for their buck.

Take Me, I'm Yours

One of the most counterintuitive notions for a person intent on selling their wares is to give it away. We get into this in a vocational capacity to earn an income, to pay for our gear, to live debt-free and pay the bills. We get into it to do what we love. Giving it away seems like the wrong way to get down the right street, and so many of us never explore the advantages. In fact, so often the resolve not to work for free, not to be taken advantage of, stops us from doing what we love. I know this goes against the flow, but I'm going to put it out there anyway—free is powerful. For those of you who just got goosebumps and a desire to write me a rebuking e-mail about how this is killing our industry, stick with me. In fact, in the next few pages I'll discuss the need to guard against this kind of thing. But it's your career—your calling and passion—and if creating photographs without a fee attached to it helps further that, then it might just be that the industry needs a recalibration.

I have worked without a fee attached. I still do. But it's never free. It always costs someone—usually me—and I'll discuss that in a bit. So it might be helpful to stop using the word *free*. Perhaps calling it no-fee photography is more accurate. Working sans fee—not only at the beginning of your career but all the way through it—can bring some strong benefits worth considering.

Not the least of the benefits a no-fee shoot can bring is the freedom to create work that you can put into your portfolio. We are judged by our work and our experience, and you need work to get work. Doing some collaborative shoots for a person or group that has no budget allows you to create work and to experience the collaborative environment of a working relationship without risk for either side. They get images—you get experience. I'm careful to say that this

would be for a client without a budget because if it's a freebie for a cheap client with a large budget, then it's exploitation, and I'm pretty sure that's a step back for everyone.

Related to this is the control that you have over an end product when working without a fee. When a client pays you, you surrender a certain amount of creative liberty. That's the reality of combining your craft with commerce, and if you'd prefer not to deal with this then you might experience less angst by crossing "vocational photographer" off your list of ambitions. There is always a measure of compromise, even if it's just the constraints imposed by the fact that you're shooting a cover and need room for a masthead. Shooting without a fee will introduce you to some of these constraints; after all, your images are no good to the client if you don't shoot the brief, but you'll have greater freedom to play and explore your options. That's the trade-off the client accepts; if they aren't comfortable with that, then an appropriate fee can be arranged.

Shooting without a fee can get you into places and gain you access to people you might not otherwise get. Donating a week or two of your work to a struggling conservation agency in Rwanda could gain you access to mountain gorillas that few others can get without paying an extraordinary amount of money. It's a win-win-win situation. You get to create the work you're passionate about, the conservation agency gets images it can use for fundraising and awareness-building, and the photographic community at large isn't harmed because it's for an agency that wouldn't have had the budget otherwise.

Finally, shooting without a fee is sometimes just the right thing to do. You got into this, I assume, because you love it, not because you love money. And there are times when you need to free yourself from the money-chasing that this business can lead to and just go give it away. Call it karma, call it reaping what you sow—giving it away is good for the soul. And, not to put too fine a pragmatic point on it, it's good marketing. It's more relationships, more contacts, and another chance to make connections. It's casting your net wider. That's the shiny side of the coin.

Free is a powerful word, and a powerful concept. It's getting a lot of discussion in the marketplace, with some going so far as to suggest it's a commerce model all its own. Boiled down, it amounts to this: the market is clamoring for *free*. If you don't give it to them, someone else will. In our context, they want free photography, free postprocessing, free images, free teaching. Turning a blind ear to this is not only mixing your metaphors in a dangerous way, but is a good way to get left out in the cold. We have to listen to the power of free. I write consistent and valuable content on a blog that costs my readers nothing. When we give, everyone gains—including the giver. Free wallpapers cost us nothing but give something to the market. Free prints when you book a sitting—they cost the photographer pennies, but provide a great gain for the consumer and the producer.

On the other hand, giving it all away for nothing is not viable. In some ways, there is no such thing as free. It's an illusion. My wife wants to eat, and so do my cats. My landlord comes back each month for a rent check, and my cameras are going to need to be replaced. Doing business costs money. So does living.

You've been given only so much time and talent with which to pay the bills. Give it all away and you're hurting yourself and others. I recently received an e-mail questioning the price tag of the annual Lumen Dei workshops Matt Brandon and I lead. What my interlocutor failed to realize is that these workshops take a year to plan, market, and administer. Ignoring the costs such as airfare for instructors, all meals and ground costs, and so forth, we give two weeks of our time, plus three or four days of pre-trip planning in-country and at least two days of travel. Call it an even 20 days, plus an estimated 10 solid days of planning during the year. Thirty days. If we do not charge accordingly, those are 30 days we can't use to contribute to our annual cost of doing business. So we need to take more

from those other clients—in my case, clients working with women and vulnerable children. Not an appealing thought for me.

I can only make so much money in a year, but my costs are pretty static. My overhead doesn't go away because I wish it would. I still need to pay for my website, my marketing materials, my taxes, my savings, my daily living expenses. *Free* will put you and me into bankruptcy so fast it'll make our heads spin.

Working with charities and NGOs, as I do, you'll encounter client after client who asks you to give it away for free, and they'll tell you to your face that 1) they can't afford you—probably true—and 2) they are responsible to carefully steward what little finances they have—also true. The strong implication, however, is that you are somehow responsible for their stewardship. You aren't. You are responsible to steward your own time and money. Your family and your business. This doesn't mean you can't find creative ways of doing the latter while working for the client, but it does mean you need to know what your CDB is, and whether you can actually afford to give it away. You need to remind yourself there's really no such thing as free. If they don't pay you from their budget, you need to pay yourself from your own budget.

Failure to do this means you will sit closer to the survival line, take gigs as cheap as you can, undercut the others struggling to make it, and in the end put yourself out of business, which helps no one. You must steward your time and money, and that begins with knowing the true cost of going out for a day or a week, and then finding ways to cover that that do not include a line of credit or plastic. Heed me on this. If you do not know your CDB, you need to. In actual numbers.

Again: there is no such thing as free. Someone always pays, and in this case it's you. Those of us who take pro bono (notice it's not called "free") work often fall into the trap of thinking that "we're not getting paid for this one." As if it's simply a break-even on the books. It's not. *You* are paying for it. If you need to earn, for example, $1,000 for each day you shoot in order to meet your annual cost of doing business, then that money has to come from somewhere, and agreeing to shoot a week for free means not a week without pay, but a week with a $5,000–$7,000 deficit on your annual budget. How many of those can you afford?

> "*Free* will put you and me into bankruptcy so fast it'll make our heads spin."

If this is beginning to sound like a hard-assed capitalist speaking, then good. I'm not, for the record. I'm Canadian, so I'm closer to being a socialist. As I write this, I'm wearing a Mao Tse-Tung T-shirt I got in Beijing, and I have a strong affinity for revolutionaries (though I have a strong dislike for their methods, and I wear this T-shirt with not a little cognitive dissonance; I digress). The dollar is a tool, not a god. But you have to wield your tools well, and most photographers are very kind people who want to give it away, unconscious to the staggering cost of doing this, even as a hobby. I'm not saying you need to make money your priority, but you do need to make the wise management of your time and money a strong priority.

Here's what I've done to steward my time and money while continuing to work for clients with small or nonexistent budgets:

- I have strong sponsored relationships with generous leaders in the photography industry. They give me products that I would otherwise pay for, lowering my overhead and thereby lowering my CDB. I can afford to spend more time doing pro bono work.

- I have sought alternate means of funding. Someone has to pay for me to photograph child laborers in central Asia, but that doesn't mean it has to be me or the NGO. One of my recent assignments was paid for by a businessman in Vancouver who wants to make a difference in the lives of children. He cut me a check and told me to go shoot. Be creative about how you fund your work; find a way to make this a win-win for everyone.

- I have diversified and sought multiple income sources from shooting and teaching (I discuss this in the next section). I shoot while I am home and charge more to my commercial clients than I ever could to my paying NGO clients. One subsidizes the other.

- I have been blessed to have a couple of solid clients who see the value in what I do. One of my projects raises several millions of dollars for the organization. They see that emotionally compelling images create exponentially more powerful fundraising and advocacy campaigns, and in the end that means more money. They pay me well. But they are the exception. Educating other potential clients on this is important.

I still give it away sometimes, but I do it selectively and with my eyes wide open to the actual cost. All this doesn't temper my idealism and desire to change the world. It doesn't make me greedy or mercenary. It doesn't pay for a Mercedes—in fact, I choose not to own a car at all. It means one thing: I can continue to do what I love and feel called to do without going bankrupt or neglecting my family, or wondering how in the world I am going to replace the camera that just broke or was stolen. It means I can do this longer, and be of greater good to the world than I could otherwise.

Dig More Streams

My mother used to tell me not to put all my eggs in one basket. She also used to tell me not to count my chickens before they hatch, and not to cry over spilled milk. There were a lot of animals involved in her wisdom. But the eggs in the basket—that one is sound business sense. If the basket falls and the eggs all break, well, you have no eggs. Now that I think about it, I guess a better basket might also have done the trick.

So forget the eggs—let's look at income streams. You're a wedding photographer who gets paid for going out and shooting a full-day wedding. That's one stream. When you sell albums, that's another. When you teach newer photographers to shoot great weddings, that's another stream. When you also begin to do maternity shoots from clients who got married last year, that's another stream.

The more streams you have, the better. They all lead to the same place, but the diversification that these streams represent brings opportunities to serve clients in related markets, with the same branding but serving different needs.

The point of thinking creatively about income streams is to serve the same clients in different ways, or different levels of clients in the same way. If you approach it right, it allows you to solve the problem presented by any work that demands your presence. Shooting a wedding is active income. You gotta be there to earn. Selling DVDs to younger photographers wanting to better serve this market is a passive income; it doesn't require any more than a one-time investment of time and money, and a way for people to order and pay for it.

If you are a travel photographer, like Gavin Gough, you might consider different income streams like assignment photography (active), as well as stock or print sales (passive), as well as other active income-earning activities like writing for magazines. Can't write? Team up with a travel writer and market yourselves as a team. Travel together, shoot work for both your assignment and stock clients, and submit collaborative articles. Then come home and put up your three best images as limited-edition prints. You've already spent the money on flights and expenses; amortize those expenses over as many earning opportunities as possible. The income can be exponentially higher without an exponential increase in the time and money spent.

You might also want to look at the holes in your calendar. I can only be on the road so many times in a year. That leaves me at home to either serve a local market and dig more streams, or to sit bored and broke, waiting for the next assignment to roll around in a month. If you're a traveler, develop a market that makes use of you locally as well as internationally.

How do you begin the process of digging more streams? Go back to your personal inventory (see "Know Thyself" on page 36). Look at the breadth and diversity of your skill set and the things you're passionate about. Love teaching? Find a way to teach. Enjoy public speaking? Begin speaking and training. If it's writing, write about photography or travel or any other area in which your expertise makes you valuable. You'll not only develop another stream of income, but you'll be making solid inroads with your marketing as you expand your audience.

Your Next Step

Take some time to do an inventory of yourself. Look at every transaction you've ever made. If one person wants prints for the walls of their new home, how can you make sales to more people? If you sold a set of custom greeting cards to one client, why not more? Spend 30 minutes online and look for "ways to make money with photography." Sure, you'll wade through hundreds of ideas you'd never consider—and for good reason—but you might find an idea. What about grants? Have you looked at national, provincial, or state arts councils, or even grants provided by corporations and businesses? Have you considered creating a sponsorship program in which local businesses can participate? The more creative you become with your thinking—while making sure it is in line with your brand—the more doors you may find opening for you.

Insurance

I'm trying hard to avoid legal issues, but this one is a financial one. You need insurance. What kind of insurance you need will vary, but it probably includes coverage in case of lost gear due to theft or fire. If you have clients on your premises—either your home office or studio—you need liability coverage. If you shoot weddings, you should probably have coverage in case something happens to your images on the way home from the gig. If you travel, make sure you check the coverage carefully; I traveled internationally for a year before checking my policy, only to discover that I wasn't covered if my gear was stolen during international travel or from a vehicle. These are just examples, and most of us will require something beyond our home policy. Residential policies often will not cover you for professional gear, so look into a good commercial policy that gives you loss and liability coverage. I found mine through the agency that supplies policies to our local professional photographers association. I'm not a member, but I called and was given a similar rate on the same policy.

Years ago I was working at a youth camp teaching climbing and sailing during the summers. The day the main lodge burned to the ground and I lost everything was the last day I was without some kind of coverage. It was a devastating loss, and I eventually recovered, but my friends with insurance were back on their feet immediately.

Even without the threat of stolen gear, the issue of liability is greater. If a wedding guest trips over your tripod, breaks an ankle, and sues, will you be covered? Several times a year I get contracts from clients who specifically require confirmation of insurance in the form of a letter from my insurer. I call my agent and the letter is e-mailed immediately, confirming the required coverage. No insurance, no gig; it's one of the realities of working in a society addicted to litigation. Make sure you are covered. One mistake or one theft without insurance could put your dreams on hold.

> "If a wedding guest trips over your tripod, breaks an ankle, and sues, will you be covered?"

Chase Jarvis

ChaseJarvis.com

CHASE JARVIS has turned a passion for photographing ski-bums, snowboarders, and high-performance athletes into a tight, well-branded business as a respected commercial photographer shooting for clients like Nike, Reebok, Apple, Red Bull, Subaru, and Volvo. If there's a photographer from whom I would take business advice without a moment's hesitation, it would be Chase Jarvis.

It's mildly disappointing, then—or wildly exciting, depending on how you look at it—to find that Chase subscribes hook, line, and sinker to the notion that there are no secrets. By that I mean this: Chase neither believes in keeping secrets themselves, nor in the existence of that one secret that will make or break a photographer's career. I say it's disappointing because if there's one photographer I've met who might know the secret to making it as a photographer—in a tough economy or otherwise—it's Chase, and he's built a company with six full-time employees and millions in revenue without secrets. He's also the most transparent and collaborative photographer I've ever met, and that collaborative, relational spirit is a clue to his success.

Jarvis was heading toward a career in professional soccer, taking pre-med courses at San Diego State, when his grandfather died and left him a clunky old

Minolta camera and some lenses. Up to that point, his experience with photography consisted of looking at images his father had captured of Chase and his friends playing soccer. Something resonated enough that he took that camera on an eight-month trip to Europe, and in that time he played with it enough to discover a passion. He returned from Europe broke, with a newly discovered passion for photography, and moved to Steamboat, Colorado, to work off his debts and earn some money. He waited tables and worked at ski shops; on the side,

he began shooting his buddies and other up-and-coming skiers and snowboarders. When their sponsors started buying Chase's images for $500 and a bunch of free gear, Chase had a glimpse of possibilities he hadn't considered—a chance to make decent money doing something he was increasingly passionate about and increasingly good at. "I thought, if I can do this once, I can do it a thousand times. The trick is not doing it 1,000 times for one dollar, but finding a way to do it 100 times for ten dollars."

Chase returned to Seattle in 1996 to pursue a master's degree in aesthetics, and in 1997 he sold his first large commission to outdoor gear store REI based on the strength of his work and being open to opportunity when it presented itself. Chase was still working a couple days a week in a ski shop and remaining active in the outdoors community; looking at the mural on the walls of REI, Chase thought, "I can do that." When his path crossed with that of the marketing director for REI, he just reached out and asked, "Can I show you my work?" She liked it enough that she accepted it on the spot, bought a sizable license, and came back to Chase for commissioned work as well. Chase suddenly found himself a working photographer.

From there, Chase's career accelerated. Where others usually get to commercial work on the strength of a career in editorial, Chase went backward and found himself shooting for commercial clients first, and only later pursuing editorial work. He called and talked to anyone who would listen to him—not to give a pitch, but just to introduce himself and ask for a chance to show them his work. He put together a print book and showed it to anyone who

would give him a chance—friends, art buyers, and photo editors—and actively sought connections, saying, "If you know anyone who can use someone like me, I'd love to talk to them." He was an insider in the outdoors community, and he brought an authenticity to his work and his efforts to find more work in the same area. That this approach works at all is because it's built on two things—his passion and the quality of his work.

What accounts for Chase's success—beyond his sizable talent and ability to meet client expectations—is his passion for exceeding those expectations. Chase believes in overdelivering for every client. To him, that means understanding the client's needs as deeply as he can and executing the brief as it's presented, but it also means carving out time during the assignment to interpret the brief his way, to elevate the concept and put it through the filter of his own creativity. In so doing, Chase gives the client much more than they asked for; he's training them to hire him for his unique creativity and vision, not merely for his ability to produce a shot and press a button. He's moving his value from being just a photographer who deals in the execution of a shot to one who deals in the ideation, and a photographer who can do both is far more valuable to the market—becoming not merely a commodity but a brand.

If there's one thing that strikes me about Chase, it's his focus. Chase knows why he does this, knows what he wants out of it, and knows what he has to offer that makes him unique. Out of that has emerged a keenly delineated brand. The brand serves Chase powerfully. He knows who he is

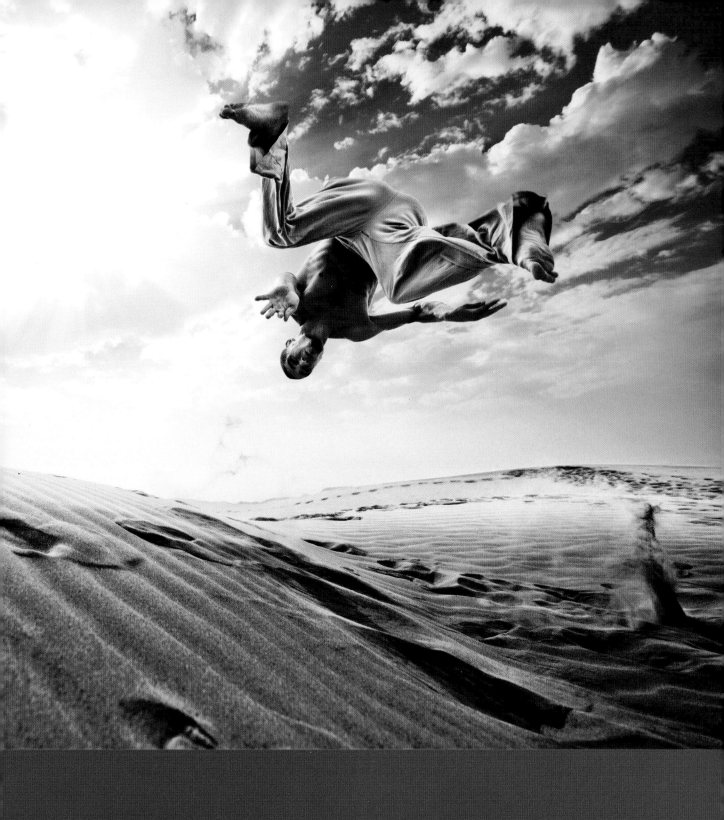

and who his market is, and he isn't distracted by seeking work outside his market. Chase was never satisfied with taking pictures just to fill a bucket for a client. He's true to his core, and that's kept him on track and given him the freedom to do what he's passionate about—creating and sharing. I know this sounds thick on motivational mojo and low on business wisdom, but that's the thing about photographers who are truly succeeding—their passion, focus, and courage to stay on track are the most powerful, and rarest, of business assets. It simplifies things. Used well, the logos, branding, and websites support that; used poorly, those same things become a distraction from it.

Chase's perspective has created a paradigm that excludes the notion of competition. When you sell your vision and the unique package that makes you who you are—in this case, it's Chase's experience in the industry, his passion, his vision, his uniquely talented crew, and his expertise in the active and urban markets he serves—then who do you have to compete with? Certainly not the photographers who bring nothing more than their technical abilities to the table, and not with other photographers who shoot from their own unique vision, either. This freedom from the competitive paradigm allows Chase to work on his own terms, serve clients in a highly relational way, and create work with others that is collaborative in nature and feeds the creativity that he offers back to his clients.

The model Chase came back to several times was one in which the vocational photographer is concerned with three things: creating work, sharing that work, and sustaining the work of creating and sharing. His commitment to art and the process of creation is core not only to his brand but to himself as the artist that brand represents. Creation is not only the means of his business but the reason for it, and that can't be overstated. Sustaining that work is the chief concern of anyone wanting to make the transition into vocational photography, and Chase's perspective is much like mine—though I use a back door/front door metaphor and, somewhat oddly, Chase uses juggling. It's important you do whatever it takes to keep those balls in the air, and the transition from hobbyist to vocational photographer is not unlike moving three juggled balls from the left hand to the right. You move them one ball at a time. You keep waiting tables while you shoot and find clients. You keep doing whatever it takes to sustain the creating and the sharing—to keep those three balls in the air—while the right hand gets used to juggling one ball, then two, and finally three. However long it takes to move those juggling balls from the left to the right, you have to keep them in motion. To abandon the metaphor, you need to sustain it. "If you don't like what you're doing, quit. Quitting and failing are our allies; they open doors to the things we do want to be doing. Figure out what is the bare minimum you need to sustain yourself, and do that as you move over, but when you've got enough to sustain yourself, quit. Life's too short."

Once you've made the transition, you just keep those balls in the air. Chase doesn't do it with cold calls or slick marketing. In fact, he doesn't use mailers or slick gimmicks at all. He'll send a custom portfolio when it gets called in, but his efforts go to maintaining client relationships and to creating and sharing new work—that's his marketing engine.

He's using social media and the internet to astonishing effect, not as part of a well-conceived marketing plan but because he loves to create and share. The hidden brilliance in this is that those efforts pay off because the market sees not a representation of his creativity, and not a sales pitch, but the actual results of his creativity. The best way to sell your creativity to a market hungry for creativity and excellence is by exposing them to your work. Chase doesn't merely talk about creativity on his blog or Twitter or through his viral videos; he engages those media in his creativity and clients see the results, not the talk. ▣

All images on pages 225–231 © Chase Jarvis

It's a Brave
New World

HAVING DINNER WITH JOE MCNALLY during my first trip to New York City, we were shooting the breeze and talking about "the industry," among other things, and he alluded to how exciting and terrifying it was to be a photographer these days. Everything's changing. Old models are dying without so much as a moment to say goodbye—or, if not dying, they're in a constant and unpredictable state of flux. Exciting. Terrifying.

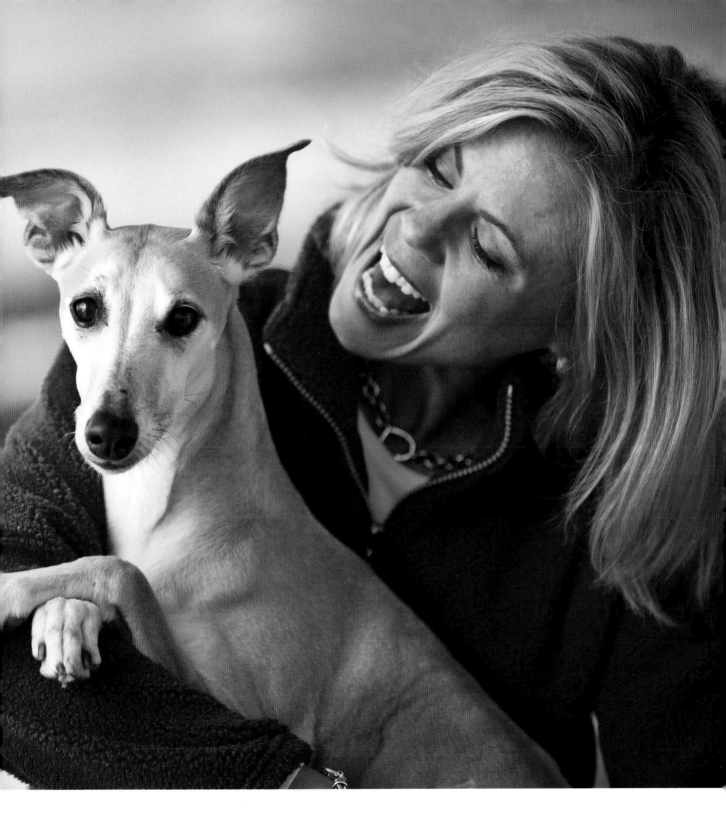

"What a
freedom it
is to have no
choice but
to act."

After so many years of leaning on my creativity to make a living, I more often come down on the side of exciting. Where once we might have been hesitant to carve our own path, to take risks to pursue the decision to combine our craft with commerce, we now have literally no choice. What a freedom it is to have no choice but to act.

Life is short, and while you probably aren't reading this for a recap of the movie *Dead Poets Society* or a dose of existential warm fuzzies, that's the blunt truth of it. At the heart of things, we resonate with pithy truths like "Gather your rosebuds while you may" and "Carpe diem!" because we recognize in them a truth and in us a longing. The truth is that 1) life is indeed short, and 2) by far, the majority of us are a bit nervous about gathering our rosebuds or seizing the day. Life is also complicated, and the needs of family and other obligations don't simply go away for wishing them so.

So many of the questions I have been asked simply have no answer, and more often than not I think what people are looking for is the permission to risk, to try it their way. Yes, your kids need to eat. But they also need to find in their parent a legacy of living life to the fullest if they're to do the same. Living your dream and pursuing your passion—as long as you do it with wisdom—is not reckless parenting but responsible. Better the gift of courage and passion than a new GameBoy. It's for this reason I've written this book. It's not a manual, and it's the furthest thing from a text on business practices. Those are out there. There is no shortage of books on running a business. What is in short supply are books that encourage you to take that next step, to embrace some of that fear and to go for it. In my experience, it's worth it. It's worth some of the worry, the sacrifices, and the questioning looks from friends and family. I'd trade it all again for the chance to do what I love with my brief years. I believe I'm leaving the world a better place in the way I was gifted to do, and that allows me to live with passion and purpose. I go to bed tired. I wake up excited.

I also wrote these pages to share with you some of the wisdom I've learned from others who are living their dream as well—in part so you go in wisely. As encouraging as I'd like to be, it would be unfair of me to simply urge you on with "Go for it! You can do it!" because you might not be able to. I don't know your gifts, your photographic skills, or how tenacious you are. The plain truth is many simply can't do it, and the kindest thing I can do is recognize that. But how do

you know if you don't try? What do you gain but regret if you never take some initial steps through the back door of this whole thing and test the waters? Life offers no rewards to the tentative, to those who tiptoe cautiously through life only to arrive safely at death.

If photography is what you think about on your lunch break, during class, all the way through your night shift, and as the last thoughts that go through your mind when you go to sleep, you owe it to yourself to try.

Being a vocational photographer won't earn you a badge of merit or elevate you above another photographer. It won't make you more interesting at parties, and it's unlikely to make you rich. It will, at times, burden your creativity with the demands of clients and make you sick of holding a camera. It will make dipping into, and constantly refilling, your creative well a necessity and not a luxury. It will change things. But if you do it right, market yourself well, make genuine connections, manage your money well, and never stop making decisions based on why you wanted to do this in the first place, you might just pull it off, and I'll be damned if this isn't the most exciting, rewarding thing I've ever done with my life.

Above all, remember this is *your* journey. You are unique among billions, and your path should be just as unique. Why should it be odd that I pursued my career after theology school and a career in comedy? Your own story is as remarkable, if not for the novelty of it then for the courage required to take the first step. That courage alone makes it remarkable. It's a new world for photographers, but what makes it brave is you. Corny? Probably. Do it slow, do it fast, do it however you choose, but do it your way. Any other path will suck the joy from the endeavor.

If you haven't already done so, look for the resources I discuss in this book. *VisionMongers* wasn't created to be the final word in becoming a vocational photographer. Far from it—it was created to complement what's out there and to add to the discussion. If you haven't already done so, I suggest you read my first book, *Within the Frame*. It too touches on topics and themes I address here, but concentrates on the topic of pursuing your vision—and you're about to spend a lot of time doing that. I blog frequently, and often those posts are on the topics found here; in fact, many of these discussions had their first tentative steps on my blog. You can find me at Pixelatedimage.com/blog.

> "If you do it right, market yourself well, make genuine connections, manage your money well, and never stop making decisions based on why you wanted to do this in the first place, you might just pull it off."

Finally, thank you. Thanks for being part of my own dream. When I made the transition I knew I wanted to teach, to share what I love with others. And while a photograph exists and has purpose even if you are the only one who ever sees it, a teacher without people to listen and dialogue with is just a madman rambling. Thanks to those of you who've bought my books, faithfully read and interact on my blog, join me on workshops, or reach out to let me know I've been in some way helpful. I'm deeply grateful.

Peace and light to you.

David duChemin
Vancouver, 2009

Appendix

Questions and Answers

A while back, in the research stage of this book, I put this question to my readers: what questions do you have about "going pro"? They replied, some of them with incredible candor. Some of those questions helped determine the content of this book. Others—from both the blog and e-mails I've received—I want to answer, if too briefly, here.

Am I good enough, and how do I know?

I don't know. But there's a good way to find out. Start slow, make some sales, get through all those initial rejections that might convince you otherwise, and find one paying client. Then another. And while you're doing that, just keep shooting what you love, all the time, every time. Study your craft. And when you've got a couple of paying clients, and they refer you to others, then the answer is yes, you are good enough. You're good enough for those clients, and unless you've stumbled across a collective of clients with the lowest standards on earth, there will be more like them for whom you are good enough. And you'll keep getting better at your craft—because that's the nature of it—and your client base will grow and evolve and you'll always keep asking as you look at each new client, "Am I good enough?" Only one way to find out: shoot the gig, knock it out of the ballpark, and give them the best work you can.

Is it okay to ease in or should I leap?

One person's easing-in is another's leap. For some of us, the first steps seem like a leap. And if that's how it feels, then leap. We all face the worry that we'll fail, because going out on your own and leaving the perceived security of the cubicle or the 9-to-5 is risky. But if you look at this as one giant wall you need to leap over, you might never muster the courage. Look at it like a hill that is climbed one step—one considered step—at a time. Take the back door. Ease

> "When you've got a couple of paying clients, and they refer you to others, then the answer is yes, you are good enough."

in. Go in your way. For some, that needs to be an all-or-nothing, quit-the-day-job kind of step. For most, it'll be more gradual. But for nearly everyone it'll be nerve-wracking. That's okay. The important thing is that you get into the pool—ease in one inch at a time, or take the diving board. Just get in the pool. Sitting poolside trying to muster the courage is not swimming; it's sitting poolside. Take the next step.

> "Set a goal, make a plan, break it into steps, and take it one by one."

I want to do this, but I just don't know what my next move is. What's my next step?

Everyone's journey is different. To know how to answer this I'd have to know you and where you're heading. I do know that most people who ask this seem to be asking the wrong question, jumping the gun and asking how to get there when they haven't decided where "there" is. You need to step back and look at your plan. An actual, written-down plan. But let me suggest to you that it be considered and bold and confident. For some of you, this next step is to stop being evasive and falsely modest and start calling yourself a photographer. Nail your colors to the mast! For others it's the need to begin charging for your work. When the next person says, "Hey, I love your work. Can you shoot something for me next week?" consider replying with, "I'd love to. What's your budget?" Maybe it's deciding on your niche (scary, isn't it?) and getting your logo and marketing collateral designed. And for others still, you need to stop disguising your procrastination as indecision. Submit your work to someone in your market every week. Don't know who to submit to? Then that's your next step. Whatever it is, it's easier to steer a moving ship, so you need to gain some momentum. This didn't just happen for me or for any of the photographers I interviewed for this book. We took one step, probably tentatively and fearfully at first, then another. You're not missing something. You haven't been left out of the club meeting where we told the secret to this thing. You just need to set a goal, make a plan, break it into steps, and take it one by one.

Can I do this without compromising my vision?

You must. There will be times when you need to find compromises; that's what creativity is. If you go into this to shoot what you love and to give your clients the best results of your passion and vision—and not as a photographer who's simply a hired gun who knows how to use a camera—then what you are selling them is that vision. It's not in the way of you succeeding; it is the way.

How do you go from taking what you think are good-quality photographs (in my case, travel photography) to getting published or shown somewhere, anywhere, in order to get your name out there?

Here's a great example of asking a question that's too vague to answer. No wonder you're feeling intimidated. Where do you want to get published? Go to the store and look at every magazine that uses images similar to yours. Actually go to the store. Pick them up, and look at the stories and the images they use. Are there hints in there that your work might fit well? Now look for the submissions information and submit your work. Make a goal to submit to one, two, five publications a week. You have to show your work, and it'll happen faster if you put it in front of them in their preferred way. Waiting for them to discover you on Flickr is a long wait for a train that's unlikely to show up.

Isn't the market too saturated already? If you feel your niche is full, what do you do?

Yes, it is. It's full of photographers. Absolutely maggoty with us. And there's room for more. What there is no room for is another Steve McCurry, Annie Leibovitz, Chase Jarvis, or Ami Vitale. There sure as heck is no demand for another David duChemin. But there is room for you because you're unique. Even if the market doesn't think there's room and every photographer out there says the pool is full, there's room for you. If your niche is full, you need to redefine that niche. Find a dusty corner that no one has considered, clean it out, and hang out your shingle. Or you need to go niche-ier. Out-niche the others and find a niche within the niche.

How do you maintain your passion and your creativity?

By tending to them purposefully. By making time for your own work. Always. By not taking work that you know is not you. By taking work that is uniquely you, and for clients with whom you have a good chemistry and who you trust. Sounds idealistic, right? Of course it is. But you need to stick to your ideals, at least to the core of them. If you've done your marketing honestly, it's why your clients are hiring you.

What are the key ingredients to making photography a vocation?

The photographers I've worked with to make this book happen all shoot different work for different clients. They have different skill sets entirely, and follow different passions with unique vision. What they share is a commitment to their

> "Be really good at what you do, find your niche, and then work hard."

craft, and the fact that they are unmistakably good at what they do. They are perseverant, resourceful, and not easily dissuaded from their goal. They share a willingness to engage their chosen market on their own terms but in a strongly relational way. None of them has a system; they just have a desire to connect with people and shoot for them. They have all chosen a niche and made it their own. There are no generalists here, and if you look at their portfolios you will immediately know what they love to shoot and how they love to shoot it. They've all made an intentional decision to pursue the business and marketing of their craft as a separate discipline that needs study and commitment. They've all been smart—though not always—with their money, and they run tight ships. And they all have a staggering amount of passion. They're living the dream, as I am, not because the dream materialized in a cloud of pixie dust and chose them specially, but because they heard a call from somewhere, knew this is what they wanted to do, and then chased down that dream.

No, seriously, what's the secret?

Seriously? Be really good at what you do, find your niche, and then work hard. Build solid long-term relationships. Know who you are and who your market is, and then put the two together as creatively as you can while never, ever letting your craft slide. Want more of these secrets? Read the book. You looked for the answers in the back, didn't you? Cheater.

A Conversation with Joe McNally

Joe McNally was driving from Phoenix to San Francisco, on his way to shoot for *National Geographic*, when we caught up by phone about some of the changes going on in the photographic industry.

Photo: Anne Cahill

Joe McNally has been shooting for *Life* and *National Geographic* longer than many of us have been alive, much less holding a camera. He's made a living with his camera since about 1979.

Most people are in agreement that the so-called rules are changing. What is the biggest change that you've seen over the last few years?

Throwing a dart at the wall, you could say digital photography. I often refer to it as the democracy of digital. Far more people are involved than ever before. That's a good thing, but it's brought profound change to the industry. It's a two-edged sword that cuts both ways. There's an omnipresent aspect to digital photography; it's everywhere. It used to be that as a pro you had gear and a basement with a darkroom and chemicals. Ansel Adams had his 8x10, everyone else had his Brownie. There was a big gap between them. The marketplace has become saturated and it's harder and harder to define value. You have to perceive photography as a marketplace, and if that's the case then market principles like supply and demand come to bear, and right now the market is being flooded with cheap goods. Pictures, often good pictures, are plentiful right now. It is exuberant and fun to watch, but it makes it harder and harder to hold the line on value.

So how do you define that value?

Well, I have a hedge provided by those 30 years. Those clients I have history with are a safety net. People will stay with you, and there's still a market that sees value in seasoned, well-known photographers with lots of experience. The jobs I often get have a good deal of pressure associated with them, and thankfully the clients know that, and thus they turn to someone who has been around the block a bit.

What is the biggest obstacle you see facing new photographers who want to do this vocationally?

The marketplace. It's harder than ever to cut through the noise and be noticed. My advice is to be varied in your approach. You have to be your own

"I am more
jazzed about
shooting
pictures than
I've ever been."

entertainment complex—you need to know how to create stills and video, know how to blog, Twitter, and update a website. These are now essential skills.

It used to be you could have the same portfolio for a year or two and skate on it. Now you have to be updating your website on a monthly basis, and that's hard—even for photographers who are shooting all the time and have staff. The pace is very fast now.

When we spoke in New York City you said this was a terrifying time for photographers, as well as an exciting one. Can you elaborate on that?

I am more jazzed about shooting pictures than I've ever been. The big pipelines are dying, or changing, for sure. A *Time* cover used to be more prestigious than the cover of *Life*. When you got a picture on the cover of *Time* you spoke to the world in a special way. But there was just a news item I picked up online that talked about a recent cover for *Time* being bought as micro stock for $30. Every cover I've ever done for *Time* paid between $3,000 and $5,000. $30? That's a problem for all of us. But on the other hand, here's what's exciting to me—photographers don't necessarily need *Time* magazine covers anymore. They still have their place and their cachet. But, for instance, I've got a blog that gives me the route to self-publish. I can talk to my audience in books and communicate to lots of folks without needing to wait for a big magazine to notice me and give me a job. My blog is a bit like having a newspaper column. I'm reaching roughly 80,000–100,000 people a month. Its not big-time publishing but it's satisfying and fun. It gives me a voice. With traditional means of publication, you had to wait for a phone call. That's changing. At this point I'd rather work for myself and take my chances. Many magazines still want to pay you rates that date back to the '80s, all the while ramping up demands for rights. I'd rather work for a smaller client or do a personal project than work for a client that's just going to kick my ass anyways. We have an opportunity now to get our work noticed and out there in newer and non-traditional ways.

So how has your business model changed?

When I came along it would not be strange to work for 3–5 magazines a week. One hundred bucks and expenses to go shoot a headshot of an executive or a shoot on a sound stage with Liza Minnelli. You did bits and pieces and then got affiliated with a mom-and-pop-shop agency. It was small scale and informal,

like family. Hell, small agencies would let you sleep on their couch if you had to. They'd work with you and re-sell those images all over the place, and that was a significant revenue stream. That's changed, as well, with the internet disseminating material globally in an instant. We have a commercial rep in New York, and we circulate eight books, but even getting to the bid process is hard.

I look at it like fishing. I used to be fishing for trout. Now I'm fishing for whales. I'm fishing for three or four jobs a year. In the past I'd have done 250 days for a whole variety of clients over the course of a year; now I work consistently for a select group of clients. That's dangerous when one of those big clients drops off.

In light of that, talk to me about diversification.

Diversification is huge. Take the corporate mentality that applies to large successful corporations and apply it on a personal level—build a brand and diversify your revenue stream. I've had friends who were one-client shooters, and then that client disappears or moves on. That's disastrous. You need to diversify your revenue stream to prevent that, and you need to diversify your skill set.

What does that mean for Joe McNally?

Historically our revenue path was pretty singular. We did assignments and then put that into a stock library. Now we do a lot of different things. Our pattern of income has changed. Our annual income is represented by assignment work, stock sales, royalties from books and videos, as well as lectures, articles, workshops. The blog returns some finances. It's a much wider net now.

Have recent changes forced you to change your branding and the way in which you do business?

Sure. But in part our recent re-brand was just a matter of time. It was a smart move but also necessary with a new blog and a look that had grown stale. If you have enough time to tinker with your blog on a consistent basis you aren't all that busy, so our site was out of date because we're busy. It's a good problem to have. We've also tried to simplify and make a synchronicity between the design of the blog and the site, and we liaised with Livebooks to create it, and that makes it more user-friendly and more easily updateable.

"I used to be fishing for trout. Now I'm fishing for whales."

Is this a case of old dog learns new tricks, Joe? I mean, you're blogging and on Twitter. You weren't very visible and suddenly you are. What changed?

My assistant, Drew, was pushing to do this; he's young, and hip to current sensibilities. We went to Dubai and spent time with Chase Jarvis, Zack Arias, and David Hobby, all of whom are very up on this stuff. Even though I did fall asleep in one of the lectures—which David gave me some well-deserved grief about—I did get that the whole idea of social networking made sense. If you're going to be connected and known as a teacher, which I wanted, it makes sense to expand your audience of people who might listen to you. When you're able to ramp up that blog presence, and people feel it's a worthwhile read, the better your position to keep reaching out to this diffuse and broad marketplace.

Does that apply to photographers who just want to be photographers? Could the blog or Twitter be useful to someone who just wants to shoot?

Sure. But I think the days of wanting to "just shoot" are over.

You've worked for **National Geographic** *a lot during your career, you still do. The* **Geographic** *is the dream for many photographers. For many, that rectangle isn't just yellow, it's gold. Is it?*

Still working for *Geographic*, for sure. It still creates opportunities. Photographers—especially those just coming into the market, though—have to realize that editorial clients like *Geographic*, etc., are not paying tremendous sums of money to anyone. Commercial work, annual reports, weddings—you can just about name almost any type of photo work, it will pay more than editorial day rates. That's always been a truism, and it still is.

It's the prestige and the perception of the life of the adventurous and first-class travel around the world. But it's not like that. Grinding out a tough assignment is a draining, involved, and physically difficult proposition. I know when I've been on assignment for the *Geographic* and things weren't going well, I've been profoundly miserable.

Many photographers working for the *Geographic* are working selectively for the *Geographic*. And then they spend their time doing other types of commercial work and commissions. Even the *Geographic* itself has a commercial agency for photographers.

For those who won't be dissuaded, how do you find yourself working for Geographic? Most young photographers feel intimidated, like it's impossible to break the ranks.

It seems that way because it is, to be honest. The idea of a young photographer even gaining access to an editor at the *Geographic* to look at work and have that translate into an assignment—it's extremely difficult. It's a long process. Some of the top shooters in the world are competing for very few jobs. On top of that, an editor will be very nervous about having a newbie on their hands. When you first went out with the *Geographic* you'd go out with a budget of $150,000–$200,000; that's a lot of money. It's very expensive, and to commit those resources to someone untested is a huge risk.

On my first couple of jobs for *Nat Geo*, my editor didn't even want to talk to me, and I was already an established, seasoned, New York City pro who had shot cover stories for many major magazines. It's not for the faint of heart. In terms of the long term, hardcore work that's been presented in the magazine for the last 20 or 30 years, there are no more than maybe 100 shooters on the planet who have produced that work. It's a very tough nut to crack. But if you won't be dissuaded, the best route there is to get an internship at the *Geographic*. Otherwise, become a daily newspaper shooter and learn to tell stories. If you look at the *Geographic* shooters, most of them were newspaper shooters because that came with basic schooling in becoming a communicator. Thinking it's just about taking great photographs is a trap; you need to learn to tell a story and deal with people. It's more often an exercise in human relations and not an exercise in pixels.

You aren't a niche photographer, are you?

I am known as a generalist, but for the most part my work has to involve people, probably stemming from a background growing up as a newspaper photographer. Being a generalist can have downsides; the market does speak to niches and carving out a specific identity, for sure. But no matter which way you go, there has to be a connected quality to your work. One of my criticisms of younger photographers is that their portfolio often doesn't tell me what they shoot. It's more of a collection of pictures and not a portfolio. The best photographers, even if they shoot all kinds of stuff, do have a central theme, be it the way they work with light or people, or perhaps with color. Find your style. That may mean finding a niche, or it may mean finding a coherent approach with the lens that gives you appeal to art directors.

> "Thinking it's just about taking great photographs is a trap; you need to learn to tell a story and deal with people."

I think many people will buy this book hoping that there's a secret to "making it." There's something we "professionals" know that we just aren't telling the "amateurs," and while they won't believe me, you seem trustworthy. So give us the straight goods. Is there a secret?

No.

Really?

There is no secret; absolutely no secret. There's luck sometimes, being in the right place at the right time, but no magic key that opens the vault.

So many photographers go in with their eyes closed to the realities of this work. If you could preach one sermon—fire a warning shot across their bows— what would that sermon be?

I'm a huge preacher of the gospel of tenacity. It's a far too overlooked component of success in this business. Photo magazines talk about successful photographers with vision and style but what is also common to those photographers is a single-mindedness. You have to be willing to hear "no" a lot more than you hear "yes." Sure it's tough, but if you have an itch you absolutely can't scratch unless you pick up a camera, then you have no choice but to plunge ahead. If you can do that with clarity of approach, vision, market savvy, and technical skill, you will make it.

Index

time management skills, 188
trade shows, 22
Travel Photographers Network, 137
travel photography, 151, 223
Trout, Jack, 99
trust, 100–101
Turning Gate website, 143
Twitter, 68, 138–140, 246
TypePad.com website, 150

U

unique selling proposition (USP), 208
uniqueness, 36

V

value, 205–206, 212, 243
van Gogh, Vincent, 34
Viisual.com website, 53
vision, 8, 9–12
VisionMonger profiles
 Arias, Zack, 199–204
 Chon, Grace, 107–111
 Clark, Kevin, 49–55
 Delnea, Dave, 127–133
 Gough, Gavin, 151–157
 Grobl, Karl, 165–170
 Jaksa, Chris and Lynn, 19–24
 Jarvis, Chase, 225–231
 Wiggett, Darwin, 81–85
vocation, 15
vocational photographers
 amateur photographers vs., 13–15
 approaches to work as, 62–63
 business changes for, 244–245
 career roadmap for, 8–9
 challenges of work for, 28–30
 changing rules for, 16–18, 243
 complementary skills for, 186–188
 craft and skills of, 44–45
 financial wealth of, 47–48
 first assignments for, 77–80
 hobbyists vs., 34–36
 importance of marketing for, 47, 85
 key ingredients for, 241–242
 market knowledge and, 41–44

 mentors and, 63–66, 67–68
 peer relationships and, 68–70
 planning process for, 56–61
 questions for aspiring, 30–33
 secret to "making it" as, 248
 self-knowledge and, 36–41
 work habits for, 71–73

W

War of Art, The (Pressfield), 157
wealth, financial, 47–48
Wealthy Barber, The (Chilton), 198
Web 2.0, 134, 135, 138
Web marketing, 53, 85, 111, 134–150
 blogging as, 143–150, 157, 202
 building a website, 140–143
 generating Web traffic, 134–137
 leveraging, 202–204
 portfolios for, 163
 sharing new work as, 230–231
 Twitter as tool for, 138–140
websites
 compared to print media, 202
 considerations on building, 140–142
 importance of updating, 244
 resources for creating, 143
wedding photography, 20–24
Whitman, Walt, 89
Wiggett, Darwin, 81–85
win-win situations, 206
Within the Frame (duChemin), 237
word-of-mouth marketing, 55, 112–113
WordPress.com website, 150
work
 challenges of, 26, 28–30
 developing habits of, 71–73
Workbook.com website, 53
World Vision, 5
writing, 37
 blogs, 143–150
 tweets, 138–140

Z

ZackArias.com website, 199

Meet Creative Edge.

A new resource of unlimited books, videos and tutorials for creatives from the world's leading experts.

Creative Edge is your one stop for inspiration, answers to technical questions and ways to stay at the top of your game so you can focus on what you do best—being creative.

All for only $24.99 per month for access—any day any time you need it.

peachpit.com/creativeedge

VisionMongers: Making a Life and a Living in Photography
David duChemin

New Riders
1249 Eighth Street
Berkeley, CA 94710
510/524-2178
510/524-2221 (fax)
Find us on the Web at www.newriders.com
To report errors, please send a note to errata@peachpit.com
New Riders is an imprint of Peachpit, a division of Pearson Education

All photography © David duChemin except as follows: author photo on About the Author page © Kevin Clark; photos on pages 19–25 © CHRIS+LYNN PHOTOGRAPHERS; photos on pages 49–55 © Kevin Clark Studios; photos on pages 81–85 © www.darwinwiggett.com; photos on pages 107–111 © Grace Chon / Shine Pet Photos; photos on pages 127–133 © Dave Delnea; photos on pages 151–157 © Gavin Gough-www.gavingough.com; photos on pages 165–170 © www.KarlGrobl.com; photo of Zack Arias at top of page 199 © Lucas Brown; photos on pages 199–204 © Zack Arias (www.usedfilm.com); photos on pages 225–231 © Chase Jarvis; photo of Joe McNally on page 243 © Anne Cahill

Editor: Ted Waitt
Production Editor: Hilal Sala
Cover and Interior Design: Charlene Charles-Will
Layout and Composition: Kim Scott, Bumpy Design
Indexer: James Minkin
Cover Image: David duChemin

ISBN-13 978-0-321-67020-5
ISBN-10 0-321-67020-5

9 8 7 6 5 4 3
Printed and bound in the United States of America

VISIONMONGERS

MAKING A LIFE AND A LIVING IN PHOTOGRAPHY

David duChemin